DESIGN IN PLASTICS

Deepest thanks are due to my design partner and wife Linda Cleminshaw, who spent countless hours collecting, selecting, following up and organizing the materials for this work, as well as in shepherding me through it. Without her the book would not have been possible; it has been truly a joint effort. My special thanks go also to authors of the included essays: Arthur Pulos, Kenji Ekuan, Gianfranco Zaccai and Dan Gilead. Many other friends assisted in the work in ways known only to them; I am grateful to you all. Special thanks, too, go to publishers Stan Patey and Don Traynor, whose faith in the work never wavered.

—Doug Cleminshaw
Tully, New York
December 1988

DESIGN in PLASTICS

Rockport Publishers

A publication of Rockport Publishers
5 Smith St.
Rockport, MA 01966
(508) 546-9590

Book Layout & Production:
Blount & Company
12 Station Rd.
Cranbury, NJ 08512
(609) 655-5785

Jacket Design, Type Specifications, Essays & Chapters Openers:
Cleminshaw Design

Printed in Japan by Dai Nippon

ISBN: 0-935603-11-5

**Distributed to the book trade and art
trade in the U.S. and Canada by:**
North Light, an imprint of F&W Publications
1507 Dana Ave.
Cincinnati, OH 45207
(800) 543-4644; Ohio: (800) 551-0884

**Distributed to the book trade and art trade
throughout the rest of the world by:**
Hearst Books International
105 Madison Ave.
New York, NY 10016
(212) 481-0355

Other distribution by:
Rockport Publishers
5 Smith St.
Rockport, MA 01966
(508) 546-9590
Telex: 5106019284
Fax: (508) 546-7141

INTRODUCTION

Novelists have often been prescient in analyzing where society and technology are headed. "Natural" materials (which is to say traditional non-polymer materials) were very much the standard of excellence when Mike Nichols wrote *The Graduate* in 1966. Plastics had entered the language, but as a euphemism for ersatz. Fake. Teakwood, slate and tile were the real thing. Plastics were not.

But Mr. Robinson was right. Today, plastics are the watchword of our everyday environment—from the carpet that cushions the floor of your automobile to the "jellies" your teenage niece wears on her feet.

Other plastics are hidden, their presence unnoticed, but their performance well-known: Plastic adhesives, plastic coatings for wood and metal, laminates for furniture, the shine on your no-wax floor.

Why shouldn't plastics be everywhere? Plastics are the fourth great class of materials after natural fibers, ceramics and metals.

Half a century ago plastics engineering was relatively simple: Choose from a relatively narrow selection (Bakelite and few also-rans) and try to make it look like a natural material. Just a quarter-century ago an interested novice could learn the basic characteristics of most known plastics with relative ease. Today, the welter of trade names alone would make a lexicographer dizzy: from Acetal to Kevlar and Lexan and on down the alphabet to Zytel. Plastics engineering and design are complex specialties.

Plastics have gained in applications and in acceptance. But they still lack something the fibers, metals, woods and ceramics have long enjoyed: a tradition of design. Each of us has notions of how something made of wood should look. We recognize ancient traditional designs in metal when we see them. We simply haven't had enough experience with plastics to know how we should feel about a piece of plastic. A vague sense that there's something tacky about plastic lingers. We have to examine designs in plastic on a one by one basis, questioning the merits of each piece.

That's why this book is in your hands.

In its most basic sense, design means an arrangement; it is the result of a deliberate act on the part of the designer. It is also an act of communication about how the elements that caused it to come into being—the function of the object, the selection of materials and process—have been resolved. Good design fits the application to the task at hand.

In a truly good—total—design, everything works, both with itself and with the rest of the world. The best designs have a harmony so total that if any element of their makeup is disturbed, the result suffers. Good design is unexpected; we recognize something creative, a new contribution to the tradition.

When we see good design, it makes us feel good. When a result makes eminent good sense to all of our senses, we feel pleasure. We recognize its excellence without having to fully or consciously understand what it is about the thing that makes us feel that way.

Particularly from the vantage point of the designer, plastics are truly a medium of the post-industrial age. No design in plastics can result from a single intellect engaged alone in a creative act. A design in plastic is the result of many forces. Some are technological—someone had to design the resin and the process for shaping it. Some are economic—capital investment and marketing considerations. Some, including environmental and safety regulations and fashion, are purely social. All of these influences bear on the designer at his drafting board or—increasingly—CAD terminal. Good design in plastics results from excellence in a wide array of disciplines.

These materials are so easily shaped, they earned the name *plastic*, meaning formable. Plastics are amenable to a variety of processes: injection molding, casting, sheet molding, drawing filaments, hand layup. Ironically, in only a few of these are the tools used to shape plastics themselves made of plastics. Design in plastics is heavily influenced by what can be readily cut in metal. Achievements in metal technology dictates what can be achieved in plastics. On the other hand, the extreme malleability of plastics creates a demand for more creativity in shaping metals to work the plastic with.

However fascinating the processes, this book is not about technology. It's about how our lives are profoundly different and better because designers have this delightful new medium to create in.

There are tens of thousands of things made of plastic. It's difficult to find a place where you cannot see something made of plastic, even if it's only on the tips of your shoelaces (assuming you still wear leather shoes, of course). So this book has not been drawn from all the things that are made of plastic, but from a selection of pieces that are both current and typical; especially

from those categories where no product would exist if there were no plastics.

Some of these products have won design competitions. Others are here by reason of publicity about some aspect of their design. Still others were chosen by consensus of their excellence.

There is a bias here in favor of form and visual design. A variety of intellectually-stimulating products have been neglected. Their beauty is no less real, but it is not as easy to discern in an illustration. When the choice has been between pleasing physical lines and an intellectually elegant product, the choice has been in favor of those which please the eye.

A really good product "has stardust on it," to steal a line from another movie, one of Woody Allen's. Good products raise the human spirit. This book is a paean to the intellect and all its resources, to the material wealth we share, to aesthetic design solutions to the complex problems of executing products in this wonderful new class of materials we know as plastics. Because plastics are so new and because we are on the lower part of the learning curve, the entries in this book show only a beginning. But it is a beginning filled with promise.

—Doug Cleminshaw
Tully, New York
September 1989

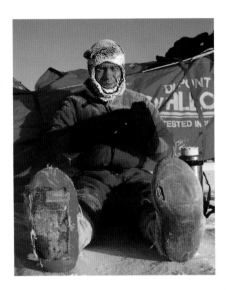

FOREWORD

by Arthur J. Pulos

There are children today who may believe that nylon sheep graze in Lexan fields under polyethylene clouds hard by the Dacron woods. There are also women, one may suppose, who insist that nylon is better for stockings than plastic. And there must be men who are convinced that the best leather comes from nauga cattle. Yet, while such old expressions as "clear as a crystal" and "light as a feather" are familiar to everyone, few people would question that there are materials in existence today that could challenge the superiority claimed by natural materials. Acrylics are known to be clearer than crystal and that Styrofoam can be made that is lighter than feathers.

The fact is that these materials have become so familiar in their own right that it is difficult to remember that they are man-made polymers—plastics—that until relatively recently carried pejorative connotations derived from their original development as cheap substitutes for valued natural materials such as tortoise shell and ivory. At the same time it may not be normally realized that the so-called natural materials are not as natural as conventional wisdom would have it. A living thing, a tree, is cut down and transformed by brute force into useful pieces. High furnace temperatures are used to transform sand into glass. And electricity is turned on to shock aluminum out of bauxite.

Over the past century chemists and other scientists have learned how to reduce matter to its simplest elements and recombine them into new materials endowed with predetermined properties to be trained to be compliant servants to human wishes. As a matter of fact, inventors and manufacturers have been hard put to keep these new materials from becoming generic in the public mind. When this happens, the material is legally endowed with a life of its own, rather than continuing to be the exclusive property of its owner or patentee. Early on, the DuPont company dropped its claim of ownership to its invented product, nylon, when it realized that the material had rushed into the public consciousness to fast to be contained. As far as the public was concerned this only meant that the coined word Nylon had dropped its capital N to become nylon, a common substance that anyone could manufacture. The DuPont Company, however, is still holding doggedly onto Dacron, as is Owens Corning with Fiberglas (one s) and General Electric with Lexan.

Until the Depression of the 1930s syn-thetic materials were tolerated, but not particularly respected by the broader public even though enthusiasts of the Art Moderne style had endorsed them as materials of the moment. Celluloid and Bakelite had been around since the last century however the flammability of the former and brittleness of the latter had limited their acceptance by the public. It was only after the General Mills company hit upon the idea of promoting its new cereal by giving away a bright blue Skippy bowl with each purchase of two boxes of its Wheaties that plastics become a familiar material. Skippy was the name of an orphan character who appeared with actor Wallace Beery in the 1930s film, *The Champ*, and was taken to heart by the public as a symbol of the pathos of the times. The free bowl was made of a formidable and even unsanitary-sounding material, urea formaldehyde that proved in use, however, to be hygienic and virtually unbreakable. Over five million bowls were distributed followed quickly by other plastic premiums that were all welcomed by the impoverished public of the times. The head of one company that benefitted from this experience was to comment later that, "This mass sampling of a relatively unknown material helped to introduce the entire emerging plastics field to the American consumer market."

Before the end of the decade the public had become familiar with a number of new plastics that were to compete with and, in some cases, displace original natural materials. Acrylics under the names Lucite by DuPont and Plexiglas by Rohm and Haas appeared in the marketplace in 1935 in the form of crystalline giftware that caught and held the attention of the public. The optical clarity and toughness of the new material also proved to be indispensable to the Air Forces during World War II in the form of transparent bubbles for gunners and bombardiers. On the side, airmen found another, albeit surreptitious, use for the gleaming acrylic rods that were snaked through the wings of a B 24 bomber transmitting light to the cockpit that enabled the pilot to see if his wingtip lights were working. Aircraft mechanics managed to liberate pieces of the rods to be made into bracelets, rings and earrings for the girls they left behind.

In 1939, the DuPont Company, exploring potential applications for a new synthetic, linear super-polymer plastic put women's stockings made of the material on sale in a test market in Wilmington. Public response to a product that would cost half as much as the increasingly scarce silk stockings,

wear ten times as long, and look even better on a woman's legs than silk was so impressive that DuPont decided to expand its production of nylon to meet anticipated national demand. Accordingly, it licensed some fifty companies to manufacture stockings aimed at national distribution to be launched the following year. In May 1940 when four million pairs of stockings were put on sale the entire supply was virtually exhausted within four days. With nylons, described as a miracle protein-like material made out of coal, air and water, paving the way plastics could no longer be thought of as a substitute for the real thing.

During the war, a new thermoplastic, polyethylene, appeared and was immediately pressed into war service as an insulating material. However, a chemist, Earl S. Tupper, believed that polyethylene had great potential for post-war applications and by reformulating it in 1945 was able to successfully manufacture his first product, an ordinary tumbler. Before this time the value and durability of kitchen wares were associated in the public mind with rigidity, weight and expense—ceramics, glass and iron. With Tupper's new product just the opposite philosophy prevailed. By its very nature the material was at its best in simple modern shapes that were flexible, durable and eminently adaptable for refrigeration, storage and table use. And perhaps, above all, the products were inexpensive. He originally called his material Poly-T to help dissipate lingering public doubts about plastics being too cheap to be useful. Later, the products, now known as Tupperware, found their way around the resistance of marketing outlets (apparently because there was not enough of a profit there to please merchants), directly into people's homes by means of a unique system of Tupperware Parties that entertained a gathering of neighbors as well as demonstrated the value of the products. It is now generally recognized that flexibility, lightness and translucency can be assets rather than faults in container design—today a great variety of food products are marketed in plastic contain that find a new life in the home.

In 1947 *House Beautiful* magazine commended the form of Tupperware products as being art objects, and compared their material to alabaster and jade. Other similar recognition came from their selection by the Museum of Modern Art for its Good Design Exhibitions in the 1950s. These honors were accepted by the public as being justly deserved recognition that precious materials and uniqueness were not the only criteria upon which esthetic value should be based and that even the humblest products could also have eternal cultural value.

Even though melamine, a formaldehyde-based thermosetting compound, had been known for more than one hundred years to be a tough, yet light material that was scratch-resistant, as well as odorless and tasteless it was not until the wartime demand for tough helmet liners for the Army and light shipboard dinner trays for the Navy that manufacturers turned to this material for their answer. This successful use of melamine to meet military needs helped pave the way to its acceptance at the public level.

At war's end the American Cyanamid Company was convinced that melamine had a future in dinnerware for other institutional markets as well for the home if fresher and lighter colors could be made available. Moreover, the company believed that melamine's resistance to scratching could overcome the whispering campaign, encouraged by the ceramics industry, that there were dangerous bacteria lurking in the most miniscule scratch on a dinner plate.

Accordingly, the company decided in 1945 to test public acceptance by commissioning Russel Wright to develop a special line of melamine dinnerware to be tested first in restaurants. The commission came to Russel Wright because the wife of the president of American Cyanamid was an ardent admirer of his successful ceramic American Modern dinnerware line. Wright had convinced her that materials for daily living should be modest rather than exotic. Thus, his elevation of humbler materials to domestic respectability—aluminum and stainless steel for silver, maple rather than mahogany, and now melamine for ceramic wares—complemented rather than displaced other materials that were considered more appropriate for formal and ceremonial occasions.

The company subsequently equipped several restaurants with sample sets of Wright's design that were modern and attractive in form with a surface judged to be comparable to glazed china. Within a year after its spectacularly successful field test the line, now named Meladur, was made available to the general public. More than a dozen other plastic molders also began production of their own melamine dinnerware that, with designs by Joan Luntz and Belle Kogan, brought in a feminine sense of form. And, when colorful melamine inlays became possible, a fresh approach to decoration that was appropriate for a more casual style of living became fashionable.

Thus, while the American porcelain dinnerware industry has virtually disappeared because it has not been able to grow beyond traditional styles, designers have demonstrated that they could conceive new forms in new materials that the general public would welcome for everyday living. And, to give weight to this conviction, while some merchants are reluctant to display such products alongside their fine china, silver, and glasswares, melamine, and other modest materials have found a convenient and profitable place in the modern living sections of department stores and specialty shops that cater to a younger generation.

Other interesting manifestations of the impact of plastic materials include their virtual displacement of glass containers for products ranging from beverages to cleaning compounds. It is evident that, apart from the savings that result and the elimination of glass breakage there has been a substantial reduction in shipping weight. One interesting result of lighter weight is the fact that the replacement of glass with plastic in the small bottles of alcoholic beverages aboard passenger airliners has resulted in weight savings that enable the airline to add, on the average, two more fare-paying seats to each flight.

These these have been only a few examples of the interplay between polymers and people. Others could have been added from the areas of architecture, business and domestic furnishings, appliances, transportation, and recreation to illustrate the degree to which plastics have been serving and, in the opinion of some, may be threatening the quality of life. In view of some evidence that plastics should be held accountable for a substantial percentage of the waste that is now going into landfills it has been proposed that their production should be curtailed and that research programs should be supported for the development of biodegradable replacements.

In closing it may be interesting to note that polymers may be more comparable to the human species than one might imagine. They, too, are of biological origin—even if several times removed. Living things follow cycles of conception, birth, service, death and renewal. So do polymers. They, too, are consumed by use and like other products of nature are destined, or should be designed, to disappear and be renewed without encumbering living spaces on this planet.

COMMENTARY

by Kenji Ekuan

Nyoi is an oriental word. Nyoi means to have things come out in exactly (nyo) the way one wishes (i). In order to attain a state of nyoi, one must first obtain will power and direction (vector). When volition is added to a wish, things undergo alteration. For the Japanese, whose culture has always taken as its theme the development of materials, plastic presented a new challenge. Plastic became a material that satisfied the desire to have things come out as wished.

First, coloring was provided for everyday life. Its high chromaticity had a strong impact. In the context of the traditional Japanese lifestyle, almost everything used to be made of wood, bamboo, paper, clay and straw. Glass was used for only a very small number of items. Thus, the only things that lent color to daily life were textiles, pottery and lacquerware, with most of their colors being of the subdued variety. Plastic added a great deal of brightness and color with utensils with a high chromaticity.

The next phenomenon to appear was the making of imitations with plastic. Since it had superior flexibility, it was made to imitate a broad variety of materials—wood, to imitate bamboo in the making of baskets, to imitate pottery, glass and metal. One of the greatest accomplishments in plastic was the imitation of the great traditional Japanese crafts of lacquerware that had been developed through the use of natural resin.

So what is the true essence of this material which can convert itself into so many differing textures? One result of this flexible superior student material was its role in pointing out the true value of the original materials which it was made to imitate. The self-sacrifice of one material clarified the existential significance of another. From the midst of this imitation game, the consciousness of the worth of natural materials was raised.

While on the one hand the Japanese people appear to be cheerfully absorbed in the making of imitations with plastic, on the other hand, they have continued to have feelings of distrust and dissatisfaction toward it.

The reason for this distrust is found in their view of the transience of time. Everything is in a constant state of change. The Japanese find joy in discovering these changes in all things, and utilizing their discoveries to deepen their philosophy of life. And it is through such delicate changes that they confirm the health of their own sensitivities and find satisfaction.

The waxing and waning of the moon, the blooming and falling of blossoms, the seasonal burgeoning and disappearance of the voices of insects. These are the indications that announce the instant-by-instant passing of time on the faceless clock of nature. And this is the basis upon which the culture of Japan has constructed its precisely accurate natural calendar.

But the major premise of plastic is immutability. It denies wear and termination. Plastic never dies.

The Japanese people have so entirely based their sensitivities upon the transience of time that they even include their own deaths in their natural calendar, and they keep transience in mind in everything they do. Thus they feel not only uncomfortable with, but they even hold a horror of this thing called plastic that denies death; that even when death of use/function finally comes does not show its death in a change of shape, that never undergoes any change. A culture which places the highest value upon change feels as though it is being violated by a material that takes immutability as its major premise. The resultant strong resistance is always behind the Japanese attitude toward plastic, which reveals itself on the foreground as a devising of new ways to make plastic imitate other materials.

What was the reason for this phenomenon? Perhaps it was due to an inveterate distrust of this new material in the hearts of the Japanese.

The Japanese were too taken with their view of natural materials as honest and therefore correct. Perhaps this is what kept them from taking as straightforward and guileless an approach to plastic as Americans. The Japanese can't quite bring themselves to truly believe in plastic. They cannot see its true value. They don't know where this material was born. They know it to be a superior student that can accomplish anything it sets its hand to, but they feel that something is missing. It is this sort of suspicion under which plastic has suffered in Japan.

In the process of skillful handling of imitations made of this new material called plastic, the Japanese seem to have begun to acknowledge it anew in accordance with their own sensibilities. Now it appears that a new way of understanding and acknowledging plastic is beginning.

Japan's industrial strength has extended its greatly varied capabilities. What is to be manufactured with the productive power it has thus gained? The consummation of an industrialized society is the starting point for creation of an informationalized society. And it is here that plastic is establishing itself as an information media material. Have we not just gone through a quarter-century of testing the extent to which this material that possesses the ability to become anything at all can endure as the three-dimensional alphabet of information?

Nyoi is an expression of will, and the way in which nyoi is expressed indicates the breadth of a person's desires. In this context, Japanese people have pinned the way they wish things to be upon materials and tested their cultural adaptability for themselves.

So what is the reason behind the acknowledgement that the information society may be the place where plastic can be utilized to realize the way they wish things to be? I believe that it was the traditions of Japanese culture that made the Japanese people come to think in this manner.

Actually, Japan has two anticipatory material cultures that have amalgamated the original meaning of the word plastic with the immutability that symbolizes its inherent character. One is the world of pottery which was a world of form developed through what we refer to today as ceramics. The other is the world of lacquerware developed through natural resin.

Products made from clay and lacquer were utilized more as carriers of information than as functional items. They have always served as carriers of information concerning the areas where they are produced and the craftsmen who made them.

With these two materials as its base, the possibilities of form and expression were pioneered as an important subject of Japan's culture of form. The act of giving concrete form to the way one wishes things to be unexpectedly questions human nature. It was the pottery and lacquerware craftsmen of Japan who made the brave attempt to answer this severe question by challenging the state of the way they wished things to be.

It has been said that the home where the raw materials were born and nurtured can be seen in such conventional materials as wood, paper, textiles and pottery. If their home can be seen, people can find the pil-

ing up of of the hypotheses that indicate their origins, even if their nature has been slightly twisted or if they have gone off the beaten track, and it is here that we can discover the key to their understanding and acknowledgement.

"Plastic does not reveal its home of origin, and for this reason, its behavior cannot be accepted." This attitude is no longer acceptable in Japan since the experiencing of the post-War period of high economic growth. The raw material of plastic is petroleum. Since petroleum is one of the resources produced by nature, it is a natural element.

Kenji Imanishi, an animal behaviorist has said that, taken back to their origins, all living things—and even minerals—are nothing but natural forms of our earth.

For human beings, the creation of a material for the making of man-made objects is the same as creating a new life form. This is the way Japanese people view plastic, and I believe it is the reason that it is correct to say plastic has succeeded in gaining a life in Japan.

Kenji Ekuan is president of GK Industrial Design Associates, headquartered in Tokyo, Japan. He is also the past president of the International Council of Societies of Industrial Design and a philosopher of design well known around the world.

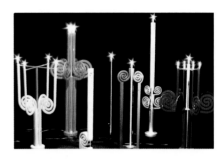

SPORTS & RECREATION

Sports, games, outdoor pastimes, and entertainment are expanding everywhere. One reason for this is increased consciousness about the possibilities for use of leisure time through modern communications. But the major reason is that the economies of mass production have made equipment for sports and active leisure pastimes affordable for millions more than could have ever afforded the old-fashioned toys for the rich.

Modern sports have their cultural roots in the classical materials—wood or brass-head golf clubs with wooden shafts, wood-framed rackets strung with the intestines of cats, bamboo fishing poles with silk lines attached, leather-covered balls stuffed with bird feathers, gutta-percha balls, wooden skis with leather bindings, cotton sails for wooden boats and so on. But these "classical" materials will not do for modern sports. In every field, of course, there are purists who relish the old forms and old-fashioned ways of doing things, simply for the sake of preserving the past in unchanged form. But ask a modern contact sports player about, say, protective headgear. A suggestion to return to the leather model used by generations before will be greeted with raw incredulity.

Not long ago skis for downhill racing were made of wood with steel edges attached by screws. Today's very sophisticated carefully engineered intricate composite skis would be utterly impossible without plastic resins. And the performance achieved on skis would be impossible. Plastics are both the physical and conceptual adhesive that holds it all together; that makes it happen.

The changes in sports are everywhere. Consider the effect of Astroturf, the grass-like plastic carpeting that has made possible totally enclosed climate-controlled year round indoor playing fields. The costs of maintaining natural living grass turf in heavily-used indoor entertainment arenas is prohibitive. Hence Astroturf. There follows next subtle changes in the equipment used

and the way sports are played on this new plastic surface.

Boating is sport for millions of people because of the cost economies of Fiberglas reinforced polyester resin.

Pole vaulting records are in a range inconceivable without the remarkable energy-storing capabilities of today's equipment. The gladiators of American football are clad in plastic armor. The familiar Frisbee flying saucer started life as a metal pie tin, but is quintessentially a plastic sports plaything.

When we include rubber as a plastic material, there is no question that modern sports depend on plastics. Rubber a plastic? Of course it is, synthetic or not. Plastics are the class of viscoelastic materials. Rubber from tree juice is a natural elastomer unquestionably belonging to this group and no other. Interestingly, the remarkable stretchy and springy properties of rubber were unknown in the West until the dawn of the age of plastics. The unfamiliar qualities of elastomers and viscoelastics came on Western culture all at once. We are still very much in the process of discovering what forms and designs fit well with the new and culturally unfamiliar properties of the members of the group. The new materials have been used many times in old forms, old designs, familiar old shapes, always inappropriately and with disastrous results. No wonder plastic has been used as such a derogatory adjective.

The viscoelastics—plastics—are characterized by very long molecular chains with lots of bends in them. At various points in the long organic molecule there are double-bonded oxygen atoms. These make for very flexible springy joints in the plastic molecule. This characteristic arrangement of atoms is the basic molecular fact that makes plastics—including rubber—a class unto themselves, one quite different from the other three fundamental classes of materials.

What would sports and games be like without the plastics known as rubber? Children the world over toss rosy

air-filled bouncing balls at walls and paving, inventing games as they go. Young girls everywhere play a game of picking up things (called "jacks" in the United States) with a little sponge rubber ball, usually red. Tennis would be a very different game without an inflated rubber ball.

The traditional game of tennis has been changed through plastics not only because the equipment has been greatly improved, but because the very weather conditions under which it can be played have changed.

Would there be any table tennis without the strong, lightweight, resilient properties of cellulose nitrate to suggest creation of the little ball, and thus the game?

As for newer games, the sport of sailing on surfboards—boardsailing or windsurfing—would probably never have been invented without plastics. These light, agile, durable craft are nearly exclusively plastic. Hull, mast, sail, battens, fins, flotation, all are sophisticated composite plastics.

The sport of kayaking has changed along with the kayak. Its popularity increased as kayaks evolved from wood-framed structures covered with animal skins into assemblies of Fiberglas or aramid-reinforced thing structures into today's nearly indestructible one-piece rotomoldings. Much of the appeal of modern kayaking comes from the ability of plastic boats to bounce harmlessly off rocks in turbulent whitewater rivers. This is quite a different end use than open water transportation in the Arctic, though we still call them kayaks.

In sports, winning counts. Superior performance is valued more than tradition. Good plastics design abounds. The different and new capabilities of plastics can be freely used in honest expression of their own unique abilities. In sports plastics are never used as substitute or ersatz anything; they are only used when superior to other materials in the use at hand. Sports applications demand careful design, careful choice of plastic resin, careful

engineering and processing to get the optimum blend of properties that will result in superior performance—the winning advantage, the "edge."

We indulge in sports and pastimes for fun. Whatever seems like more fun will be the direction in which sports evolve. The fact that plastics as a class of materials offer capabilities we may have never known before means that many, many new sports and active leisure pastimes will be invented, all of them using plastics.

Outstanding performance means the truly optimum blend of properties available at the time of design. Because sports are so performance oriented, plastics—and design in plastics—will always be an arena in which they excel.

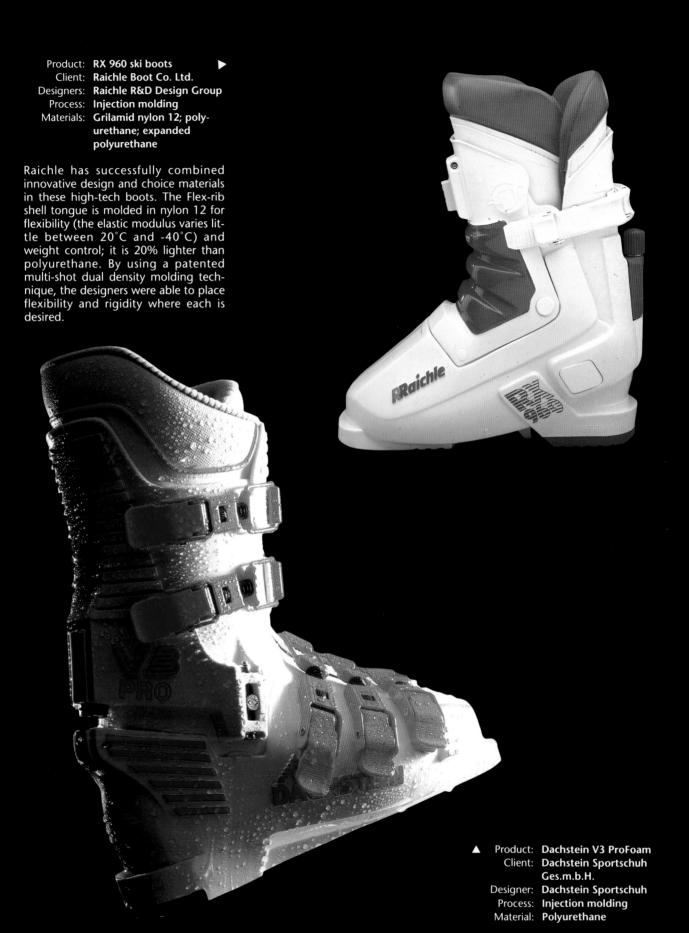

Product: **RX 960 ski boots** ▶
Client: **Raichle Boot Co. Ltd.**
Designers: **Raichle R&D Design Group**
Process: **Injection molding**
Materials: **Grilamid nylon 12; poly-
urethane; expanded
polyurethane**

Raichle has successfully combined
innovative design and choice materials
in these high-tech boots. The Flex-rib
shell tongue is molded in nylon 12 for
flexibility (the elastic modulus varies lit-
tle between 20°C and -40°C) and
weight control; it is 20% lighter than
polyurethane. By using a patented
multi-shot dual density molding tech-
nique, the designers were able to place
flexibility and rigidity where each is
desired.

▲ Product: **Dachstein V3 ProFoam**
Client: **Dachstein Sportschuh
Ges.m.b.H.**
Designer: **Dachstein Sportschuh**
Process: **Injection molding**
Material: **Polyurethane**

To achieve a snug yet comfortable fit,
the skier's foot is used as a mold for
custom pour-in-place polyurethane.

Product: **Tyrolia 480 ski bindings**
Client: **Tyrolia Freizeitgeraete**
Gmbh & Co.
Designer: **Tyrolia R&D design team**
Process: **Injection molding**
Material: **Delrin acetal**

While color, looks and style play a part in the design of ski bindings, performance is the primary consideration. The designers made extensive use of Delrin acetal, which resulted in sleek-looking housings and internal parts with reliable frictional characteristics and low weight. Delrin rollers, placed where the boot meets the binding, keeps boots in place, yet releases the binding when desired.

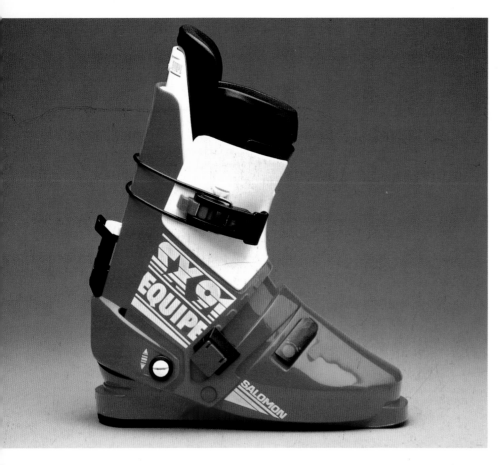

Product: **SX 91 Equipe ski boot** ◄
Client: **Salomon/North America**
Processes: **Injection molding;
injection pour**
Materials: **Polyamide, polyurethane
foam**

A twin-foam design highlights these performance ski boots. A thin, resilient inner layer snugs up to the peculiarities of the wearer's foot, giving an individualized fit. A firmer outer layer sandwiched between the liner and the hard outer shell improves steering and lateral control.

Product: **Cross-country ski bindings** ►
Client: **Berwin Inc.**
Designers: **Berwin Inc./Win
Hulstrand; Walter
Bieger Design Associates**
Process: **Injection molding**
Materials: **Delrin acetal; Zytel
nylon**
Molder: **Steinwall, Inc.**

Designed to stay flexible in extremely cold temperatures, these X-C ski bindings were used on a 1986 expedition to the North Pole. Unlike metal bindings, which can freeze up in below-zero weather, the bindings took the abuse of -40°F. temperatures and of skiing across extemely abrasive Arctic ice. It was "like walking on shattered glass," one of the skiers said.

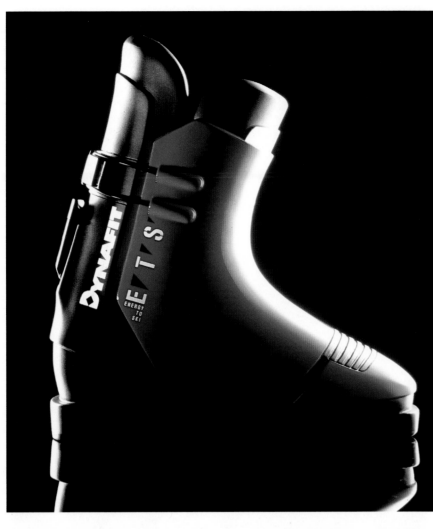

Product: **ETS ski boot**
Client: **Dynafit Inc.**
Designer: **Dynafit Inc./Kurt Hillgarth**
Process: **Injection molding**
Materials: **Polyamide; polyurethane**

The unique shell material of the beautifully-styled Fischer Dynafit ETS flexes forward naturally, without pin hinges, to transmit energy accurately to the ski, aiding in control. A web-effect adjustable fit system accommodates the changing shape of the foot as it flexes.

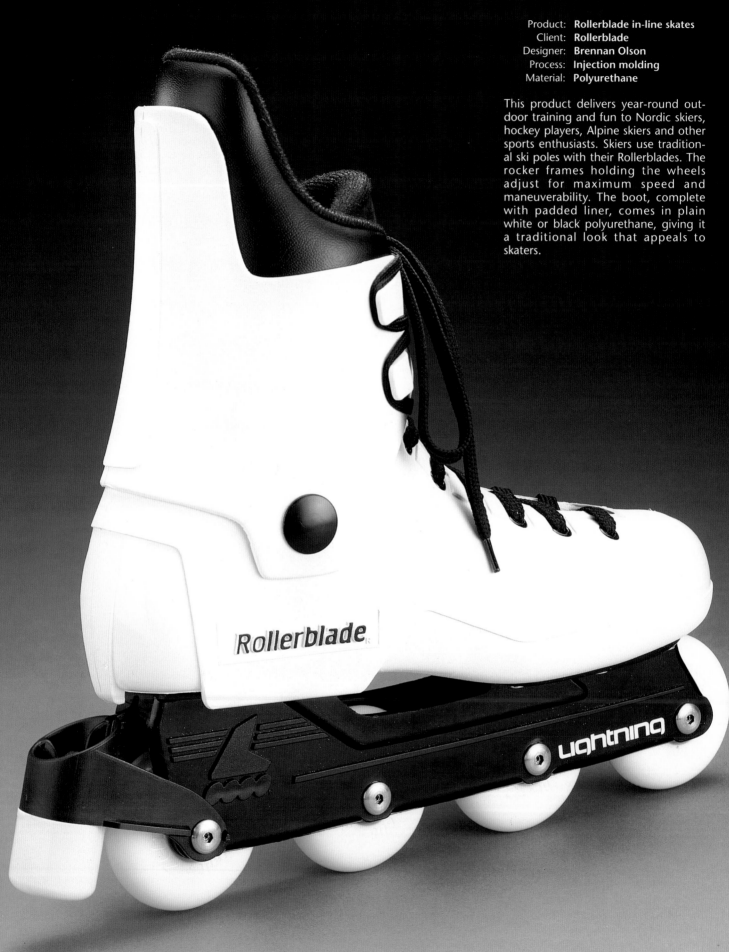

Product: **Rollerblade in-line skates**
Client: **Rollerblade**
Designer: **Brennan Olson**
Process: **Injection molding**
Material: **Polyurethane**

This product delivers year-round outdoor training and fun to Nordic skiers, hockey players, Alpine skiers and other sports enthusiasts. Skiers use traditional ski poles with their Rollerblades. The rocker frames holding the wheels adjust for maximum speed and maneuverability. The boot, complete with padded liner, comes in plain white or black polyurethane, giving it a traditional look that appeals to skaters.

Product: **Lange Freestyle ice skates▶**
Client: **Canstar Sports Group Inc.**
Designer: **Holbl**
Process: **Injection molding**
Material: **Polyurethane**

While traditional skates are quite apparently a collection of separate elements, this beautiful skate looks as if a steel edge had been put into a mold and the entire skate injected around it.

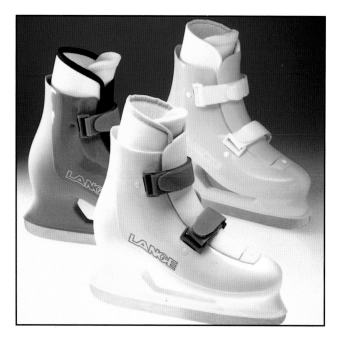

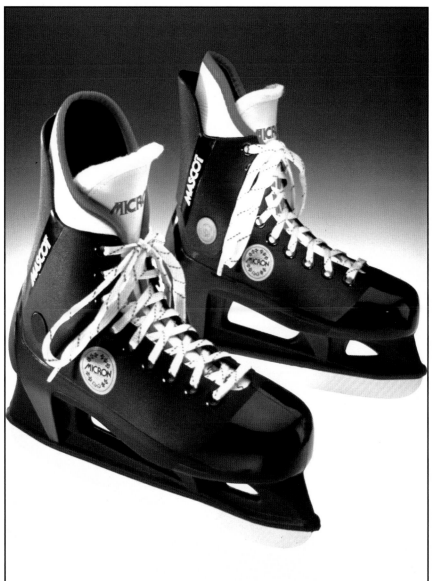

◀ Product: **Micron ice hockey skates**
Client: **Canstar Sports Group Inc.**
Designer: **Delta Design/Marc Delery**
Process: **Injection molding**
Materials: **Polyurethane boot;**
Polyethylene foam liner

Although not visually integrated, the main boot and blade holder are molded as one, simplifying production and providing true positioning of the blade to the skater's foot.

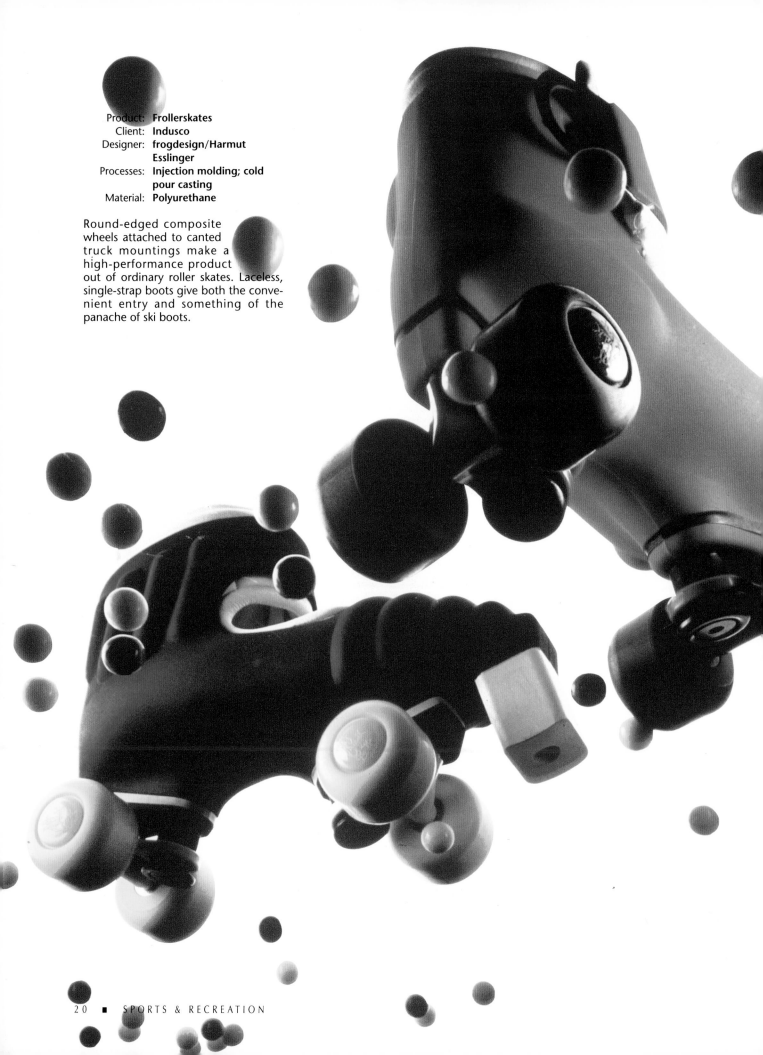

Product: **Frollerskates**
Client: **Indusco**
Designer: **frogdesign/Harmut Esslinger**
Processes: **Injection molding; cold pour casting**
Material: **Polyurethane**

Round-edged composite wheels attached to canted truck mountings make a high-performance product out of ordinary roller skates. Laceless, single-strap boots give both the convenient entry and something of the panache of ski boots.

Product: **Lazer/Eddy Merckx**
 cycling helmet
Client: **Lazer Helmets Inc.**
Designer: **Bertone**
Process: **Injection molding**
Material: **Polycarbonate**

Talk about one for the road, this handsome bicycling helmet brings both the protection and the affordable high styling that only injection-molded plastics can afford.

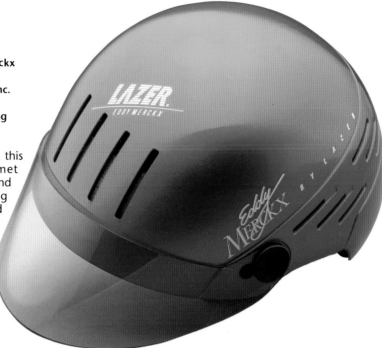

Product: **Motorcycle helmet**
Client: **Nava & Co.**
Designer: **Pierluigi Nava**
Processes: **Injection molding;**
 foam molding;
 heat forming
Materials: **Polycarbonate;**
 polystyrene;
 polyamide;
 polyurethane;
 thermoplastic
 rubber

The Nava 8 motorcycle helmet is a departure from the norm in more ways than one. First, it does not incorporate a strap. Instead, a lower molding snaps into place under the cyclist's chin. Five air ports conduct cooling outside air through the helmet, and electronics for a voice-activated intercom are easily installed.

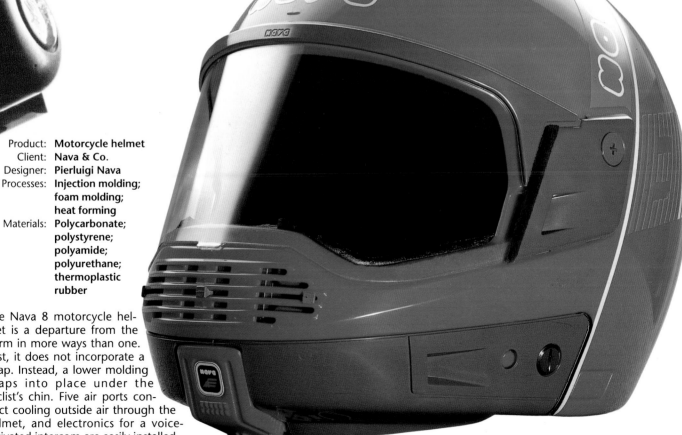

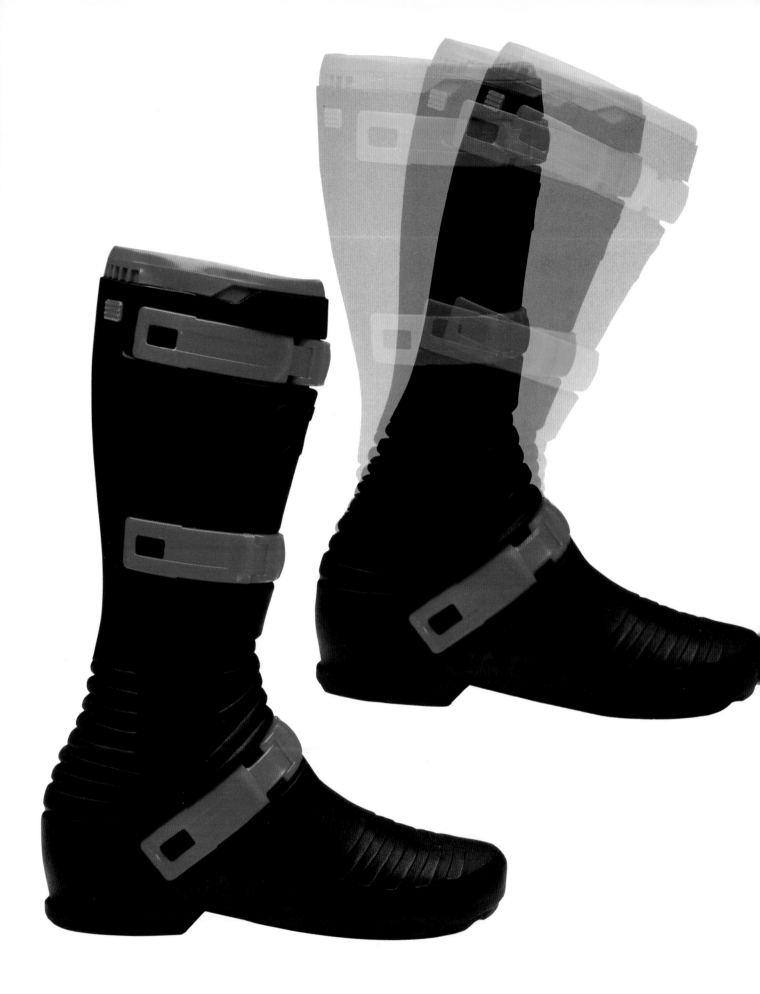

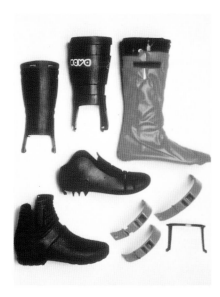

Product: **Pro Flex motorcycle boot**
Client: **Nava & Co., SpA.**
Designers: **Pierluigi Nava; Ignio Tesser**
Process: **Injection molding**
Materials: **Pebax polyether block amide (PEBA); PVC; polyethylene; polyamide; thermoplastic rubber**

Everything a motorcyclist could want in a perfomance boot—including style and panache—are included here. Moto-cross, trials and enduro racing demand tough footwear. The high, rigid calf support provides excellent leg protection and side-to-side leverage for muscling a big bike around a tight curve, yet is ribbed at the ankle for full fore-and-aft flexibility. The boots are completely waterproof, yet the open-cell inner boot breathes for maximum comfort. The PEBA resin retains its excellent mechanical properties, elastic memory and resistance to oil, gas and lubricants in temperatures down to -50°F. The component parts of the boot can be replaced—a key feature given the pounding they get—and the interior is easily washed, making it clean and fresh for the start of each race.

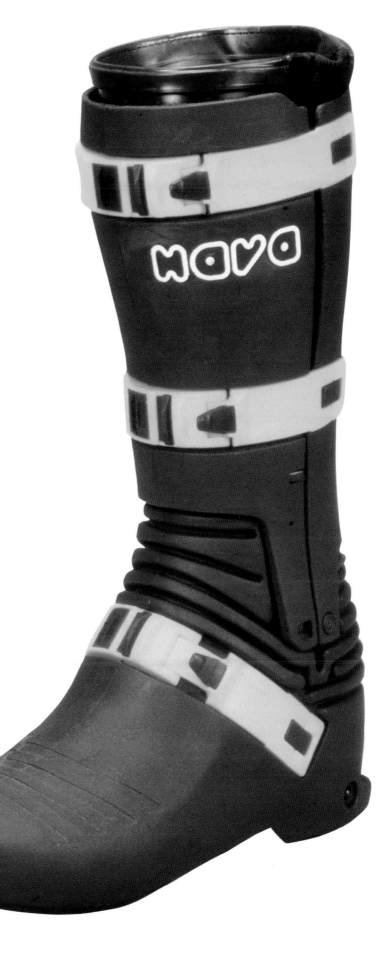

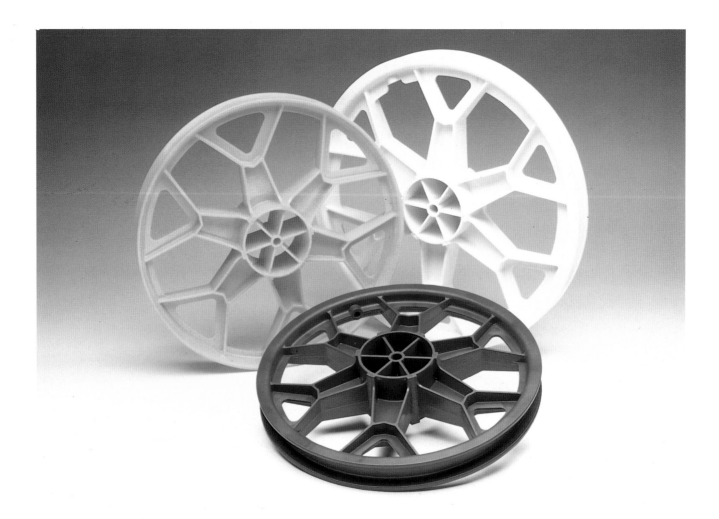

Product: **BMX bicycle wheels** ▲
Client: **Hedstrom Corporation**
Designer: **Hedstrom Corporation**
Process: **Injection molding**
Material: **Grilon nylon 6**

The bright colors of these moto-cross bicycle rims make a bold statement. The high-flow characteristics of Grilon nylon allow low molding pressures, minimizing glass fiber orientation—desirable here—and less warping.

Product: **Bicycle seats** ▶
Client: **UNI-BMX Enterprises**
Designer: **UNI-BMX/Roger Berg**
Process: **Injection molding**
Material: **Grilon nylon 6**
Molder: **Polycast Inc.**

Made for bicycle motocross (BMX) racing, these seats—especially the joint between seat and post—take a beating. The seats are Grilon nylon 6 while posts are hand-wrapped fiberglass tubes (lighter and more resilient than fiberglass pultrusions), keyed and set into the sockets with slow-curing epoxy. The Uni-Turbo seat has more, but thinner, ribs for greater strength with less weight.

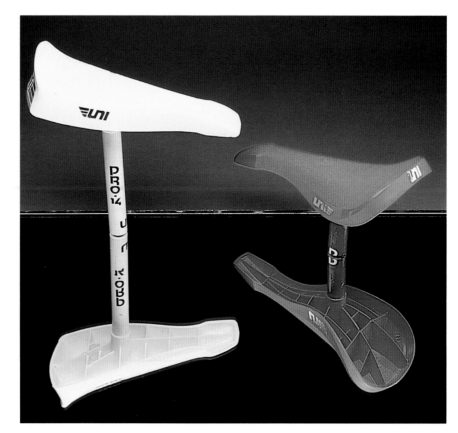

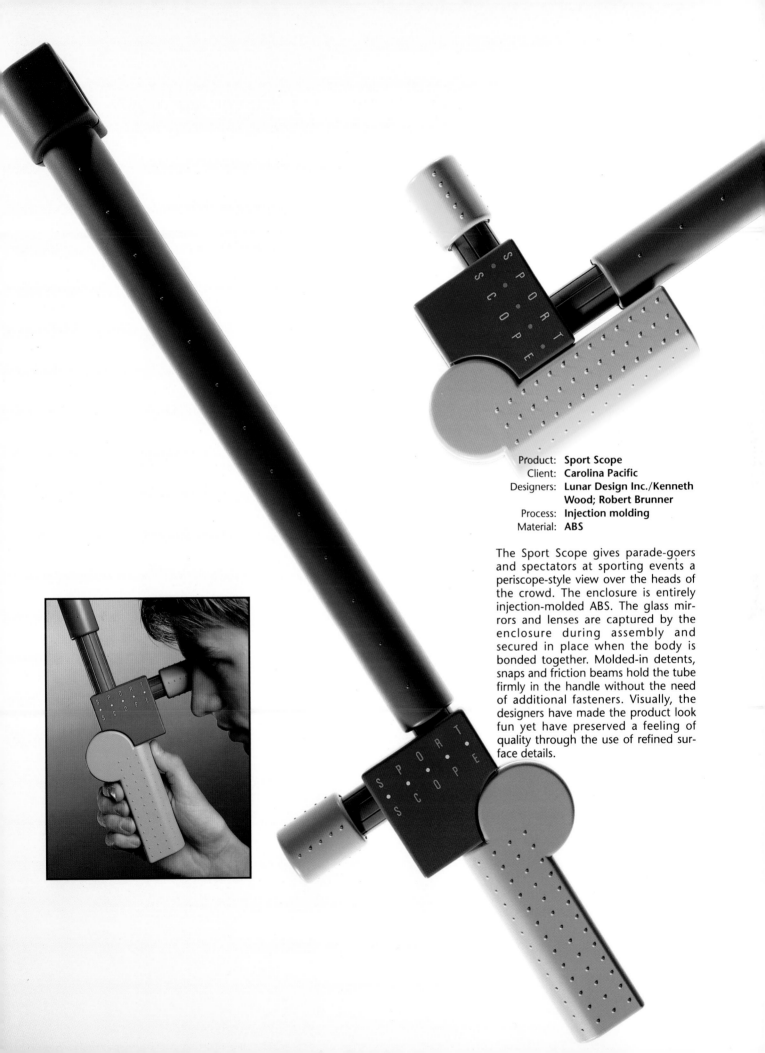

Product: **Sport Scope**
Client: **Carolina Pacific**
Designers: **Lunar Design Inc./Kenneth Wood; Robert Brunner**
Process: **Injection molding**
Material: **ABS**

The Sport Scope gives parade-goers and spectators at sporting events a periscope-style view over the heads of the crowd. The enclosure is entirely injection-molded ABS. The glass mirrors and lenses are captured by the enclosure during assembly and secured in place when the body is bonded together. Molded-in detents, snaps and friction beams hold the tube firmly in the handle without the need of additional fasteners. Visually, the designers have made the product look fun yet have preserved a feeling of quality through the use of refined surface details.

SWAROVSKI

What a lovely piece of sculpture to cradle in the hands! The softly curving exterior of these binoculars reflects the unfettered natural shape of the glass in the optical path. The smooth ergonomic design with its deep, comfortable thumb grooves makes for exceptionally easy handling. Creating this sculptured shape despite the uncompromising nature of optical elements was the difficult task of the designer, and he did it exquisitely.

Construction is from the inside out. The laser-aligned optics are embedded in epoxy, wrapped in fiberglass, then encased in react-in-mold polyurethane in a choice of colors. The result is a foam structure with a non-slip watertight outside body that's comfortable in all temperatures and resists bumps and knocks. The SL 7x50 marine binoculars (far right) and SLC 8x50W (right) are so inherently tough and water-proof that Swarovski offers no separate carrying case—only molded end caps to protect the coated optics.

Product: **Habicht Binoculars**
Client: **Swarovski Optik KG**
Designer: **Werner Holbl**
Materials: **Foamed urethane casing; glass-filled polycarbonate (objective tubes and ocular tubes and chassis); epoxy potting; nylon gears; injection molded react-in-mold casing**

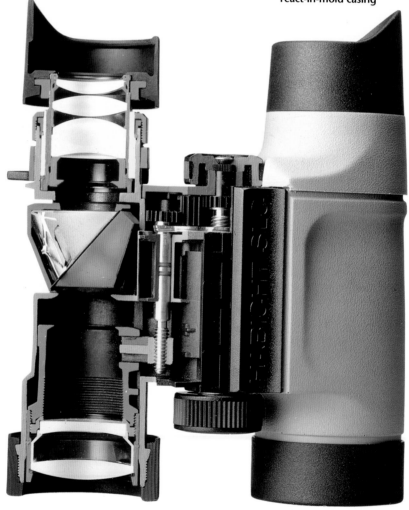

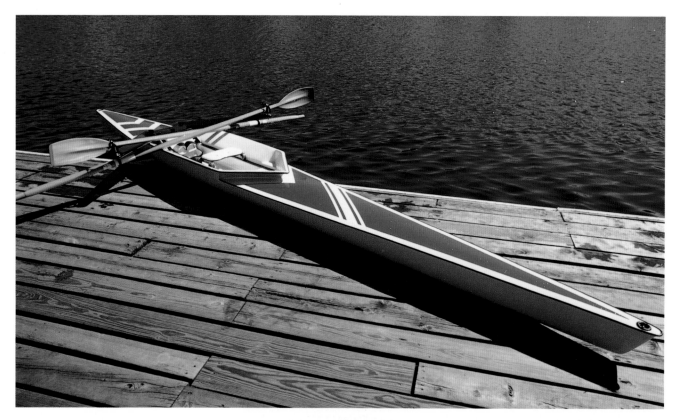

▲ Product: **Rowing shell**
 Client: **Advance USA**
 Material: **Geloy ASA**

Advance USA thermoforms this shell from extruded Geloy weather-resistant resin to achieve the same attractive color and gloss finish of fiberglass. However, Geloy is lighter and more durable than fiberglass.

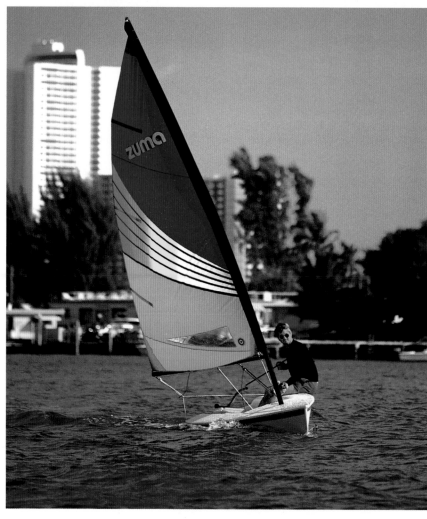

Product: **Zuma Sailboat** ▶
Client: **AMF**
Designers: **Innovations & Development Inc./Edward Meisner; Michael Ballone; Gary Grossman**
Process: **Layup**
Materials: **Fiberglass reinforced polyester; polyester sailcloth**

Designing a new sailboat that could be hauled atop a car, handled by two adults and would retail for less than $1,000 US took some imaginative thinking. Wood and metal are far too heavy, so fiberglass was the answer.

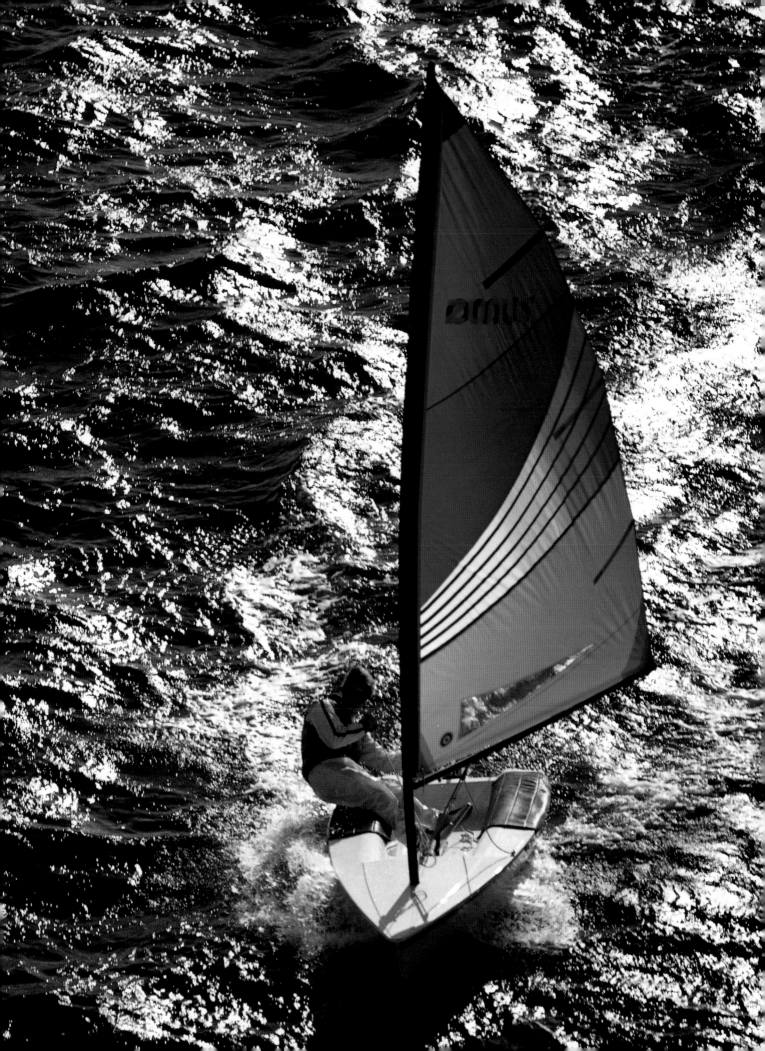

Product: **Champion IV canoe** ▶
Client: **Sawyer Canoe Company**
Designer: **Sawyer Canoe Company/**
Robert D. Gramprie
Process: **Hand layup**
Materials: **Isophthalic polyester;**
Kevlar aramid fiber;
PVC foam

Flat water canoe racing calls for a boat that is lightweight, rigid, tough and fast. The Champion IV, used by four winners of the U.S. national flatwater racing championship, features hand layup vacuum bagged core and rib construction, with Kevlar reinforcing strips over a PVC foam core. Four strips of foamed polyethylene are cemented in for padding and flotation. The canoe weighs only 34 pounds.

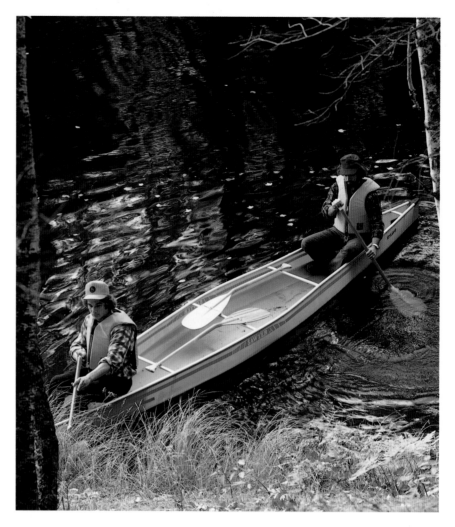

Product: **Rowing shell**
Client: **Martin Marine Company**
Designer: **Arthur E. Martin, N.A.**
Process: **Hand layup**
Material: **Polyester resin**

The assignment called for a boat that is light enough for one woman to carry, yet tough enough to withstand rough waters. Designer Arthur Martin's inspired solution was to make the entire rowing apparatus easy and quick to remove to reduce the carrying weight to 40 pounds. ▼

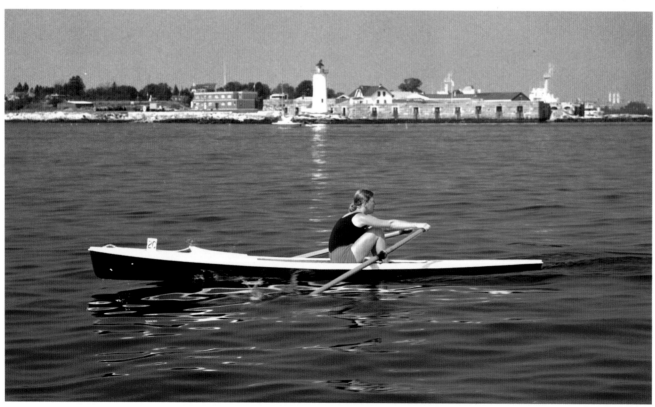

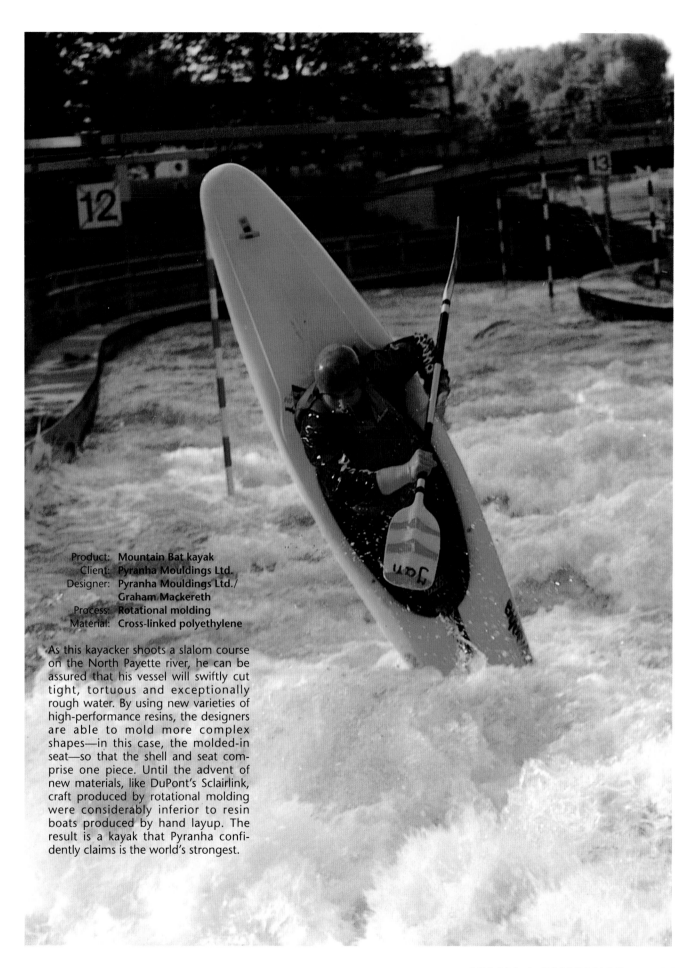

Product: **Mountain Bat kayak**
Client: **Pyranha Mouldings Ltd.**
Designer: **Pyranha Mouldings Ltd./
Graham Mackereth**
Process: **Rotational molding**
Material: **Cross-linked polyethylene**

As this kayacker shoots a slalom course on the North Payette river, he can be assured that his vessel will swiftly cut tight, tortuous and exceptionally rough water. By using new varieties of high-performance resins, the designers are able to mold more complex shapes—in this case, the molded-in seat—so that the shell and seat comprise one piece. Until the advent of new materials, like DuPont's Sclairlink, craft produced by rotational molding were considerably inferior to resin boats produced by hand layup. The result is a kayak that Pyranha confidently claims is the world's strongest.

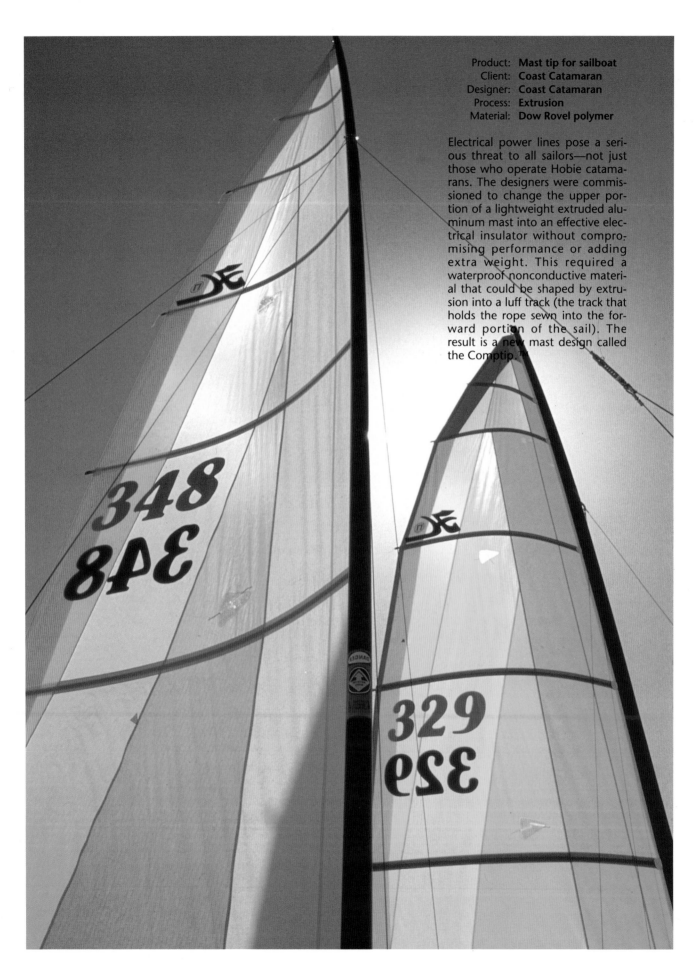

Product: **Mast tip for sailboat**
Client: **Coast Catamaran**
Designer: **Coast Catamaran**
Process: **Extrusion**
Material: **Dow Rovel polymer**

Electrical power lines pose a serious threat to all sailors—not just those who operate Hobie catamarans. The designers were commissioned to change the upper portion of a lightweight extruded aluminum mast into an effective electrical insulator without compromising performance or adding extra weight. This required a waterproof nonconductive material that could be shaped by extrusion into a luff track (the track that holds the rope sewn into the forward portion of the sail). The result is a new mast design called the Comptip.™

Product: **Sailboards**
Client: **Fanatic Schütz Werke GmbH**
Designers: **Board: McElheny/Pudenz; Sails: Monty Spindler**
Processes: **Vacuum-formed skin-glass wrapped around an EPS foam core with carbon fiber stringers; resin applied by robot; wet cocoon laid into heat and pressure mold**
Materials: **Foam core; carbon fiber; glass cloth; polycarbonate skin**

Plastics and boardsailing were made for each other. The original Windsurfer model was shaped from a slab of polyethylene foam and topped with a polyester cloth sail. Materials obviously play a critical part in keeping the boards light, but shape is also important. In this model—the Ultra Boa—the double concave channels let the craft plane at a low speed, while the flat side channels provide a loose feel in waves. Other features: thin-tail rails at the wingers and a contoured deck for relaxed high wind speed sailing.

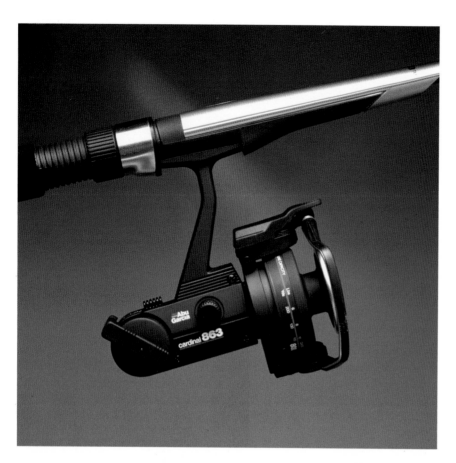

Product: **Cardinal 863 spinning reel**
Client: **Abu Garcia Produktion AB**
Designer: **Henry Dreyfuss Associates**
Process: **Injection molding**
Materials: **Polyurethane over Delrin acetal cores; glass-filled polyamide**

Graphite-filled epoxy rods and polyamide reels have gained favor among sportsmen, and with good reason. They're lightweight, tough and non-corrosive. The body, side cover and bail are made of glass-filled polyamide, while the crank handle and drag knobs are constructed of polyurethane over Delrin acetal cores.

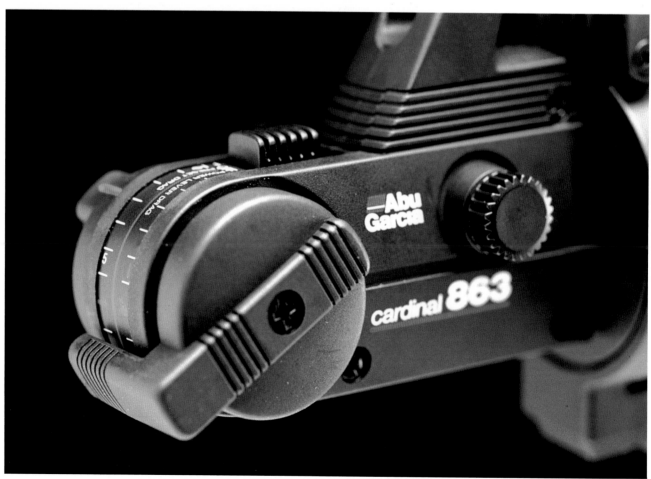

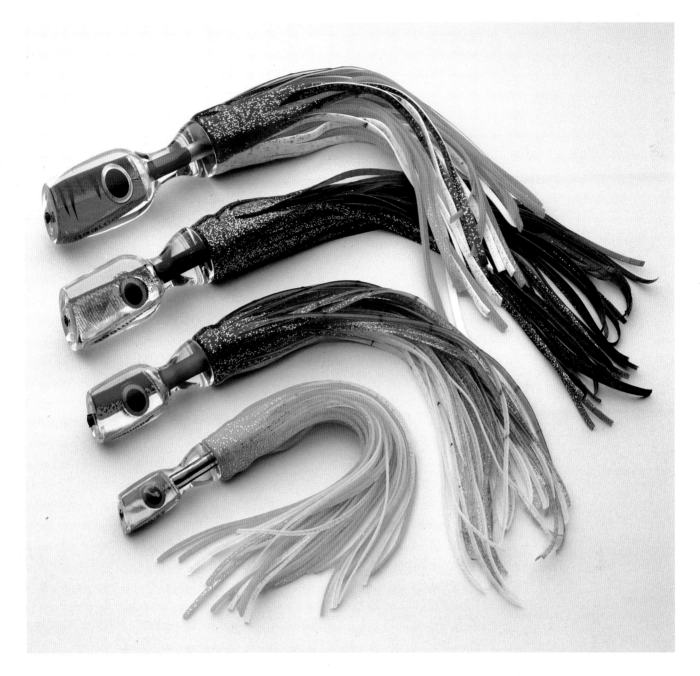

Product: **Doornob fishing lure**
Client: **Area Rule Engineering**
Designer: **Brooks Morris**
Processes: **Injection molding;**
Extrusion
Materials: **Acrylic; polyester; vinyl**
fluorocarbon

Brooks Morris, an aeronautical engineer and avid big game fisherman, applied his engineering know-how in designing a fishing lure that cuts through water at high speeds to attract tuna, marlin, wahoo and other big game fish.

Doornob fishing lures are plastic components combining acrylic, polyester, vinyl, nylon and Teflon®. The unit consists of a specially ballasted lead weight spun-cast around a Teflon® tube. The weight is then wrapped with a polyester foil. Inserts are placed in a multi-cavity mold and injection molded to form the lure body. Vinyl skirts are attached to the lure with nylon tie wraps.

Just how well do Doornobs work? For starters, they snared a 1,062-pound Blue Marlin—a world record.

And that's no fish story.

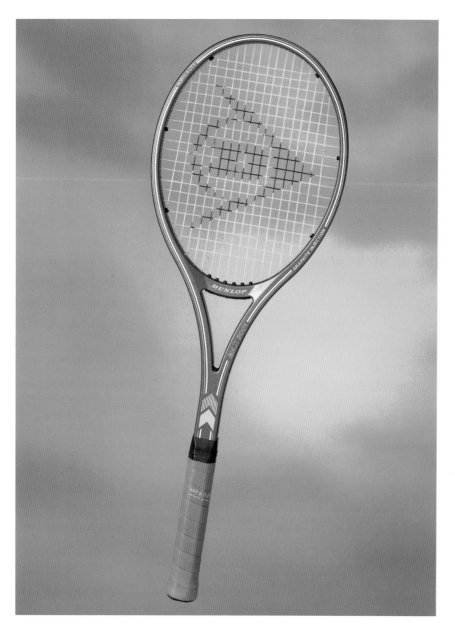

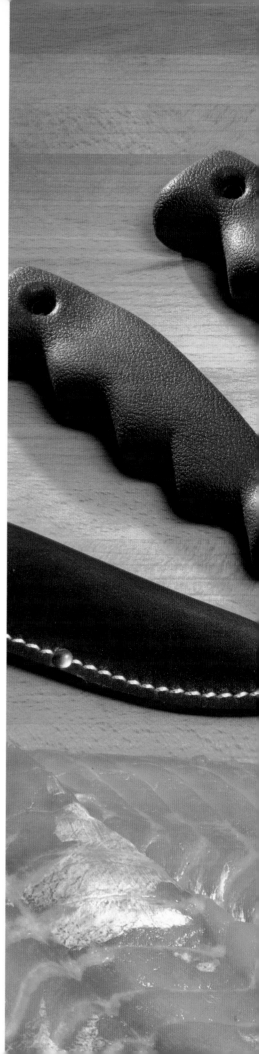

▲ Product: **Tennis racquet frame**
 Client: **Dunlop Sports**
 Engineer: **Dunlop Slazenger staff**
 Molder: **Dunlop Slazenger Corp.**
 Process: **"Lost wax core" injection molding**
 Materials: **30%-40% carbon reinforced nylon 6-6; Noryl GTX**

The idea of injecting plastic resin heated to 270°C around a metal core made of a bismuth-tin alloy that melts at 140°C sounds implausible. In practice, the metal core melts out, leaving a single-piece frame with internal hollow pillars connecting the faces. The job is finished by filling voids with polyurethane foams of varying densities to optimize weight, balance and vibration. The frame can be strung at lower tension, reducing the risk of tennis elbow while increasing power.

 Product: **Fish filleting knives** ▶
 Client: **Buck Knives Inc.**
 Material: **Shell Kraton thermoplastic elastomer**

Getting a grip on a fish filleting knife is difficult when your hands are wet. The handles of these knives feature deep, angled grooves on the non-rolling rounded rectangular cross-section, making for a tight, yet comfortable, grip.

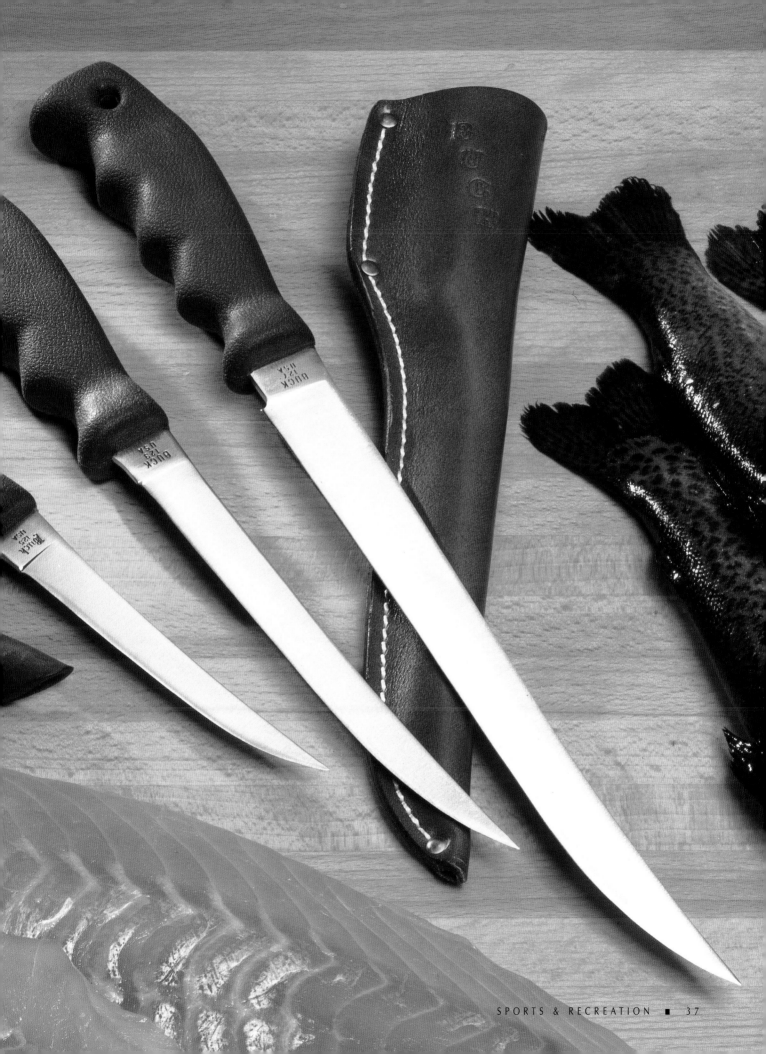

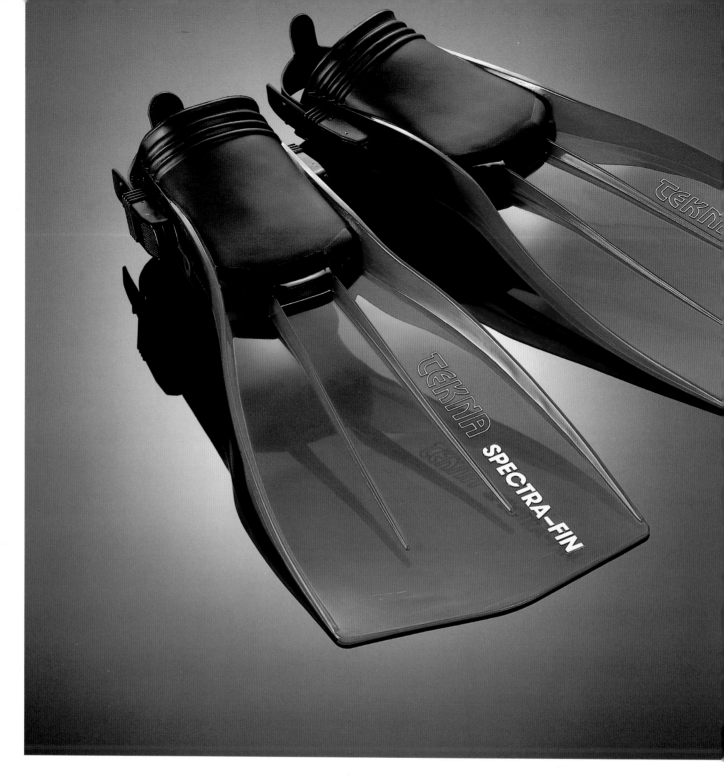

Product:	**Mask, fins, snorkels**
Client:	**Tekna**
Designer:	**Ralph Osterhout**
Process:	**Injection molding**
Materials:	**"Spectraflex" elastomer;**
	ABS; polyurethane; LIM
	silicone

Tekna has been a leading innovator in the design of recreational diving equipment. Though clear silicone fins masks and snorkels have been available for several years, these are the first colored translucent models on the market. The specially-formulated Spectraflex material used for the blades of the fins conforms to the resistance of the water, reducing stress on the swimmer's legs and producing more thrust with less effort. They also weigh about two pounds—half the weight of conventional full-size fins. The usual floppy neoprene heel strap has been replaced with a more rigid strap, which snaps down to allow the foot to enter, then snaps back into place with the touch of a button, securing the foot without binding unnecessarily. The large-bore snorkels required an even more ingenious use

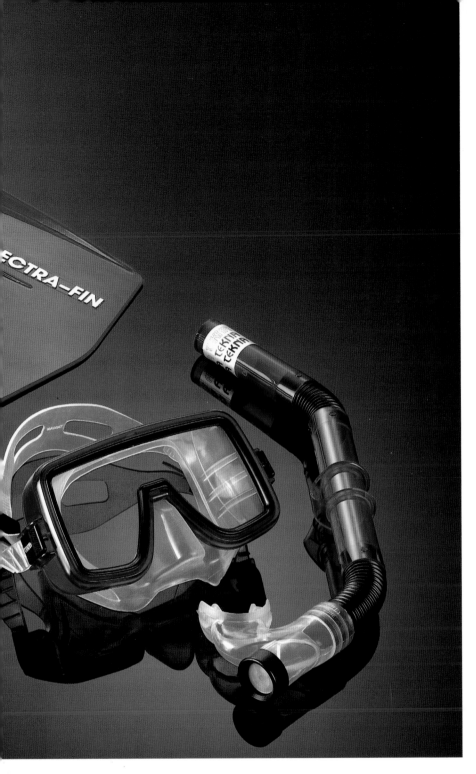

of materials. Polyurethane had the color and toughness needed, but tends to shrink tight on the cores, making it difficult to mold curves. The solution was to mold the polyurethane in straight sections, and make the elbow curves out of rigid ABS. This is the exact reverse of the traditional snorkel, in which the straight barrel is made of a rigid material and the elbows are made of soft thermoplastic rubber. By corrugating the ABS elbows, the idea of flexibility is conveyed visually, even though the bore of the elbows is smooth and inflexible.

Product: **Motor Controller** ▶
Client: **Pflueger/Fishing Tackle**
Designer: **American Industrial Design Co.**
Process: **Injection molding**
Material: **General Electric Xenoy alloy**

The rotating foot pedal on this motor controller enables the operator to steer the boat with his foot. The piece is constructed from a single set of molded parts.

Product: **Portable marine air conditioner**
Client: **Crusair**
Designer: **Machen Montague Inc.**
Process: **Injection molding**
Materials: **Structural foam; polyphenylene oxide; ABS; thermoplastic rubber; Delrin acetal**

Crusair was the first company to release a portable marine air conditioner. The structural foam housing makes the unit light enough to transport, and it mounts easily to a variety of boat decks and hatches. An adjustable structural foam "foot" with a thermoplastic rubber base allows the conditioner to remain level on sloped boat hulls. Molded-in "tie downs" keep the unit secure in rough weather. ▼

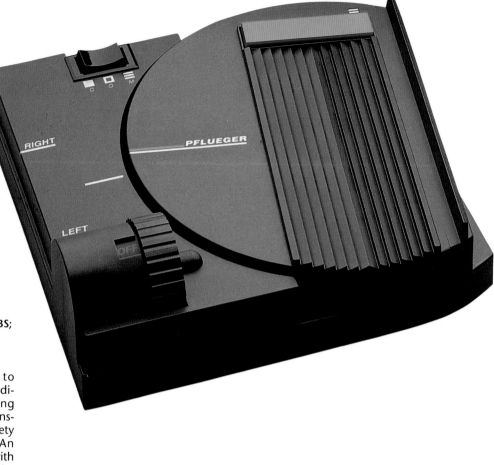

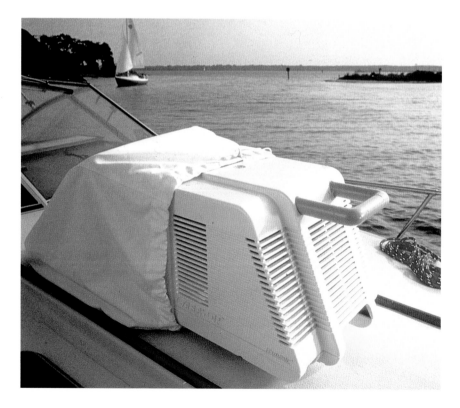

Product: **Aqua Lung Advanced Breathing System** ▶
Client: **U.S. Divers Co.**
Designer: **Mark Faulconer, manager of industrial design**
Process: **Thermoforming**
Material: **Dow Rovel**

The housing for this underwater breathing system was designed with self-draining vents to minimize resistance in the water. Rovel, an olefin-modified styrene acrylonitrile, resists decomposition due to exposure to salt water and ultraviolet light. Three 850-litre aluminum tanks are secured inside the housing by injection-molded supports.

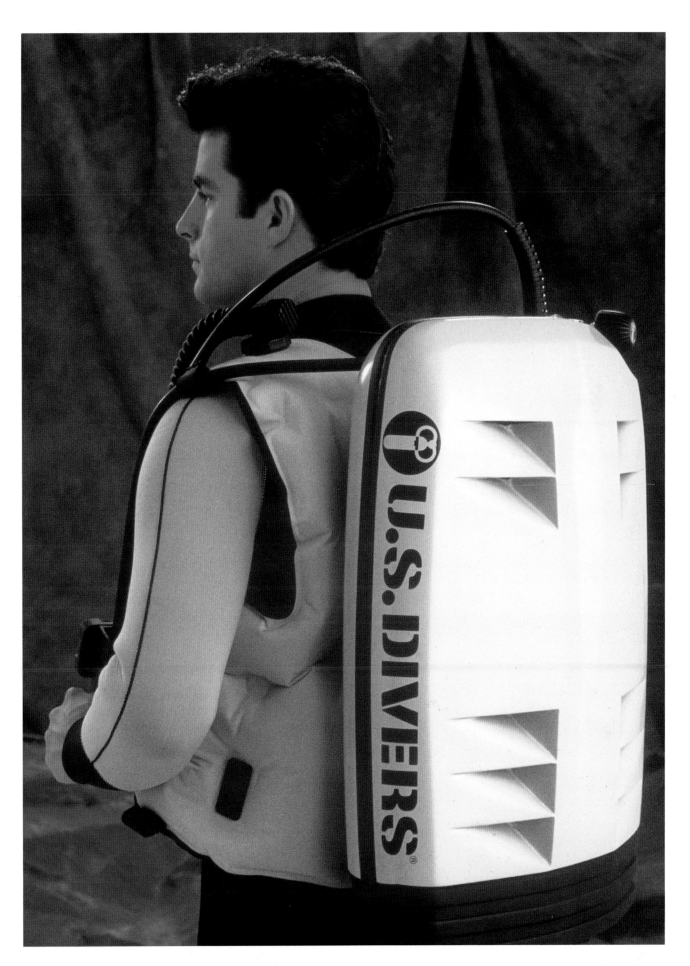

Product: **Hunting/fishing knife**
Client: **Tekna**
Designer: **Tekna/Ralph Osterhout**
Process: **Injection molding**
Materials: **Glass-filled polyester handle; 425m stainless steel blade; powdered metal lock**

Cutting matching wedges out of the drop-point stainless blade and glass-filled polyester handle—plus designing a unique ball-lock mechanism—resulted in a pocket knife that weighs just 1.3 ounces. The distinctive look of the knife is clinched by a blade that "disappears" into the handle.

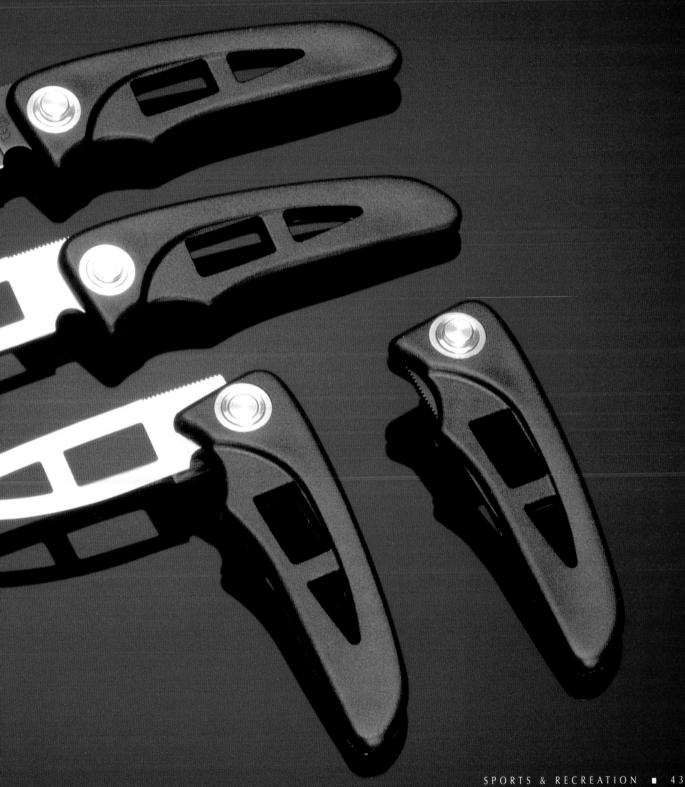

Product: **OEM flashlights** ▶
Client: **Bridgeport Metal Goods**
Designer: **Group Four Design/
Robert Staubitz**
Process: **Injection molding**
Material: **Thermoplastic rubber**

Monsanto's Santoprene® thermoplastic rubber provides a superior gripping surface in a variety of temperatures and environments. Designed as an improved "standard bearer" flashlight, this product has guided Boy Scouts and Girl Scouts through many a darkened campsite. The flashlight is also marketed under the BMG label.

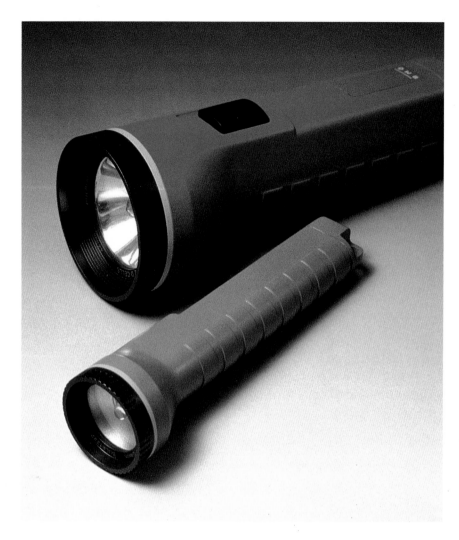

Product: **Durabeam portable lights**
Client: **Duracell, USA**
Designers: **Dole Associates/C. Minot
Dole; J. Howard; Peter
Gebhardt; Brad Burke**
Process: **Injection molding**

Here is a family of lanterns and emergency lights artfully shaped around standard "C" batteries and embellished in Duracell's copper and black corporate dress. When the quantities of a molded product approach mass market volume, production costs must be kept low and the manufacturing process simple. Plastic has become the first choice for consumer packaging of any product as chemically corrosive as a dry cell battery. ▼

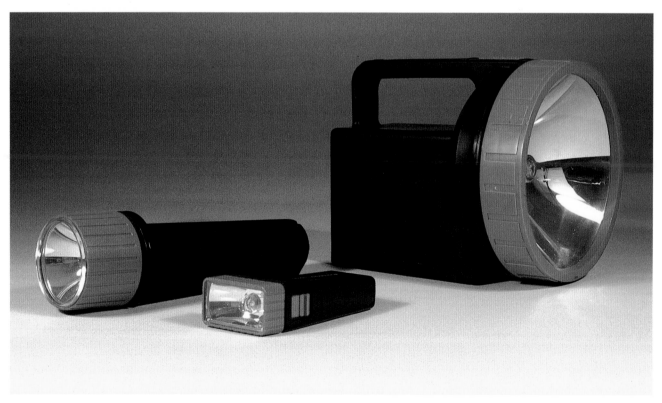

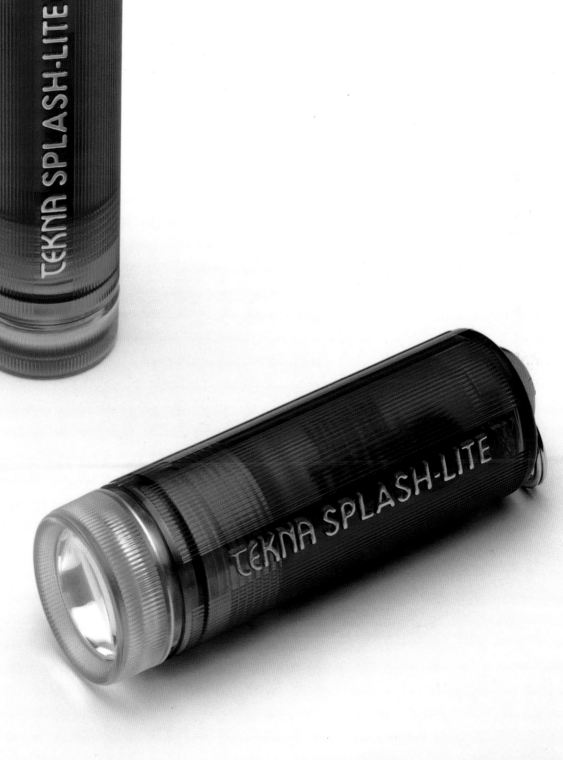

Product: **Splash-lite**
Client: **Tekna**
Designer: **Ralph Osterhout**
Process: **Injection molding**
Materials: **ABS; polycarbonate**

ABS is an excellent choice of materials when durability and visual appeal are desired. The inner workings of the Splash-lite show brilliantly through the translucent material—an appealing effect unattainable with most other resins.

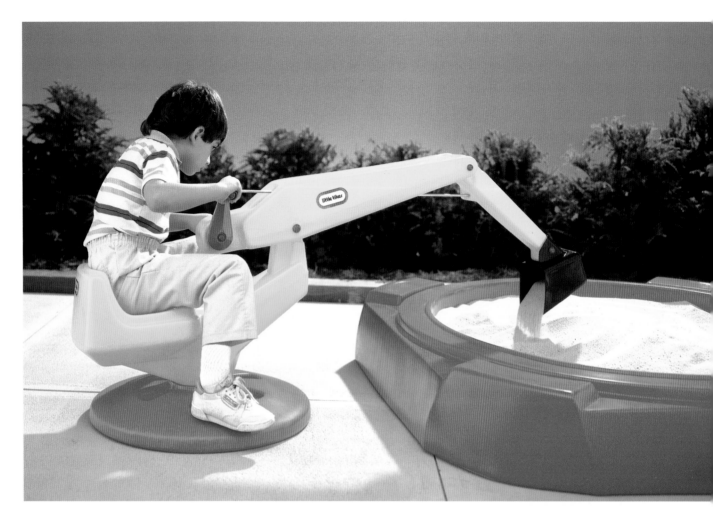

Product: **Crane and Sandbox** ▲
Client: **Little Tikes Co.**
Designer: **Design Alliance Inc./**
James Mariol
Process: **Rotational molding**
Material: **Polyethylene**

Rotational molding has allowed the mass-production—and mass-market pricing—of large toys which are basically one piece. While the sandbox is a traditional backyard staple, the child-sized crane is an impressive improvement over the shovel-and-bucket sets of yesteryear.

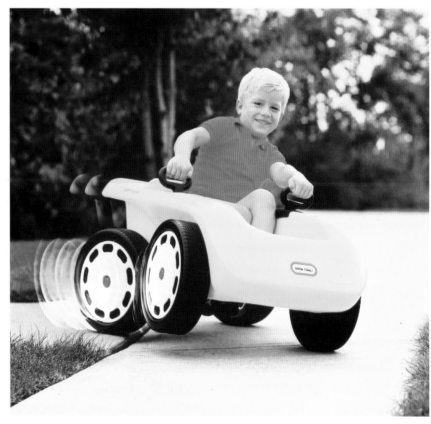

Product: **Sports coupe** ▶
Client: **Little Tikes Co.**
Designer: **Little Tikes Co./**
Kevin R. Aker
Processes: **Rotational molding;**
blow-molding; injection-
molding
Material: **Polyethylene**

The red Radio Flyer wagon was never like this. The all-plastic sports coupe features a unique two-handed steering gear connected to the rear, instead of front, wheels.

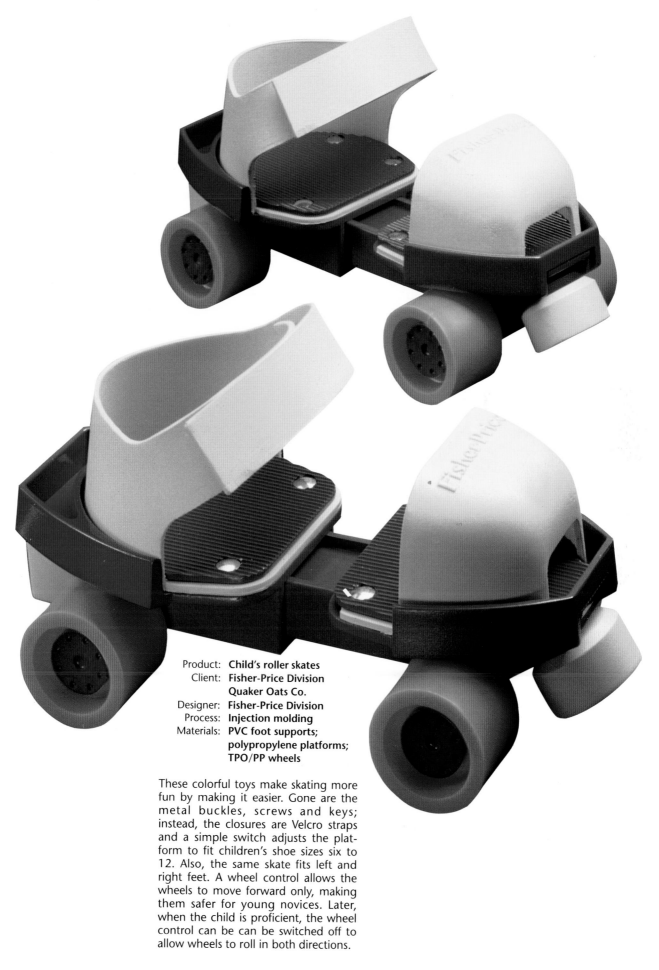

Product: **Child's roller skates**
Client: **Fisher-Price Division**
Quaker Oats Co.
Designer: **Fisher-Price Division**
Process: **Injection molding**
Materials: **PVC foot supports;**
polypropylene platforms;
TPO/PP wheels

These colorful toys make skating more fun by making it easier. Gone are the metal buckles, screws and keys; instead, the closures are Velcro straps and a simple switch adjusts the platform to fit children's shoe sizes six to 12. Also, the same skate fits left and right feet. A wheel control allows the wheels to move forward only, making them safer for young novices. Later, when the child is proficient, the wheel control can be can be switched off to allow wheels to roll in both directions.

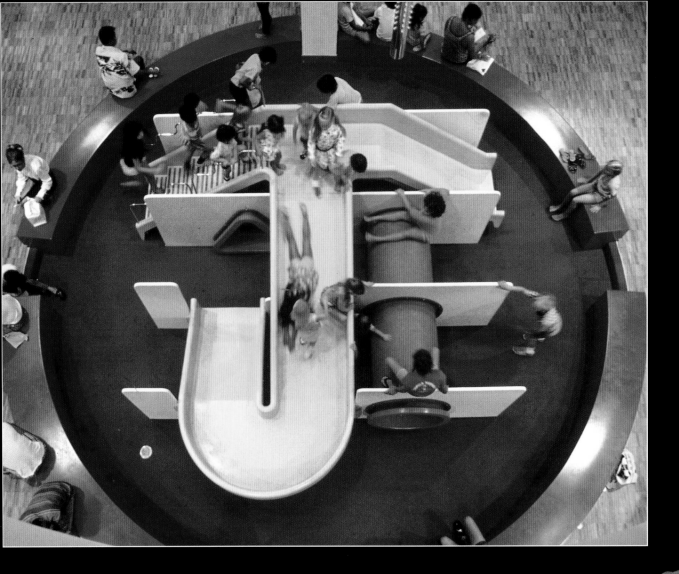

Product: **Interior playground**
Client: **Pearlridge Shopping Center**
Designer: **Robert P. Gersin Associates**
Process: **Hand layup**
Materials: **Gel-coated fiberglass reinforced polyester; metal rails**

Fiberglass provides the strength, easy maintenance and bright colors needed for a children's playground. A bench surrounds the play area, isolating it from the shopping activity of the surrounding mall. It's also a convenient resting place for weary parents and shoppers. Some other obvious benefits of the reinforced plastic: it readily takes the abuse kids dish out, softens the impact of falls and absorbs sound.

Product: **Outdoor furniture**
Client: **Harkness Company**
Designer: **Robert P. Gersin Associates**
Material: **Fiberglass reinforced polyester; formed in mold**

Robert P. Gersin Associates had the right idea when it designed this modular furniture for Harkness Plaza in New York City. Research found that people, in fact, preferred seating that could be rearranged, but freestanding chairs and benches are too easy to remove.

The problem was cleverly solved with a strip of brightly-colored fiberglass seats linked by connector plates. The flexible connectors allow the chain-like pattern to be reconfigured, providing an intriguing, constantly changing sculptural form.

Each seat has a locking caster so it's immobilized by the weight of the person sitting on it. The shape of the seat is comfortable, but not so much so that it will attract cat-nappers.

Product: **Stars & Stripes rudder**
Client: **Sail America**
Designers: **Sail America/**
Stars & Stripes '88
Process: **Autoclave cure**
Material: **BASF 5217-G40-600 unidi-**
rectional Graphite epoxy

The rudders of a racing catamaran are thin, light hydrodynamic structures that must withstand stress comparable to that encountered by a jet fighter aircraft in a high-G turn. Sail America's designers used sophisticated manufacturing processes for thermosetting composite structures (which were then autoclave-cured using bladder inflation mold pressure) pioneered in the aerospace industry to produce the rudders for the 1988 America's Cup contender.

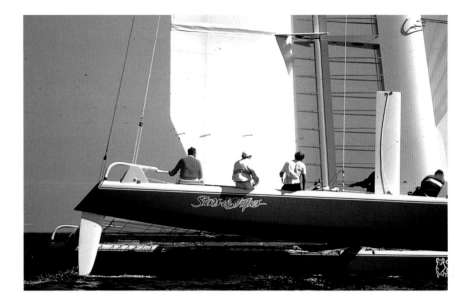

Product: **Stars & Stripes catamaran**
Client: **Stars & Stripes/**
Dennis Conner
Designers: **Morrelli Design/**
Sail America Design Team
Process: **Hand laminated with**
post-cure
Materials: **Epoxy;**
Nomex aramid;
Carbon fiber

Breaking all the traditional rules for building strong boat structures, the designers of Stars & Stripes received international acclaim for creating the lightest catamaran of its size ever built. Using the best and latest in resins and unidirectional carbon-fiber reinforcement, the hulls were hand-laminated at ambient temperature using vacuum bag pressure and post-cure. The 108-foot hardsail wing mast was built by Scaled Composites.

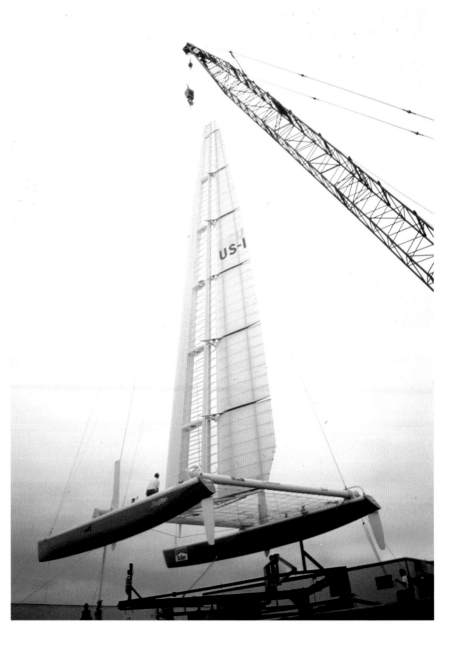

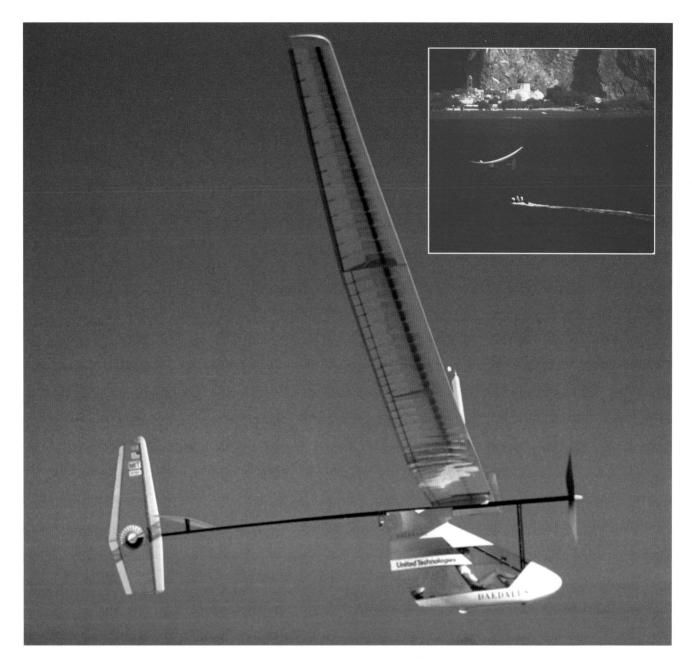

Product:	**Daedalus '88 human-powered aircraft**
Client:	**Massachusetts Institute of Technology and the Smithsonian Institutions**
Designers:	**John Langford; Mark Drela; Harold Youngren; Juan Cruz**
Materials:	**Amoco Thornel carbon fibers; DuPont Mylar polyester film; Cyro Rohacell foam; Lexan and Kevlar**

To recreate the mythical journey of Daedalus—who with his son supposedly escaped from imprisonment on the island of Crete by flying away on wings made of feathers and wax—designers at the Massachusetts Institute of Technology set out to build a human-powered aircraft that could break the records set by the Gossamer Condor and the Gossamer Albatross. The latter was a human-powered craft which flew the 22 miles across the English Channel in 1987.

With Kanellos Kanelopoulos, a member of the Greek Olympic cycling team and 14-time Greek national cycling champion aboard to power and pilot the craft, Daedalus flew 72 miles across the Aegean Sea from Crete to the island of Santorini on April 23, 1988.

The main structure is Amoco graphite epoxy T40, T50 and P75 high modulus carbon fibers. Wing ribs are light (16 kg/m³) expanded polystyrene bead board, which is commonly sold as insulation board. The leading edges of the wings were made of UC Industries extruded polystyrene foam insulation.

The skin of the wings is .5 mil DuPont T-film Mylar polyester film. The trailing edges of the wings are Cyro Industries Rohacell polymethacrylimide foam, covered with 120-weight Kevlar aramid pre-preg in a sandwich structure. The cockpit is 120-weight Kevlar pre-preg stiffened with carbon fiber and Rohacell foam formers, and the windshield is 15 mil Lexan polycarbonate. The propeller was built up with Rohacell foam blocks over a plastic composite graphite spar laminated with Kevlar. The pilot was sealed into the cockpit with heat-shrink Mylar.

The only metal parts are the gear box and a few fittings. Empty, the whole craft weighs just 68 1/2 pounds; remarkable for an aircraft with a 112-foot wingspan.

THE WORKPLACE

The environment here is the workplace. Objects for this cerebral workplace all live in the same context. They fit into it, by design. There is a job description for each object. Its look is suitable to the job, and to the place where the job is to be done.

In contrast to the exuberance of shapes and colors expressed in designs used outdoors, the indoor information workplace environment is a sober and "proper" place. Conservative. Businesslike. A place for steady daily progress toward accomplishment, a place where disturbing influences are shunned. We wear our proper cerebral workplace clothes. We dress with decorum, and look serious, busy and efficient. Work is serious; even work that involves music, graphic arts of schoolwork.

The objects we place in this earnest setting—and the physical setting itself—reflect the sobriety and seriousness of the work-ethic environment. They have proper manners, are formal, express sincerity of purpose, capability, trustworthiness. These attributes apply equally to the keyboard for a musical synthesizer or a schoolroom microscope. Let's look at the design vocabulary for these qualities, because critical evaluation of these objects outside the all-important context is meaningless.

Things want to fit in, to belong to the group, above all to be inoffensive to the working group. This means being non-different, non-threatening. It means not wearing lime-green golfing trousers to the office. Objects selected for the information workplace are reserved, dependable and understandable.

The classic geometric shapes of Euclid are eminently understandable. Straight lines, triangles, rectangles, circles. Rectangular solids, cubes, spheres and cones. Back there somewhere in our secondary education, we met all of them formally, as expressing the permanent nature of things. We know them well. They are not mysterious. They are trustworthy.

They also express regularity, perfect order, reckoning things precisely, without error.

Unfortunately, the classical shapes of Euclid are limited. When we limit the form vocabulary to these, we say quiet, reserved grown-up things—in some anonymity. At the top levels of this design pyramid, personal expression is restricted to acts of good taste, expressed through careful, exquisite proportioning and combining of the classic geometric shapes.

Sharp edges on these shapes, clearly defined, also fit in with the office ethic of "we do not touch, fondle or hug around here—not even our beloved machine-slaves." We can look at the beautiful proportions, but crisp edges say "touch only as directed and only in the officially-designated places."

Non-Euclidean swoops and swirls and shapes that might be related to animals are to be reserved for things labeled "art," relegated to the proper place. Work machines must not be demonstrative or emotional. We want any good and willing machine-slave to be trustworthy, reserved, somewhat anonymous, efficiently errorless—all qualities broadcast by the classical simple mechanical shapes.

School is a special case, an information workplace for kids, a transition from home to office. Here we try to teach the prejudices of the adult world, but at a kid's level. Which means that a little fun creeps into the equation, a little huggy-feely-touchy rounding of the shapes, use of bright colors. But shapes are still simple and geometric, to make it easy for kids to understand.

Appearances are important in the cerebral workplace, in business. For a machine here, looking businesslike means looking flawless. Perfect geometry. Looking as if it had been built without error by another machine. Looking mass-produced whether it was or not.

This kind of machine appearance makes business sense. Machines make perfection. Humans make blunders when they build things. But in the modern cerebral workplace, blunders are inexcusable. Perfection is the goal. Objects that look handmade are subject to suspicion of error. We now demand all things in our workplaces to look as if they had been made without errors. And we've figured out how to do that with plastics.

Assuming technology gave us everything except plastics, the objects here are all things we'd have in the workplace of information, plastics or no. Most of these are packages over some sort of mechanism. We call them by various special names—workstation, computer, business machine. Plastics bring some nice human qualities to the party, but there'd still be a party, plastics or not.

The happening that so many objects for this environment are rigid, square, sharp-cornered things comes from three sources. First, to broadcast that information processing is serious and precise; this is not home. Designers use this shorthand way, a cliché, of using Euclidean shapes with tightly-defined boundaries, no ambiguities. Second, these forms are practical and economical. The third reason has to do with plastics technology.

Practicality and economy have multiple roots as well. Our new plastic forms have to fit into practices growing out of old workplaces. They must not clash with what is familiarly there, in form or operation. Conservatism. Don't throw out what works. Tinker with forms slowly. Evolutionary change in shapes/forms/designs, not revolution.

Also, the machine-packages often are not made all of the same material. Portions of the outsides are indeed made of metal sheets, or vestigially out of rolled-shape angle iron legs, with a visual equivalent of sheet plywood between the straight-line edges. From the producer's point of view, machine shapes that can be produced independent of material choices are the very best kind. Since plastics are the most adaptable of materials, they can be

persuaded to mimic the shapes of other materials—even wood grain and cast marble. Even such other new apprentice materials as rolled steel shapes, extruded aluminum, rolled sheet metal. And they do.

Because of the demands of this marketplace context, plastics technology has developed processes to mimic the form vocabularies of other materials. There are the high pressure laminates (Formica and its ilk), and other sheet materials, used in the manner of sheet materials. We've long had casting and lay-up and thermo-set molding. We can extrude shapes. But the big breakthrough has been in the low-pressure molding processes—blow molding, RIM, structural foam.

We have now developed means in molded plastics to take on and hold, without warping, even the shape of flat plywood or sheet metal. Regardless of process, what we are doing is just plain overpowering the plastic part's tendency to warp. We build super-thick double-wall structures (with high section modulus, in mechanical engineering lingo. The walls are connected at intervals with welded-through linkages, the same principle as used for open-truss steel highway bridges. Or the space between the walls is filled with the least amount of shear web material we can manage (like the plate steel webs in closed-truss bridge designs), except in moldings we fill the space with plastic foam. Either way, the outside walls can't move.

Structural foam, RIM and blow molding encourage the combining of plastic parts like control panels and doors and faceplates with sheetmetal cases because the high section modulus of the plastic parts allows simplified straight-line geometry to match. Low production quantities are suitable in these processes. Precise positioning combined with an ability to pick up fine detail combined with ease of manual moldmaking has made an unbeatable combination.

So process needs, context needs, and designers' symbolic and aesthetic needs are all met by the new materials that can match Euclid's classical shapes as well.

Things we touch, like telephones, have the best chance to become something else for form. We'll accept soft shapes at the animal-to-machine interfaces—grips, handles, buttons, knobs. Objects whose function we have never seen before have a similar chance, but often blow it by trying to fit in through looking like something else that already belongs in the environment, the way early television sets mimicked sideboard cabinets or other pieces of standard furniture.

The geometry of space travel, with its clearly stated rectangles and cylinders is totally suited for objects doing their appointed tasks without emotion, without such frivolous concerns as maintaining a pleasant appearance. We transferred (quite reasonably) this seriousness as style for the workplace of the intellect. The result is a certain edgy unfriendliness in the objects, the unforgivingness of space. As our romance with space pales to the everyday, some human warmth is coming back to our offices, studios and schools, expressed in the rounded formability that gives plastics their name. The trend is clearly visible here—to let plastics, created by human ingenuity—be the material of choice for expressing warm, friendly human values.

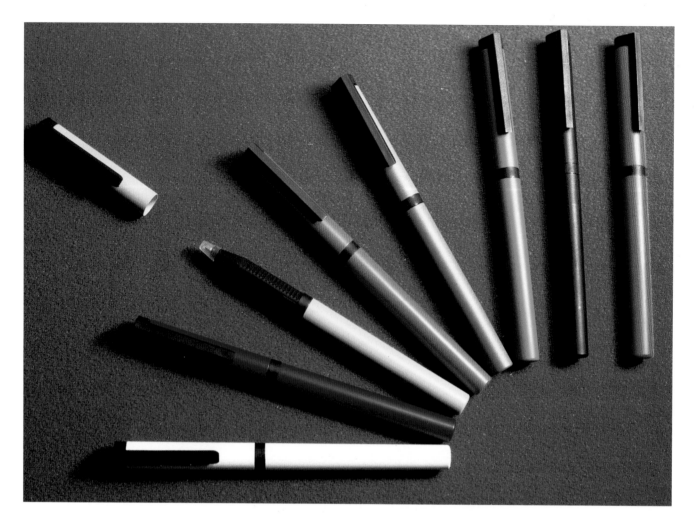

Product:	**Deltagrip refillable rolling pen**
Client:	**Sheaffer**
Designers:	**Barry David Berger + Associates Inc./Barry Berger; Tom Stoeckle**
Processes:	**Injection molding; impact extrusion**
Material:	**Thermoplastic polyester**

Sheaffer commissioned Barry David Berger + Associates to design a refillable rolling ball pen which could compete with both low-priced refillable pens and high-priced disposables.

The pen consists of a painted impact-extruded brass cap and barrel and a plastic clip, grip and internal component which holds the refill cartridges in place. The grip has a triangular section with rounded edges. The flat surfaces are textured for quick note taking, while the rounded edges provide a comfortable grip when writing long documents. The cap top is stepped down to accommodate an advertising specialty insert disc. The clip's flat surface can also be hot-stamped with promotional copy.

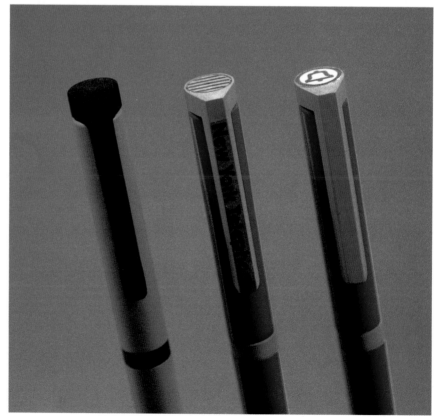

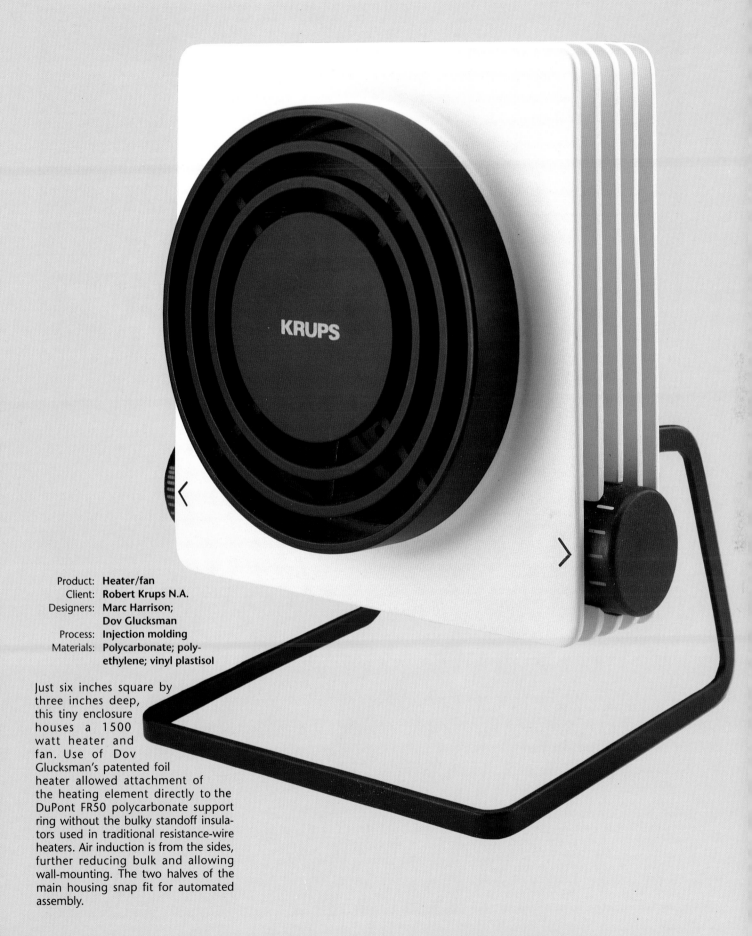

Product: **Heater/fan**
Client: **Robert Krups N.A.**
Designers: **Marc Harrison;**
Dov Glucksman
Process: **Injection molding**
Materials: **Polycarbonate; poly-**
ethylene; vinyl plastisol

Just six inches square by three inches deep, this tiny enclosure houses a 1500 watt heater and fan. Use of Dov Glucksman's patented foil heater allowed attachment of the heating element directly to the DuPont FR50 polycarbonate support ring without the bulky standoff insulators used in traditional resistance-wire heaters. Air induction is from the sides, further reducing bulk and allowing wall-mounting. The two halves of the main housing snap fit for automated assembly.

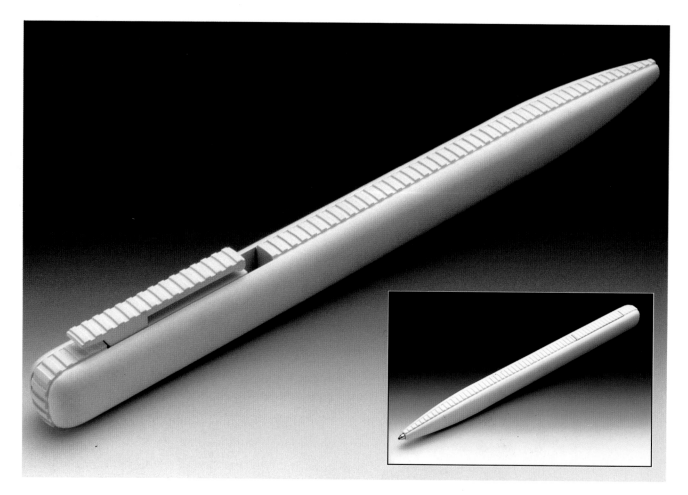

Product: **California 1 pen** ▲
Client: **Stylico**
Designer: **Interform/Peter H. Muller**
Process: **Injection molding**
Material: **ABS**

Here's an interesting design in plastics: to activate the ballpoint cartridge, simply push the pocket clip down and forward so that it's flush with the surface of the pen. A simple push on the clip retracts the ballpoint and opens the clip so that it can be attached to a shirt pocket at the same time.

Product: **Hobby knife** ▶
Client: **Testor Corp.**
Designers: **Palo Alto Design Group Inc./Jim Sacherman; John Toor**
Process: **Injection molding**
Material: **Glass-filled nylon 6/6**

Translating a familiar object based entirely on manufacturing techniques developed for metals into plastic can be difficult. A patented system for holding and aligning the blades was needed, as well as a way to transfer hoop stresses from the collet to axial stresses that can be borne by nylon.

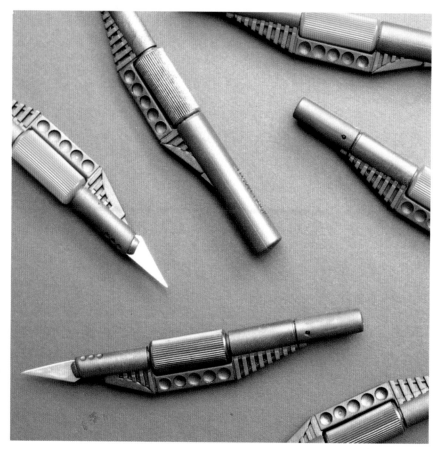

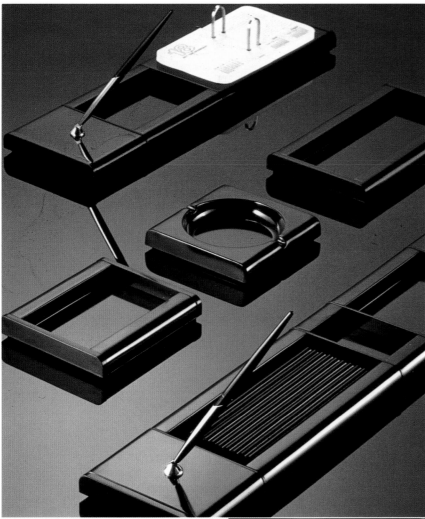

Product: **Radius Two accessories**
Client: **Smith Metal Arts**
Designer: **William Sklaroff Design Associates/William Sklaroff**
Process: **Compression molding**
Material: **SR-40 melamine**

Desk accessories have become more attractive over the years, thanks to new materials that lend themselves to smoothly radiused corners, slick surfaces and unique shapes. Melamine is a relatively indestructible material that responds well to compression molding to achieve a durable and attractive finished product.

Product: **Radius One accessories** ▶
Client: **Smith Metal Arts**
Designer: **Willaim Sklaroff Design Associates/William Sklaroff**
Process: **Injection molding**
Material: **High-impact polystyrene**

Molding thermoplastic materials into tight geometric shapes such as these is something of a challenge. Because the material shrinks in the mold, the light-reflecting surfaces tend to get distorted. The choice of molding resins, then, is limited to those that shrink the least, such as the polystyrene used in these desk accessories.

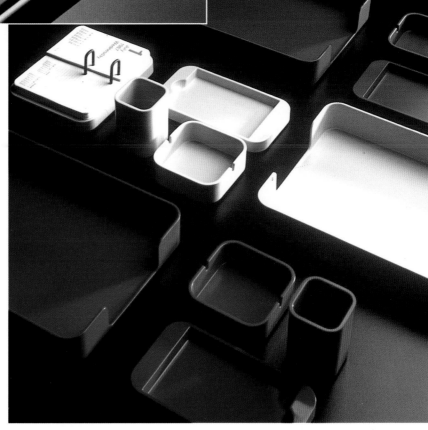

Product: **School microscope** ▶
Client: **Xerox Corp.**
Designer: **Robert P. Gersin Associates**
Process: **Injection molding**
Material: **Polystyrene**

In these days of school funding shortages and falling interest in science, a low-cost instrument that can help unlock the mysteries and fascination of nature for students is an important contribution. The molded body and optics keep the price of this microscope at a minimum. The ring base, made of plated steel, is set into the body at an angle. By simply rotating the base 180°, students can set the unit at the correct angle for viewing wet or dry slides.

Product: **Rotary file**
Client: **Bates Manufacturing Inc.**
Designer: **Group Four Design/
Robert Staubitz**
Process: **Injection molding**
Materials: **ABS; nylon**

Multiple common parts keep the manufacturing cost of this card file low. The design updates a mundane accessory while nylon swivel mounts and use of both concentric and eccentric pivot points makes it easier to use. ▼

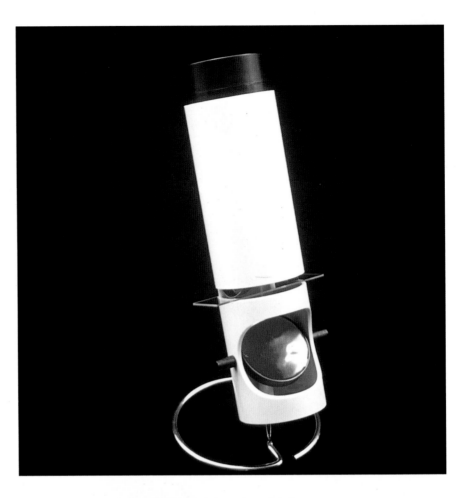

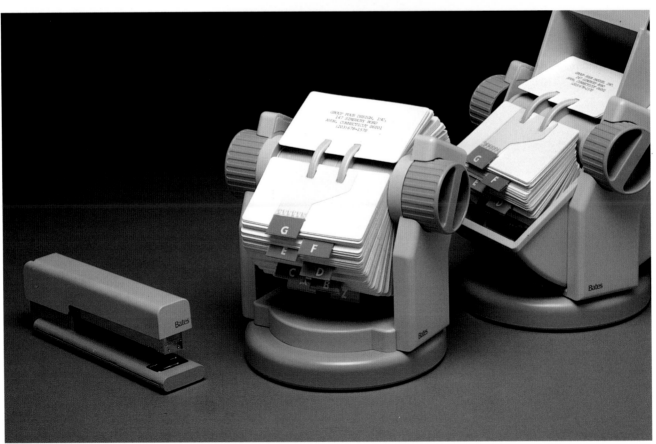

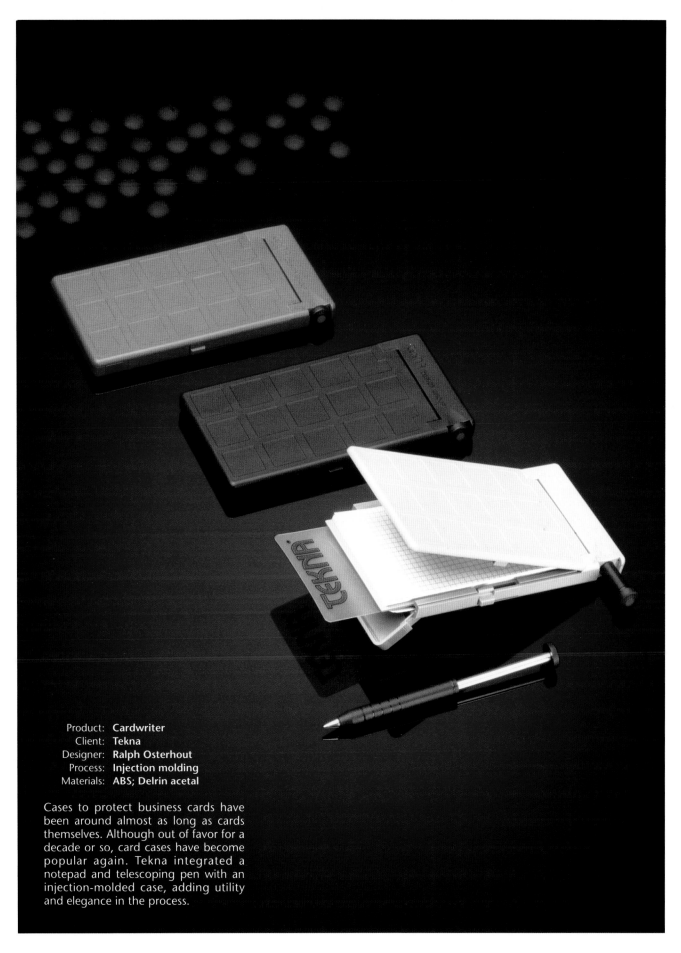

Product: **Cardwriter**
Client: **Tekna**
Designer: **Ralph Osterhout**
Process: **Injection molding**
Materials: **ABS; Delrin acetal**

Cases to protect business cards have been around almost as long as cards themselves. Although out of favor for a decade or so, card cases have become popular again. Tekna integrated a notepad and telescoping pen with an injection-molded case, adding utility and elegance in the process.

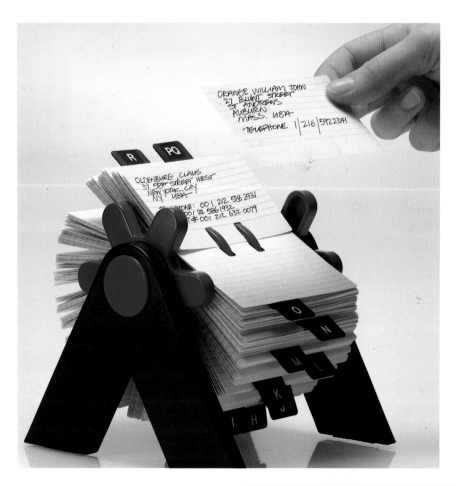

Product: **Rotary card index**
Client: **Artifakts Design Group**
Designer: **Peter Haythornthwaite**
Process: **Injection molding**
Materials: **ABS; high-impact polystyrene; acetal**

Easily assembled with a minimum of components, this rotary file has an acetal spring to supply tension to the thumbwheel. Legs come from the same cavity molding and they interlock. The daisy wheel, ring and button come from a single mold, too.

Product: **Card file**
Client: **Artifakts Design Group**
Designer: **Peter Haythornthwaite**
Process: **Injection molding**
Materials: **ABS; thermoplastic rubber**

Ease of assembly and minimum cost were the prime considerations, but that didn't prevent the designer from building in a few clever features. The rails are molded as part of the body, and the non-skid feet pick up the color of the card index dividers.

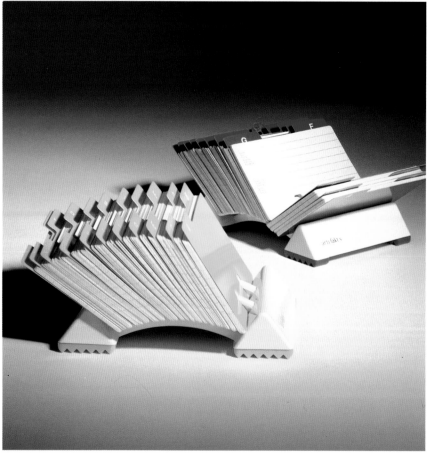

Product: **Electric tape dispenser**
Client: **Simtek Inc.**
Designers: **Jim Sacherman; John Toor**
Process: **Injection molding**
Materials: **ABS; polycarbonate; nylon**

This clean, handsome box contains a patented system for handling, dispensing and cutting tape. The need for convenient, one-handed operation and ability to handle various kinds of adhesives had to be met within a strict budget. While non-plastic materials could be used, the cost would likely be too high and the product not viable.

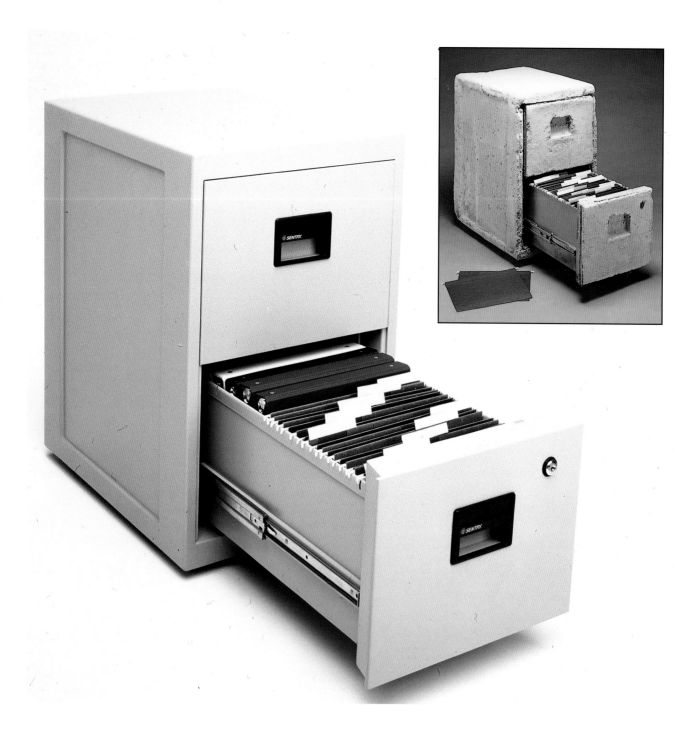

Product: **Sentry Fire-Proof Safe**
Client: **Sentry Group**
Designer: **Chase Design Inc.**
Process: **Drape blow molding**
Material: **Polyethylene**

A fire-proof cabinet made of plastic? While the shape mimics traditional metal fire-proof enclosures for acceptability, great technical innovation was required to make an economical and effective safe out of plastic. Aside from the difficulties of blow molding an object of this size, the seamless, twin-walled polyethylene housing is filled with a patented composite insulation. In a fire, the exterior wall melts gradually, releasing moisture encapsulated in the insulation. Meanwhile, the interior wall softens, welding the drawer fronts to the cabinet and sealing out oxygen. To keep the melting plastic from running into the interior storage space, a forced air barrier is used to prevent webbing between the two walls during molding. This maintains a continuous void between them. As shown in the inset, the safe works well enough to satisfy even the punctilious standards of the Underwriter's Laboratories.

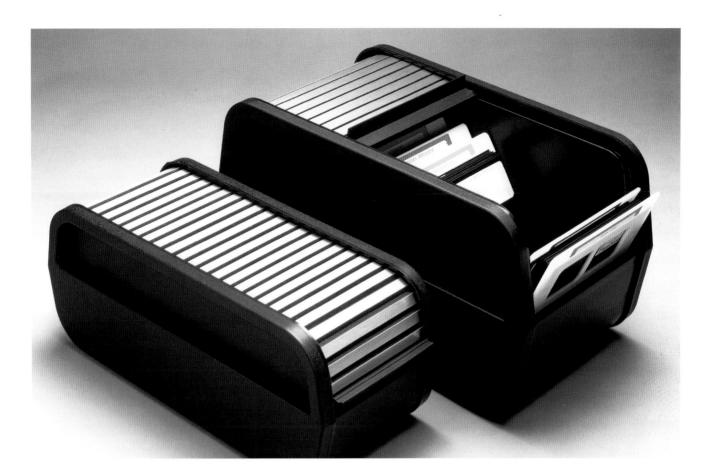

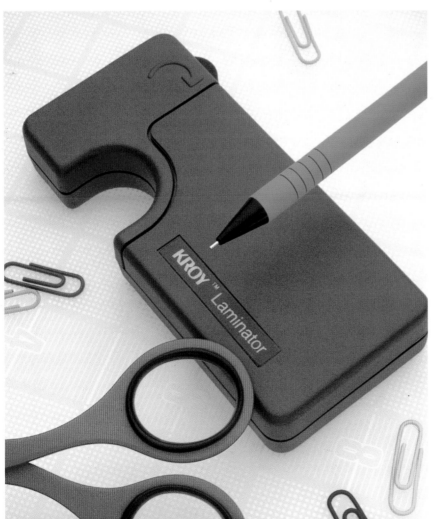

▲ Product: **Rolltop 100 disk file**
 Client: **MicroComputer Accessories**
 Designers: **Bud Hellman; Chuck Hassel**
 Process: **Injection molding**
 Material: **Polystyrene**

A patented modern interpretation of the classic tambour door in plastic yields an attractive solution for the storage of 3½-inch, 5¼-inch or 8-inch computer disks. A molded-in handle concealed in a recess in the rear folds out for convenient carrying.

◄ Product: **Laminator**
 Client: **Kroy Inc.**
 Designer: **Worrell Design, Inc.**
 Process: **Injection molding**
 Material: **ABS**

Injection-molded ABS was chosen not only for durability but for its ability to assemble with snap-fits and sonic welding. The simple parts amply demonstrate what can be done within the limitations of traditional injection molding in cavities made with cylindrical cutters on machines that operate only in a rectilinear mode. The deep groove hides slightly imperfect matches between parts, while the raised instruction arrow shows that this is clearly not drawn sheet metal.

Product: **290 K Lettering System** ▲
Client: **Kroy Inc.**
Designer: **W. Robert Worrell**
Process: **Injection molding**
Material: **ABS**

A strip printer for headline lettering, the 290 K is actually two machines in one. The basic, manually-operated unit can be purchased first. Then, through clever retrofit design, an electronic keyboard and liquid crystal display panel can be added later without the use of tools or the need for a trip to the dealer. Yet, when assembled, the two pieces form an elegant and sensibly integrated whole. The finish is Rawal MT-1055 matte finish and the colors fall within a three-step visual contrast range to ease eye strain.

Product: **Creditcard Keys** ▶
Client: **Creditcard Keys Co.**
Designers: **Donald Almblad;**
 Robert Almblad
Process: **Injection molding**
Material: **Delrin acetal**

In the hands of an imaginative designer, plastics can replace metals in the most unlikely places. Hiding an extra set of keys is made less painful by these "credit card keys." After exploring a number of resins, the designers found that Delrin acetal was stiff enough to turn locks and withstand grinding yet pliable enough to work as a hinge so the keys can be swung away from the body of the card.

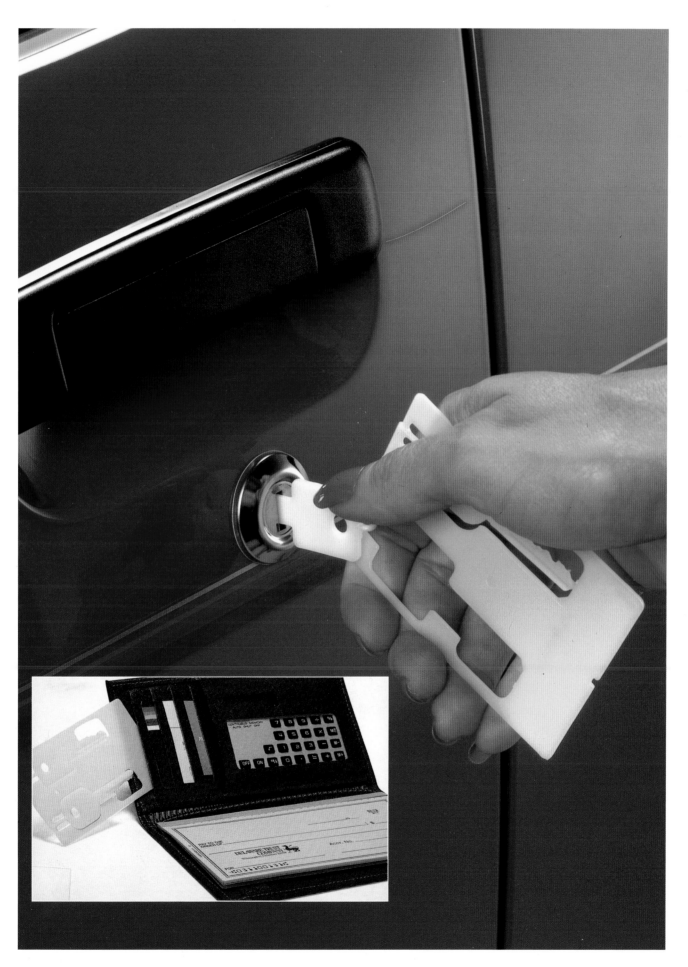

Product: **Countertop water cooler** ▶
Client: **Ebco Manufacturing Co.**
Designer: **The Corporate Design
Center/David B. Chaney**
Process: **Injection molding**
Materials: **Modified PVC cabinet;
polypropylene; ABS**

Before the designers could create the
sleek finish they had to figure out how
to shrink the components of the office
water cooler—a compressor and hot-
tank—down to half size to fit in a
countertop appliance. The solution
involved a radical exterior shape
formed by applying PVC panels over
an extruded metal frame.

Product: **Adjustable tape trimmer**
Client: **Kroy Inc.**
Designer: **Worrell Design Inc.**
Process: **Injection molding**
Material: **ABS**

ABS allowed the designers of this trim-
mer, made to trim tapes from Kroy let-
tering machines, to mold an intricate
planetary gear system. The color was
tied to the existing Kroy product
scheme and the form based on the
profiles of the Kroy 260, 280 and 290
lettering machines. Markings were
molded into the control and feed sur-
faces to make the operation of the unit
self-evident and eliminate the need for
first-time users to read instructions. ▼

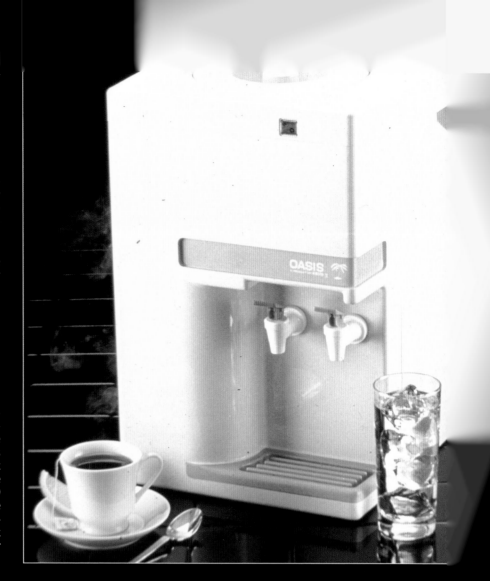

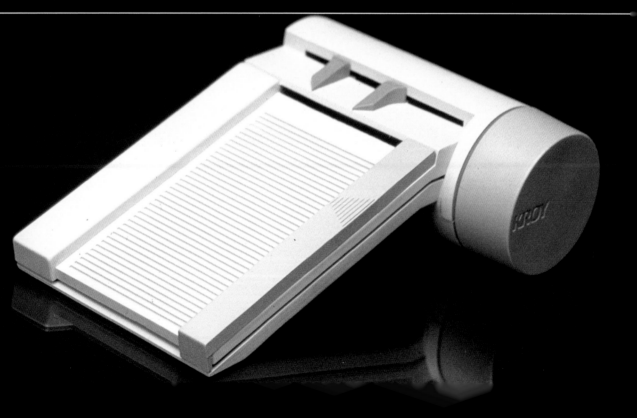

Product: **Air cleaner**
Client: **Matsushita Electric Industries**
Designer: **Matsushita Design Center**
Process: **Injection molding**

Broad, convex surfaces connected by relatively large-radius corners make the molding process easier. They also make the novel oscillating motion of this air cleaner, an important sales consideration, self-evident.

MCA WORKMANAGER

Product: **Workmanager furniture**
Client: **MicroComputer Accessories**
Designers: **Don Westland;**
Jeff Sheppard
Processes: **Blow molding; injected**
expand-in-place
Materials: **Polyethylene;**
Polyurethane foam

Although the nature of the jobs done and the tools used by office workers have changed radically in the last two decades, most office furniture is designed and built to accommodate the tasks of the past, not the present. Today's secretarial desk with return may have a word processor on it instead of a typewriter, but it is still the same desk. Various "ergonomic" furniture designed to facilitate the electronic flotsam that litters today's offices have been produced; but is often priced higher than traditional furnishings.

MicroComputer Accessories (MCA) set out to redefine the office, to bring its furnishings in line with the needs of the workers—and to do it at a price comparable to ordinary office furniture. It did this by disregarding both conventional wisdom and conventional materials. Instead of composition board clad in woodgrain or earth-tone plastic veneer, the Workmanager pieces are made of large blow-molded polyethylene panels. Because such panels tend to warp, a unique composite was created by injecting expand-in-place polyurethane foam into voids between the panel surfaces. This makes the panels extremely rigid and keeps them true without adding weight. Steel tubes were added under the top of the workstation module for extra strength. A writing surface made by thermally fusing a resin-impregnated material onto 1/4" fiber board rests in a recess in the top.

A recessed channel with a cover that pivots to open at the rear of the work surface stores cables safely and neatly. Velcro™ ties on the legs keep the cables from dangling loosely. Rear corner sockets provide a nest for adding accessories, such as a copy holder and letter trays that are elevated to keep the work surface clear. A CPU holder can be attached to the inside or outside of the workstation legs to get the biggest part of a computer off the desk as well. Desk height was set to 28 1/2", a better height for today's thinner keyboards, and the front edge of the work surface was beveled to make it easy on hands and wrists.

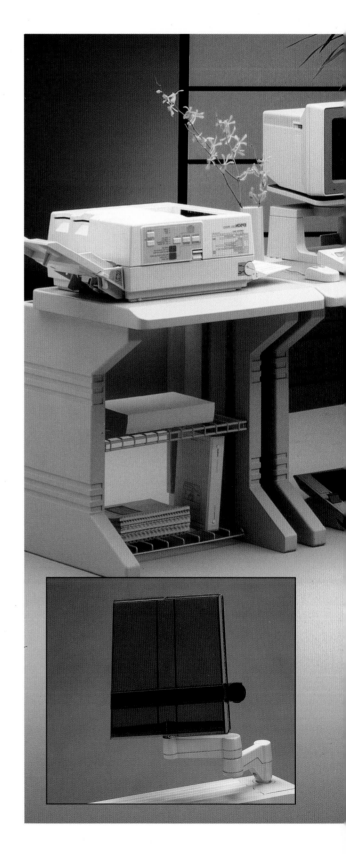

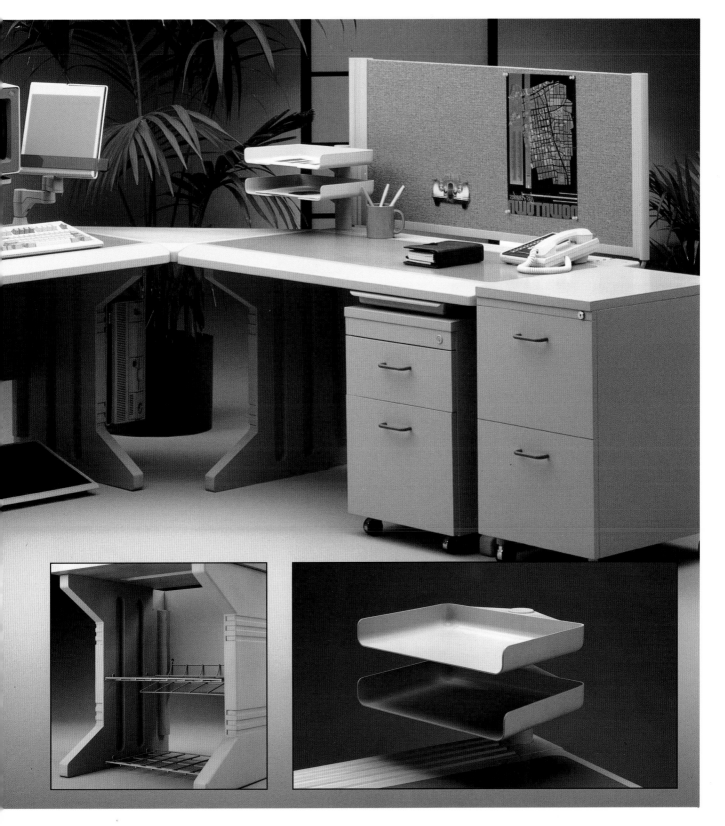

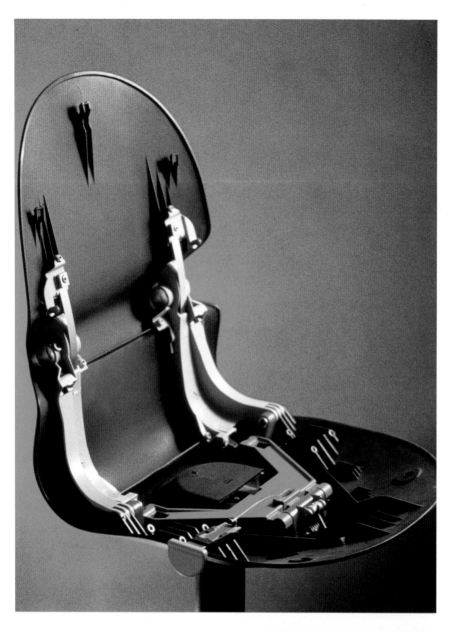

Product: **Persona office chair**
Client: **Vitra International**
Designers: **Design Continuum Inc./
Mario Bellini; Dieter Thiel**
Process: **Injection molding**
Material: **Fiberglass-reinforced
polyamide with ABS base**

Ergonomic chairs usually have their articulating structure on the outside. Injection molding allowed the economic production of the complex parts required to shape a chair to the human form from the inside. The result (below) is a form-hugging office chair with a smooth exterior and an anatomically correct shape.

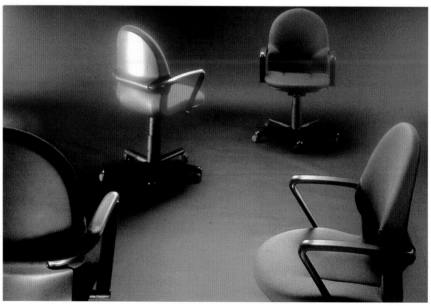

Product: **Chair base and casters**
Client: **Shephard Products Ltd.**
Designers: **Shephard Products staff/**
Jerome Caruso
Process: **Injection molding**
Material: **Zytel 72G nylon**

The goals for the Contessa chair base
were to produce an ergonomically cor-
rect base that could meet industry
strength standards and still be made at
a competitive price. Using a ribbed
structure of DuPont's Zytel
nylon reinforced with 30%
glass, the designers created
a base and casters that
actually exceed standards
created for die-cast metal
bases. The smooth curves
flowing from the base into the casters
keep the profile low, minimizing bruised
ankles, scuffed shoes and snagged hose.

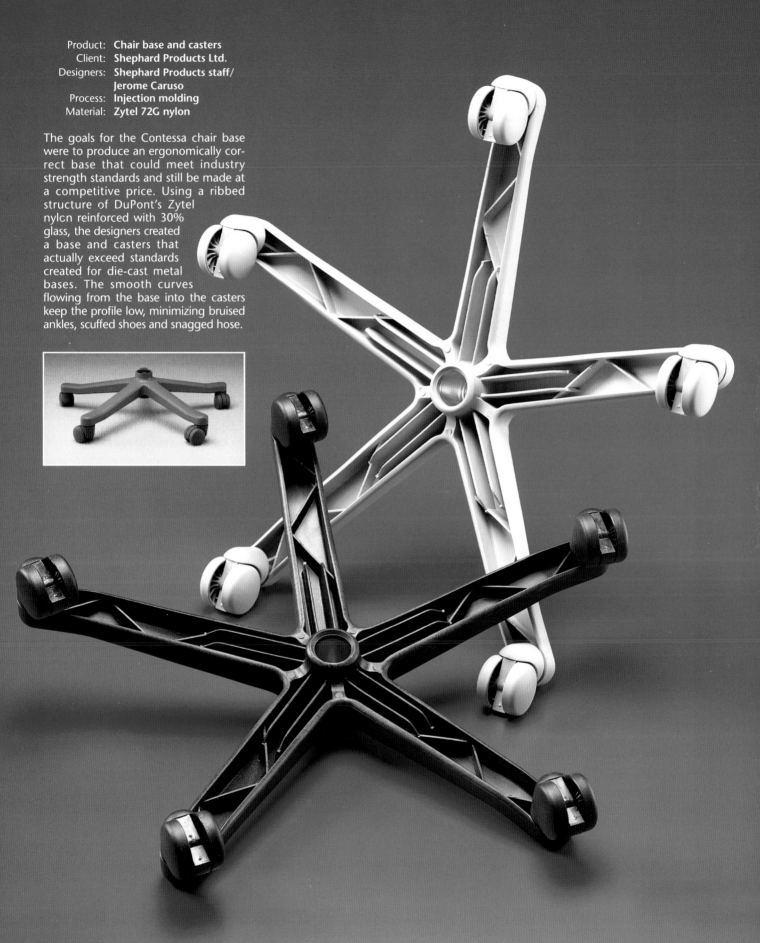

Product: **Desk lamp**
Client: **Martinelli Luce SpA**
Designer: **Elio Martinelli**
Process: **Injection molding**
Material: **Delrin acetal**

While the form of this adjustable lamp arm recalls traditional metal "goose necks," it is made of a series of individual Delrin acetal loops surrounding a flexible metal "sandwich." The result is an adjustable arm without springs or counterweights and without the annoying "memory" often found in metal arms. Designer Martinelli, who has created a series of desk and table lamps using the new arms, used Delrin for its resistance to "creep" and because its low friction allows the loops to move against each other smoothly and quietly.

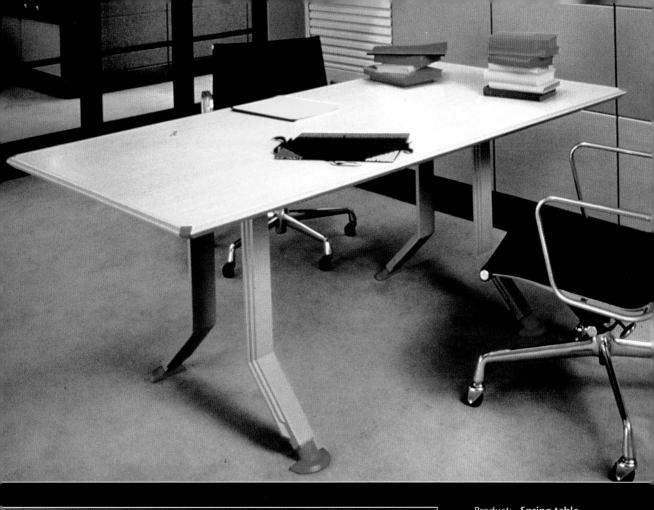

Product:	**Spring table**
Client:	**Herman Miller Inc.**
Designers:	**The Burdick Group/**
	Bruce Burdick ;
	Marco Pignatelli ;
	Susan Kosakowsky Burdick
Processes:	**Injection molding; insert**
	molding; extrusion
Materials:	**Semi-rigid PVC; nylon;**
	polyurethane

The designers wanted a table with rich details that could be mass-produced at a reasonable cost, and a variety of plastics resins and processes made it possible. The table top is semi-rigid extruded PVC with injection-molded corner plugs. The legs are self-skinning urethane over a welded steel insert with in-mold casting. The stepped-form feet are soft, adding comfort for the user. The surface colors, trim and detailing can be specified by the buyer, allowing this chameleon-like table to serve as a conference, work or dining table while harmonizing with any decor.

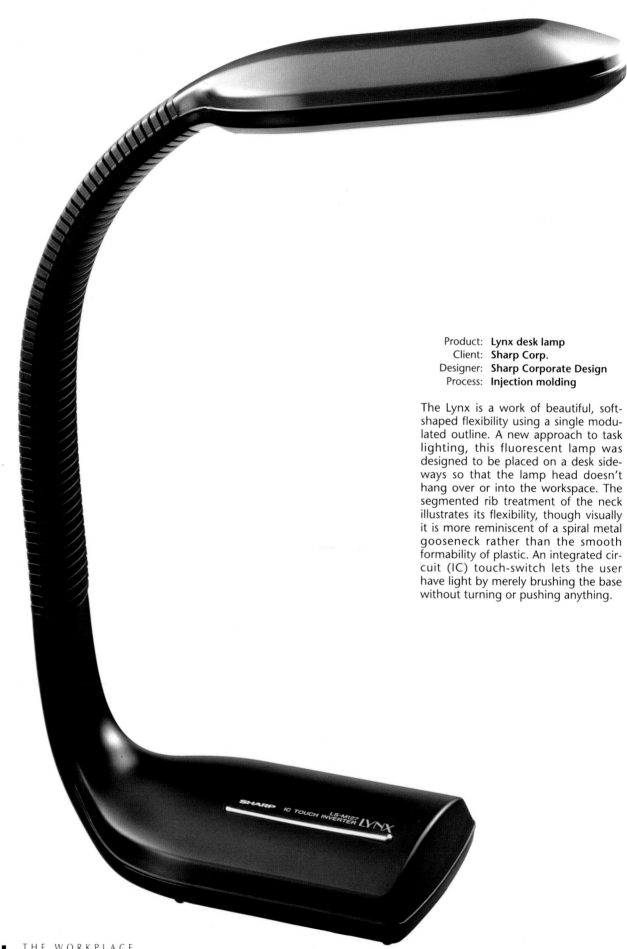

Product: **Lynx desk lamp**
Client: **Sharp Corp.**
Designer: **Sharp Corporate Design**
Process: **Injection molding**

The Lynx is a work of beautiful, soft-shaped flexibility using a single modulated outline. A new approach to task lighting, this fluorescent lamp was designed to be placed on a desk sideways so that the lamp head doesn't hang over or into the workspace. The segmented rib treatment of the neck illustrates its flexibility, though visually it is more reminiscent of a spiral metal gooseneck rather than the smooth formability of plastic. An integrated circuit (IC) touch-switch lets the user have light by merely brushing the base without turning or pushing anything.

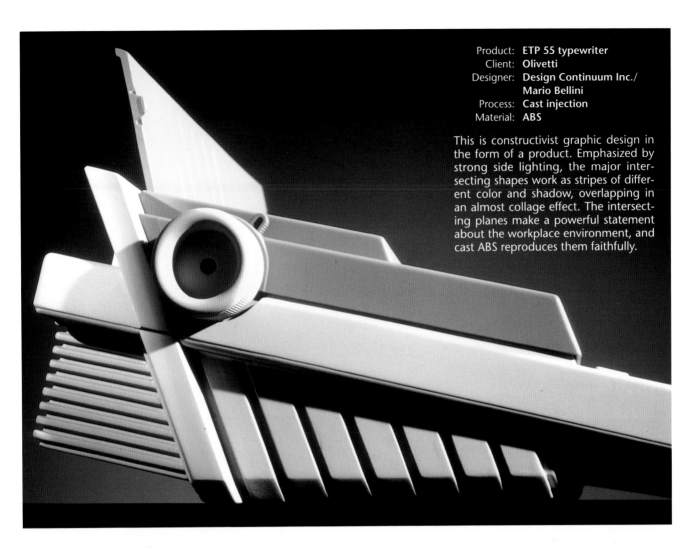

Product: **ETP 55 typewriter**
Client: **Olivetti**
Designer: **Design Continuum Inc./ Mario Bellini**
Process: **Cast injection**
Material: **ABS**

This is constructivist graphic design in the form of a product. Emphasized by strong side lighting, the major intersecting shapes work as stripes of different color and shadow, overlapping in an almost collage effect. The intersecting planes make a powerful statement about the workplace environment, and cast ABS reproduces them faithfully.

Product: **Opus 4 desktop terminal**
Client: **Esprit Systems**
Designer: **Lunar Design Inc./ Robert Brunner**
Process: **Injection molding**
Material: **ABS**

This compact desktop computer display terminal incorporates a tilt and swivel mechanism so that the viewer can adjust it for maximum comfort. The control details are integrated into the form. The enclosure is injection-molded ABS, and the molded slots in the rear case are tapered inward slightly to allow the part to release cleanly without any tool drag.

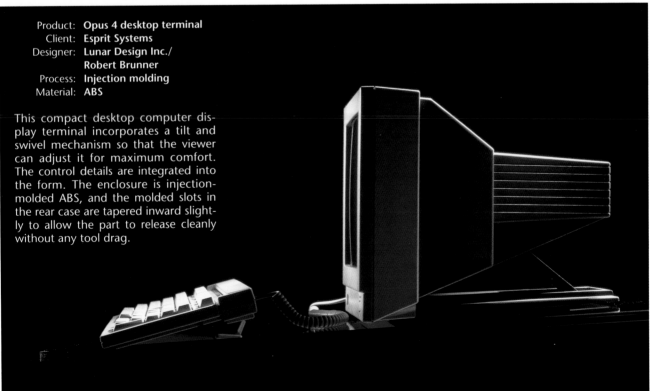

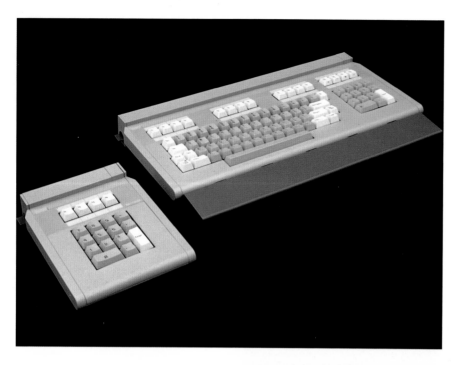

◀ Product: **Modular keyboard**
Client: **Tektronix Inc.**
Designers: **Stuart Whitcomb;**
Richard Randell;
Iraj Nikzi;
David Williams;
Eugene Lynch
Process: **Injection molding**
Material: **Polycarbonate**

When computers only did one thing, only one kind of keyboard was needed. Even though computers are now used for many different tasks, manufacturers have been slow to adapt their keyboards to the varied needs of the users. This keyboard system for graphics workstations can be reconfigured easily by the user with the manufacturer's snap-on modules.

Product: **Modular keyboard** ▶
Client: **Tektronix Inc.**
Designers: **Stuart Whitcomb;**
Richard Randell;
Iraj Nikzi;
David Williams;
Eugene Lynch
Process: **Injection molding**
Material: **Polycarbonate**

The snap-together features of this keyboard—difficult to duplicate in metal—is made possible by a system of interlocking tangs and bosses which exploit the toughness and resiliency of polycarbonate. A palm rest locks into snap-fits on the front of the keyboard for use or underneath for storage. The modular, programmable keypad at right can stand alone or attach to the keyboard using a slider plate and end covers.

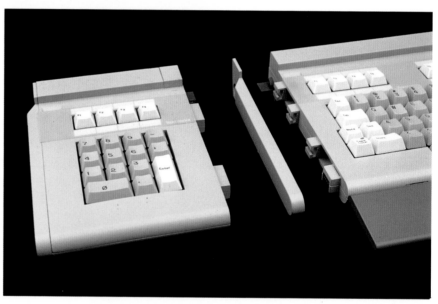

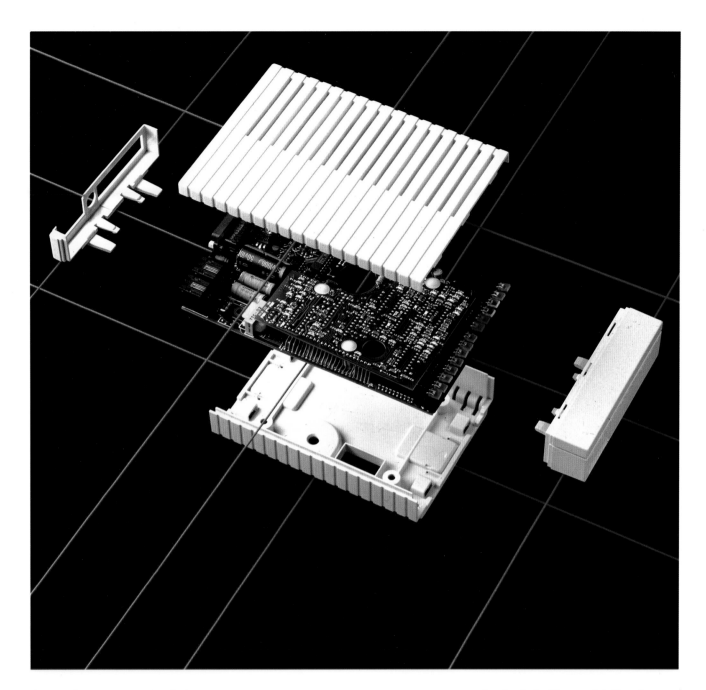

◀ Product: **Logos 5500 calculator**
 Client: **Olivetti**
 Designers: **Design Continuum Inc./**
 Mario Bellini; Bruce Fifield
 Process: **Injection molding**
 Material: **ABS**

This calculator, by Design Continuum Inc. for multi-national Olivetti, has a constructivist look. The draft angles have been minimized and have soft radius curves where planes intersect, humanizing the appearance and providing some comfort for the operator.

▲ Product: **Bizcomp Intellimodem**
 Client: **Bizcomp**
 Designer: **Lunar Design Inc./**
 Gerard Furbershaw
 Process: **Injection molding**
 Materials: **Borg-Warner ABS cycolac;**
 LNP WF 1006 polyester PBT
 reinforced with 30% glass

The enclosure for this computer modem was intended to impart a feeling of quality and solidity yet remain low in cost. The front and rear panels had to accommodate easy re-tooling to accept different configurations of connectors and LED lights. A comb-like holder was created which guides the LEDs into position between the ribs of the bezel during assembly.

Product: **6386 WGS computer**
Client: **AT&T**
Designers: **Henry Dreyfuss Associates/ Gordon Sylvester; Dan Harden; Steve Miggles; Henry Mack**
Process: **Injection molding**
Materials: **Cycolac ABS; Noryl polyphenylene oxide; molded structural foam**

Molding in structural foam allows the vent grooves to run around the corners, echoing the softly radiused curves on the injection-molded faceplate. The handle at the base is also molded-in.

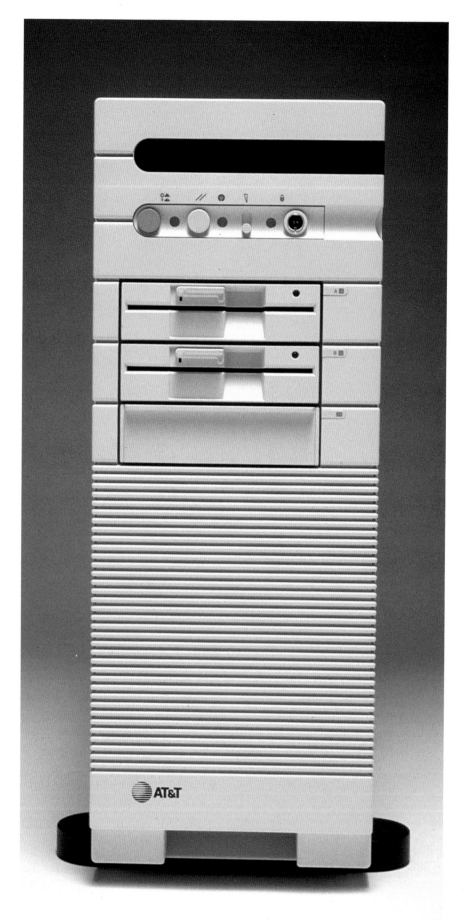

Product: **Concept for calculator**
Client: **Design Central**
Designer: **Design Central**

Formed with little regard for
ergonomics—but with great regard for
the aesthetics—this concept model for
a desk calculator openly suggests sell-
ing a small piece of sculpture by giving
it a useful function.

Product: **MV 4000 Series Cabinets**
Client: **Data General Corp.**
Designers: **Ilhan Gundogan; Arthur Chin; Steven Johnson; Mark Bates; Ian Proud; Ann Marie McKinnon; John Paras**
Process: **Blow molding**
Material: **GE Noryl polyphenylene oxide**

Elbow room is often at a premium for field service technicians. Rather than conventional one-piece swing-out doors, these tri-fold panels swing up and out of the way, assisted and held open by gas springs. GE Noryl® was selected for its excellent strength-to-weight ratio and for economy.

Product: **Personal word processor**
Client: **Smith Corona Corp.**
Designer: **Robert Kasprzycki**
Engineer: **Smith Corona Engineering staff**
Process: **Injection molding**
Material: **ABS**

To minimize production costs, the number of parts had to be kept to a minimum. Also, the user had to be able to simultaneously view the liquid crystal display panel and the paper copy emerging from the printer. These handicaps were turned to good advantage by pivoting the display panel on the center line of the printer platen. When folded down, the display panel doubles as a cover for the keyboard, eliminating the need for a separate lid. Serrations on the panel pivots provide a gripping surface while they also hide the mold witness lines.

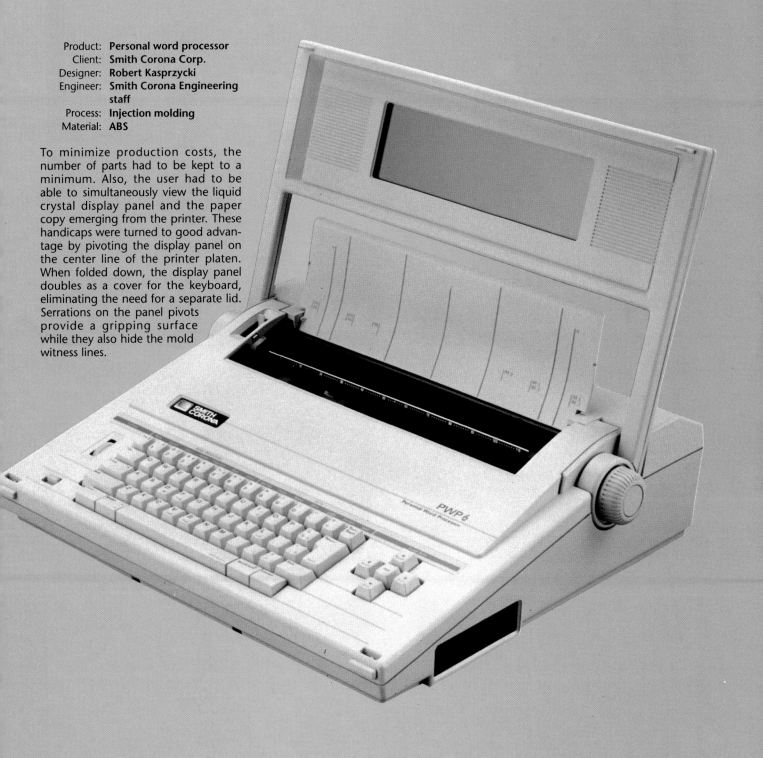

▲ Product: **Universal Data Terminal**
Client: **PCS**
Designer: **Neumeister Design**
Process: **Structural foam molding**
Materials: **TSG Noryl polyphenelene oxide**

Structural foam PPO lends itself to holding the precise, angular surfaces of this almost sculptural family of data terminals. The touch-panel control pad includes many materials—metal, plastics, plastic foils—covered with a skin of smooth plastic film.

Product: **2610 Processor** ▲
Client: **Symbolics Inc.**
Designer: **Design Continuum Inc./**
John Costello
Process: **Injection molding**
Material: **Polyphenylene ether;**
structural foam

Much of this product is extruded aluminum or sheet aluminum, required for their magnetic and thermal resistance. But the casing and keyboard could only be made of structural foam (with but ¼° draft taper) to give the visual and tactile comfort required for machines which must be used by people for long periods.

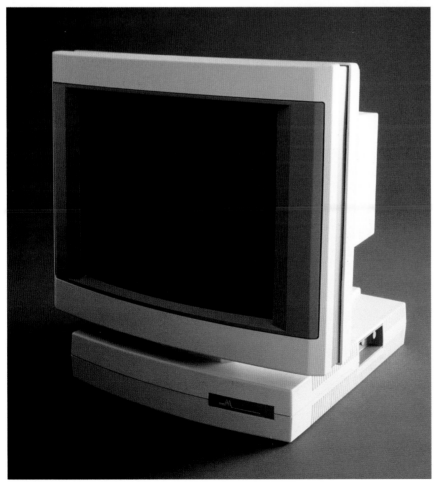

▲ Product: **High-resolution color CRT**
Client: **Monitronix Inc.**
Designer: **Worrell Design Inc.**
Process: **Injection molding**
Material: **Polycarbonate**

BE polycarbonate was chosen to support the weight of the cathode ray tube inside the cabinet without steel supports. Copper paint and special grounding clips solved the problems of EMI and RF shielding. Injection molding reduced the number of parts and the time required for assembly. Because the neck lengths of the CRTs used varies, a two-piece bezel was designed to allow the depth of the cabinet to be adjusted easily. The bevel treatment on the sides of the enclosure, the stepped treatment leading to the face of the CRT and the large-radius curve of the front soften the appearance and ease the need for geometric precision in the molding.

FOXBORO

Product: **Workstation**
Client: **The Foxboro Company**
Designer: **The Foxboro Company**
Engineer: **The Foxboro Company**
Process: **Injection molding**
Material: **Polycarbonate structural foam**
Molder: **North American Reiss Inc. Kenkor Molding Division**

To meet the needs of a diverse customer group, the Foxboro Company designed this Intelligent Automation (IA) Workstation with individual components that snap together in minutes.

This innovative design, spearheaded by senior design engineer Ron Garner and senior industrial designer Mathew Phillips, was honored at the 1988 Structural Plastics convention.

The workstation supports a broad selection of computer hardware and peripherals. It can be expanded from a single bay system to a large control room configuration, as pictured in the large photograph at right.

The use of plastics enabled the designers to integrate multiple details into individual moldings, eliminating the need for brackets and fasteners. The result: a streamlined design and comparatively low materials and production costs.

Also featured on the opposite page: (Top) detail of rotating engagement of turn-section and rear cover; (center) single-bay chassis shown with one side structure removed; (bottom) view of base, one side and rear structure of an assembled workstation.

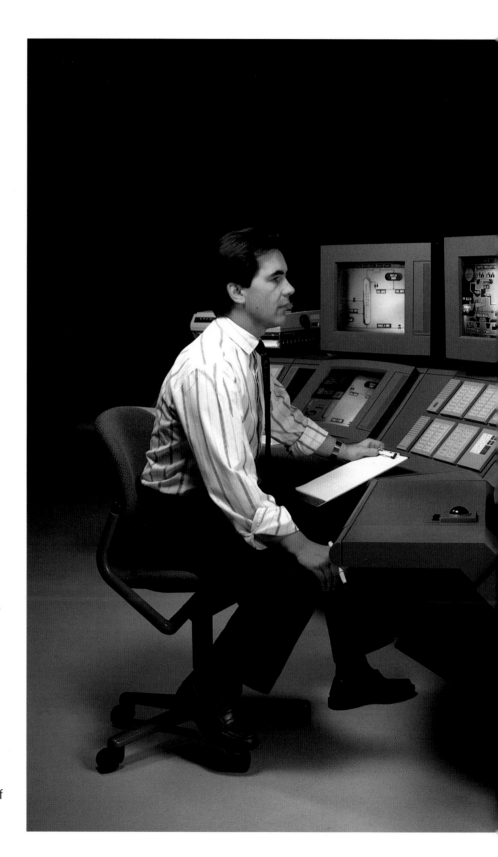

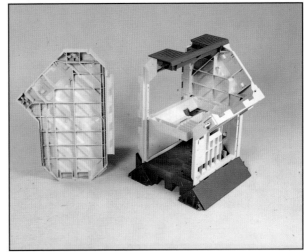

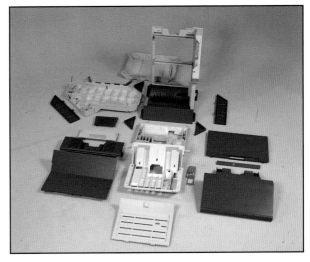

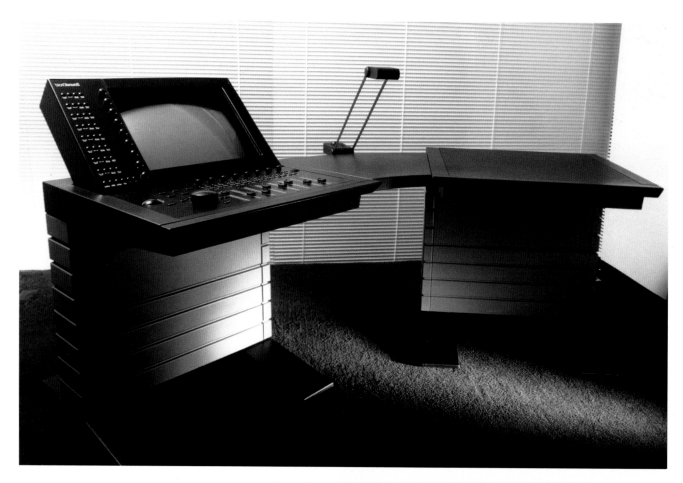

Product: **SoundDroid editor** ▲
Client: **The Droid Works**
Designers: **Lunar Design Inc./**
Robert Brunner; Jeff Smith;
Gerard Furbershaw;
Kenneth Wood
Process: **Reaction injection molding**
Material: **Polyurethane**

SoundDroid and EditDroid are computerized consoles for the editing of film, video and sound. RIM urethane parts were used throughout. The cover of the display allows upgrading to a touch screen. The front edge of the work surface is soft urethane and is comfortable to lean against.

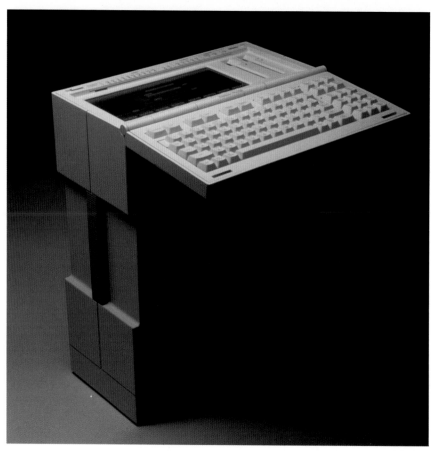

Product: **Protocol tester** ▶
Client: **Atlantic Research Corp.**
Designers: **Human Factors Industrial**
Design Inc./Paul Mulhauser;
Arthur Zarnowitz
Processes: **Structural foam; injection**
molding
Materials: **Acetal; ABS**

This tester checks communications networks. The upright design, molded in foam, allows for use in service areas crowded with rack-mounted gear.

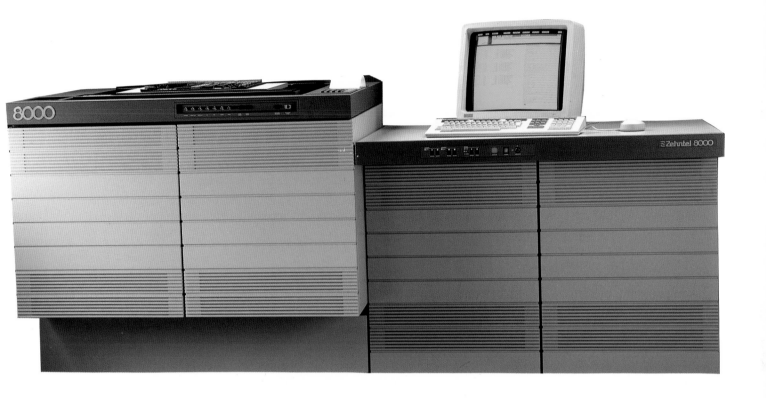

Product: **Zehntel 8000 circuit tester**
Client: **Tetradyne/Zehntel**
Designers: **Lunar Design Inc./Jeff Smith; Gerard Furbershaw; Bill Dresselhaus; Ken Wood**
Processes: **Injection molding; pressure forming**
Material: **GE Noryl polyphenylene oxide**

Pressure-formed ABS inserts to sheet metal panels were used to carry the detailing for attachment of controls, diagnostic connectors, probes, keypad and printer. This allowed the sheet metal to be made with minimal detailing and at the lowest possible cost. The eight doors on the system were produced in three different lengths from a single cavity structural foam molding tool which uses shut-off inserts to vary the lengths. The doors accommodate various vent patterns, right or left handed hinge and lock locations in a single part configuration.

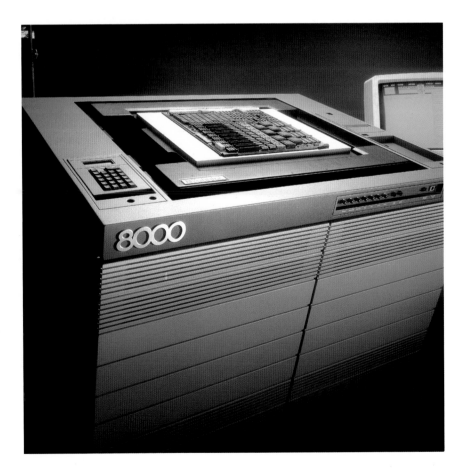

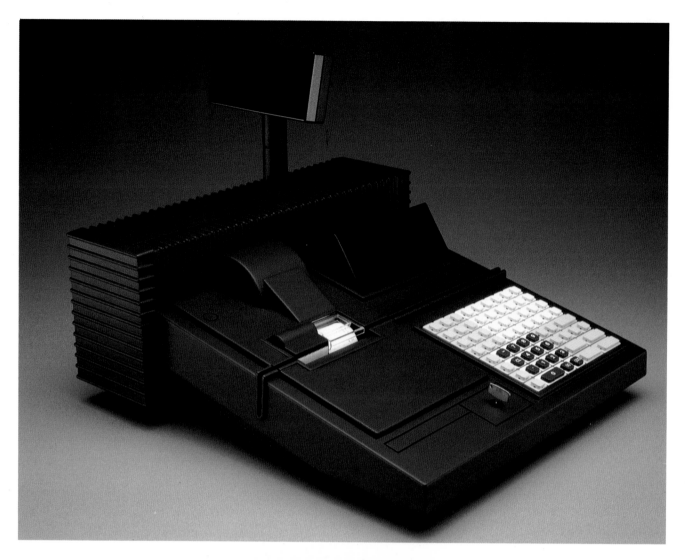

Product: **Bar code scanner**
Client: **Mars Electronics**
Designers: **Bresslergroup/**
Eric A. Schneider;
Benjamin A. Beck;
P.K. Rossi
Process: **Injection molding**
Material: **ABS**

The Mars Electronic MEQ 300 is the first product to combine a non-contact bar code scanner and inventory data terminal in a single, integrated battery operated unit. It's easily switched from right to left hand operation and has optimum weight distribution to minimize user fatigue.

Use of injected molded ABS for the frame and case made it easy to incorporate all component mounting and fastening details. The assembled product is lightweight and passes all environmental and impact tests.

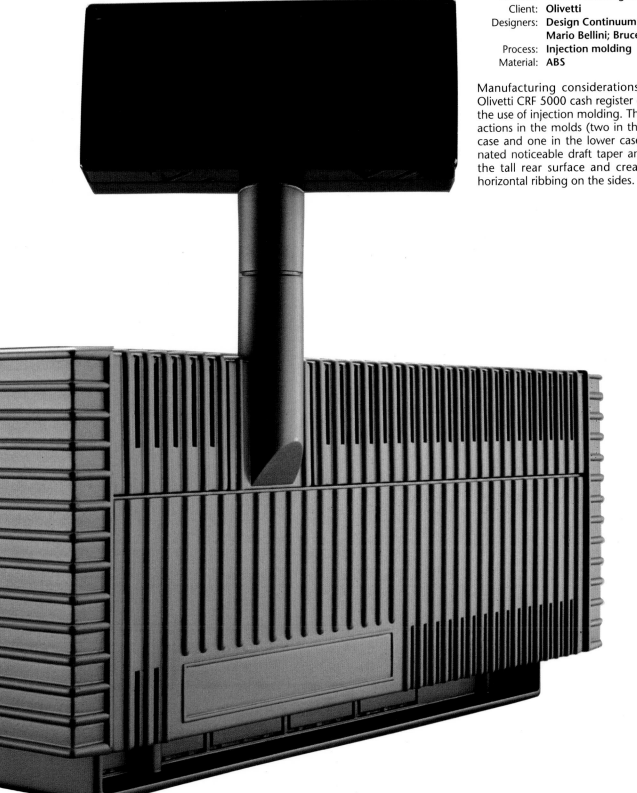

Product: **Olivetti cash register**
Client: **Olivetti**
Designers: **Design Continuum Inc./**
Mario Bellini; Bruce Fifield
Process: **Injection molding**
Material: **ABS**

Manufacturing considerations of the Olivetti CRF 5000 cash register dictated the use of injection molding. Three side actions in the molds (two in the upper case and one in the lower case) eliminated noticeable draft taper angles on the tall rear surface and created the horizontal ribbing on the sides.

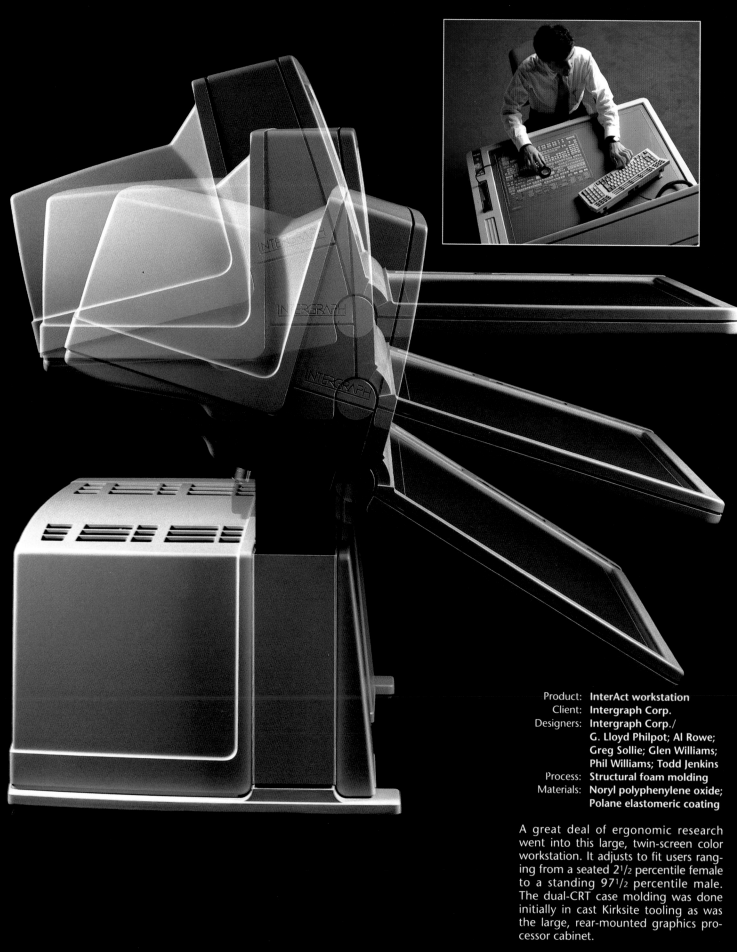

Product: **InterAct workstation**
Client: **Intergraph Corp.**
Designers: **Intergraph Corp./**
G. Lloyd Philpot; Al Rowe;
Greg Sollie; Glen Williams;
Phil Williams; Todd Jenkins
Process: **Structural foam molding**
Materials: **Noryl polyphenylene oxide;**
Polane elastomeric coating

A great deal of ergonomic research
went into this large, twin-screen color
workstation. It adjusts to fit users rang-
ing from a seated 2$^{1}/_{2}$ percentile female
to a standing 97$^{1}/_{2}$ percentile male.
The dual-CRT case molding was done
initially in cast Kirksite tooling as was
the large, rear-mounted graphics pro-
cessor cabinet.

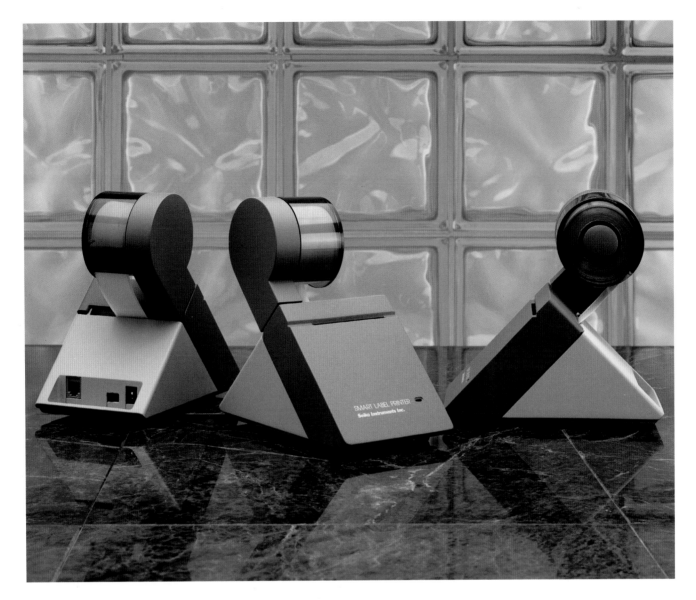

Product: **Smart Label Printer**
Client: **Seiko Instruments USA**
Designers: **S.G. Hauser Associates/**
Doug Walker; Larry Tang
Process: **Injection molding**
Materials: **ABS; polycarbonate**

The Smart Label Printer allows the
printing of letter-quality address labels,
file labels, bar codes, RMA labels and
small graphics without tying up an
office's full-size printer. The use of plas-
tic housings enabled a compact design
in a shape which clearly announces its
purpose. A serrated tear strip was
molded into the front cover, eliminat-
ing the need for a separate metal tear
plate. The clear polycarbonate stock
cover lets the operator see when the
printer stock needs replenishing.

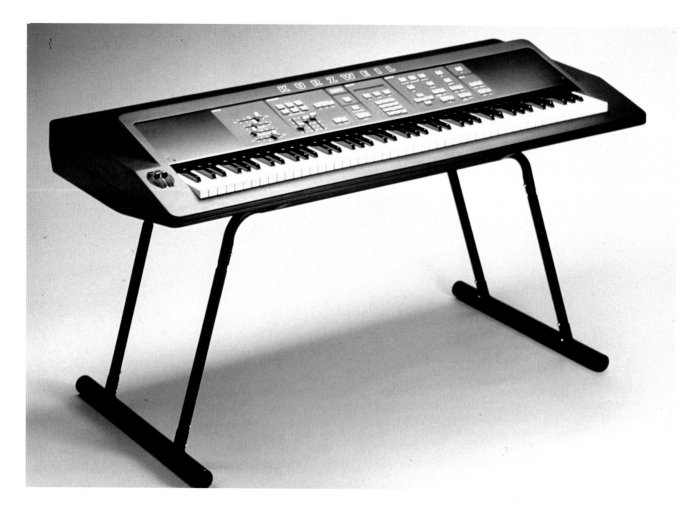

▲ Product: **Kurzweil 250Synthesizer**
 Client: **Kurzweil Music Systems**
 Designers: **Latham Brefka Associates/**
 Paul Brefka; Dave Kmetz
 Process: **Injection molding**
 Material: **Polycarbonate structural**
 foam

Molding the 48-inch case needed to carry a full 88-key keyboard and the associated electronics was a significant challenge. While the traditional wooden keys and frame helped stiffen the case, polycarbonate was chosen for its rigidity and durability. Ribs and spacers were added where testing showed reinforcement was needed. To reproduce the correct feel and key action, each key was modified with weights and anchored into an injection-molded bracket. To give the necessary head room over the keys for the control switches and circuitry, a raised section was molded over the keys. This had the additional, unforeseen benefit of preventing users from stacking extra gear on top of the synthesizer.

Product: **Video Camcorder** ▶
Client: **Ampex Corporation**
Designer: **Ron Boeder**
Process: **Injection molding**
Materials: **ABS; thermoplastic rubber;**
 polyurethane foam

We are used to seeing professional video cameras with magnesium shells wrapped in foam rubber and with a rigid shoulder rest. This Beta-format camcorder is unique not only in its use of plastic, but in its physical design as well. By molding all major body components, the designer was able to produce a camera which could rest on the photographer's shoulder in a number of different positions. The body was wrapped in thermoplastic rubber to cushion the surface, adding to the user's comfort. Molding polyurethane foam on the back of the handgrip rather than using a traditional leather strap makes a sure, self-adjusting grip. As a bonus, the articulated camera body folds flat for easy storage and carrying.

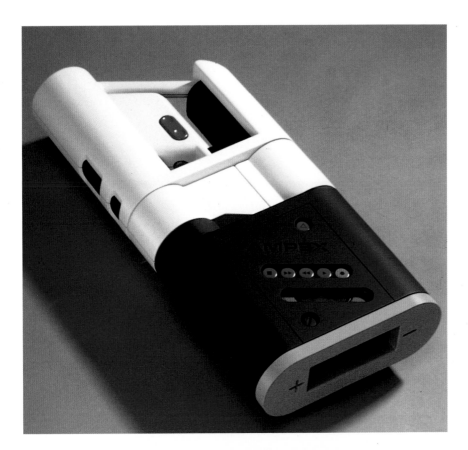

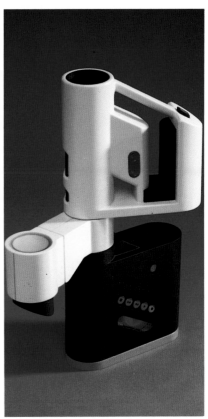

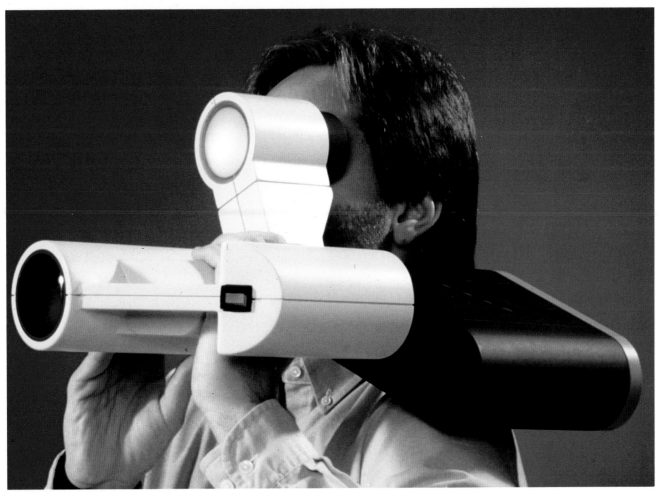

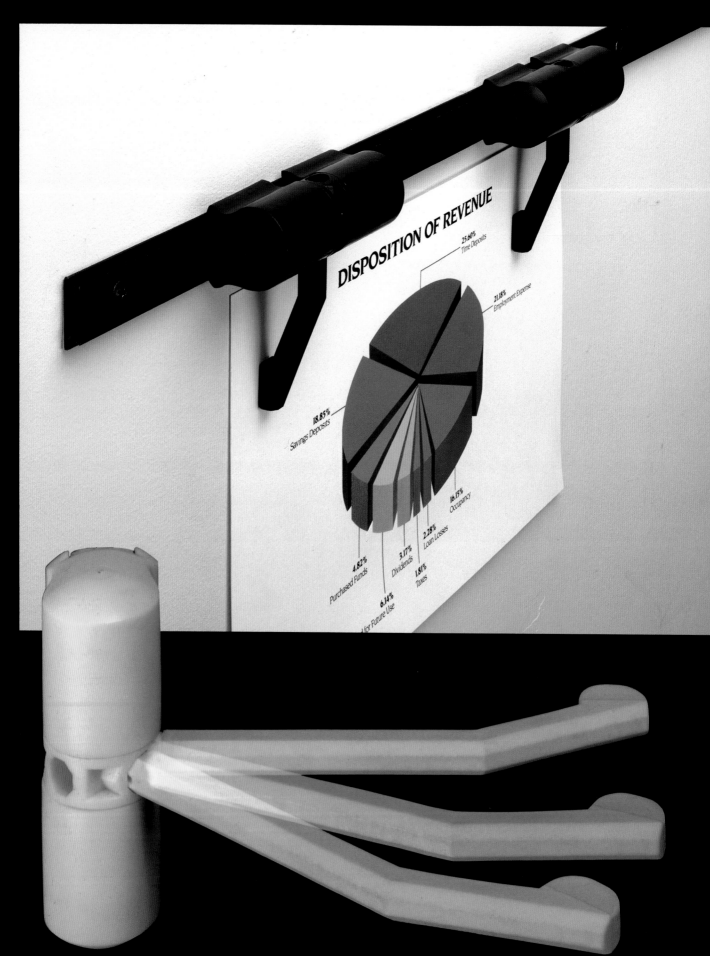

DISPOSITION OF REVENUE

25.60%
Time Deposits

21.18%
Employment Expense

18.85%
Savings Deposits

16.15%
Occupancy

2.28%
Loan Losses

1.81%
Taxes

3.17%
Dividends

4.82%
Purchased Funds

6.14%
for Future Use

Product: **Doorbutler/Viewtrac**
Client: **Molvan Enterprises**
Designer: **Fred Vandergeest**
Process: **Injection molding**
Material: **DuPont Zytel ST nylon**
Molder: **Horn Plastics**

Wouldn't it be nice if some of the doors in your home closed automatically? The hydraulic units used in offices and institutions are too big and too costly for most homeowners. Thus, the Doorbutler. The original of this product was prototyped in aluminum. Unfortunately, the cost of actually manufacturing it in metal made it commercially infeasible. But when inventor Fred Vandergeest tested it in nylon, both the economics and the ergonomics worked perfectly. Doorbutler mounts on a doorframe. When the door is opened, the Doorbutler's arm rotates the inner drum, which is loaded by coil springs held in place by press fit. When the door is released, Doorbutler gently pushes it closed again. The Viewtrac is a lineal descendant of Doorbutler. By shortening the arm and substituting lighter springs, Vandergeest produced a clip which can be mounted to a track running around the walls of a presentation room. The clips, which can be easily slid along the track, are a vast improvement over corkboard and thumbtacks.

Product: **Telephone** ▶
Client: **Atari**
Designer: **Morison Cousins**
Process: **Injection molding**
Material: **Polycarbonate**

Simple-to-tool geometric forms are rendered with great elegance. The careful layout of the controls follows Henry Dreyfus's famous dictum that the operation of a product ought to be obvious to the user, rather than cleverly hidden from view.

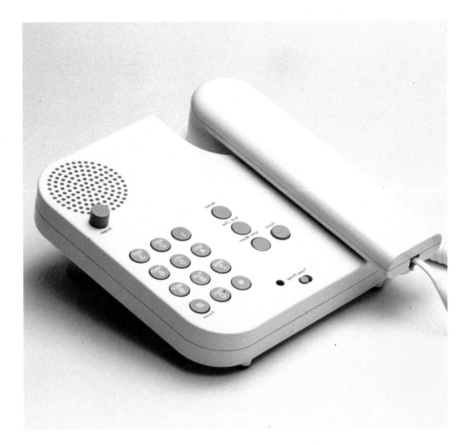

Product: **Telephone**
Client: **Lanier Business Products**
Designer: **American Industrial Design**
Process: **Injection molding**
Material: **ABS**

Rather than integrating the forms, the designers visually separated the 12-key dialing pad and its function keys from the main unit, which makes the telephone easier to use when mounted on a wall or sitting on a desk. Reversing the base molding reveals brackets for wall mounting. ▼

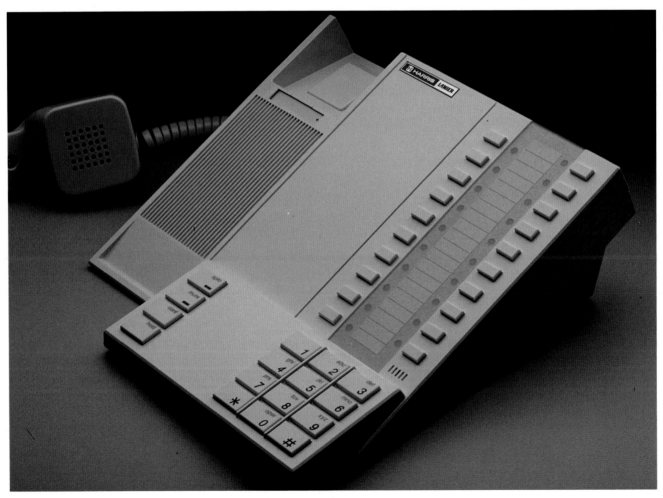

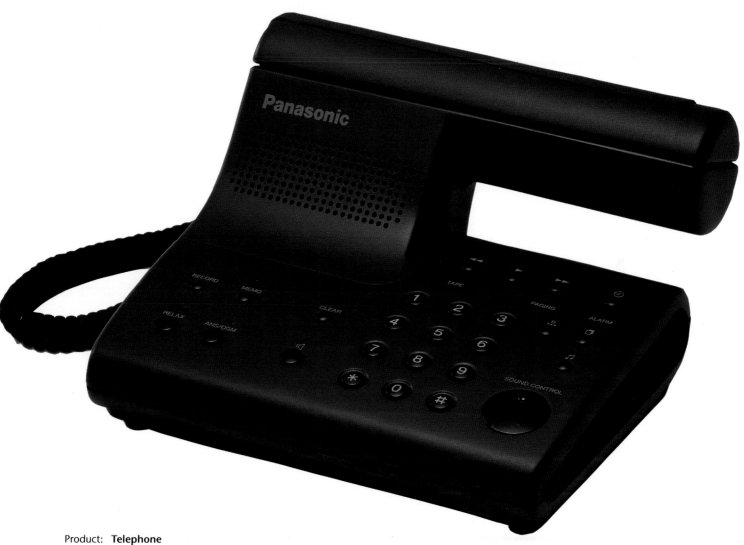

Product: **Telephone**
Client: **Matsushita Electric Industrial Co. Ltd.**
Designer: **Matsushita Design Center**
Process: **Injection molding**

This combination telephone/answering machine has a molded appearance that breaks away from the more usual boxes-with-buttons. The designers have created a beautiful interplay of convex and concave forms, second-order curved surfaces and uniform circular radii.

Product:	Telephone security device
Client:	Digitech Telecommunications Inc.
Designers:	Lee Payne Associates/ Lee Payne; Ed Stembridge; Phillip R. Carter; Rebecca J. Linser
Process:	Injection molding
Materials:	ABS; polystyrene

The Voice Safe is a telephone scrambler that provides secure telephone communications by scrambling the signal sent from one telephone to another. The device was to be marketed in upscale retail outlets and required a "predatory, high-tech" image. This was achieved by molding in black plastic and by selectively patterning the surface with the pattern of simulated electronic circuits.

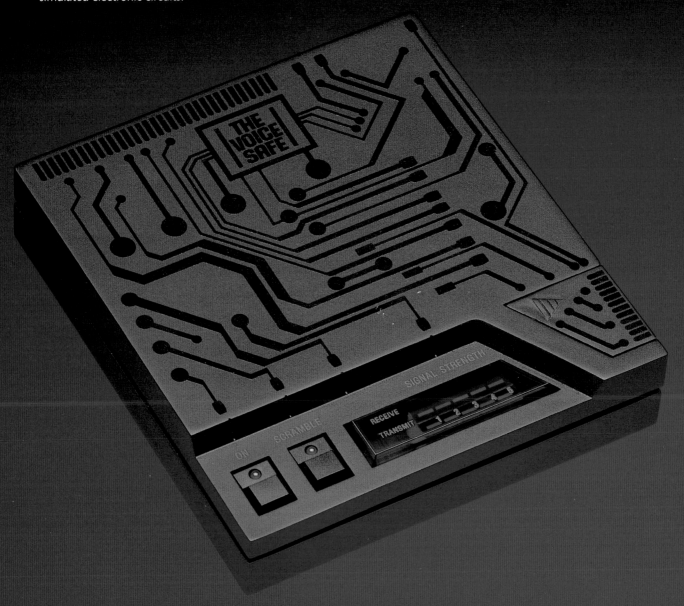

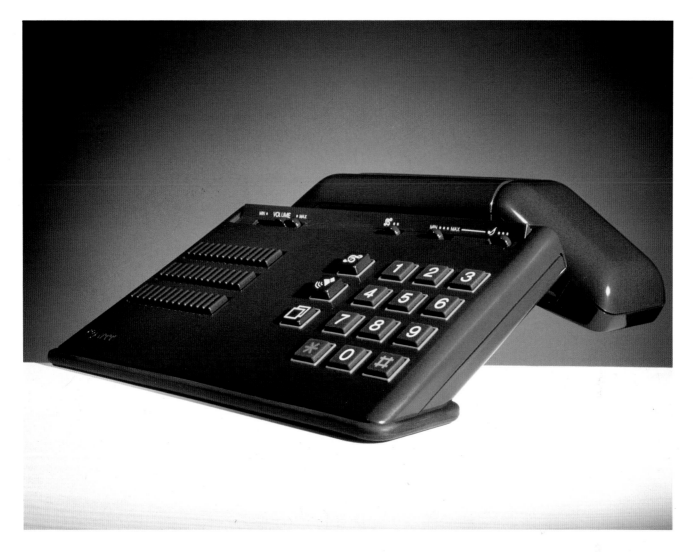

Product: **Telephone** ▲
Client: **NTT**
Designers: **Design Continuum Inc./**
Mario Bellini; Dario Bellini
Process: **Injection molding**

This telephone appears to thrust up through a well-finished slot in the desk top. The keyboard is slanted for easy dialing and the receiver poised in the traditional position for quick access.

Product: **Binding machine** ▶
Client: **General Binding Corp.**
Designer: **Herbst LaZar Bell Inc./**
Walter Herbst
Process: **Injection molding**
Material: **ABS**

GBC's binder assembles papers into neat documents using a thermoplastic adhesive instead of a mechanical punch and fasteners. Formed from injection-molded ABS, the binder brings print-shop quality finishing to the user's desktop.

INDUSTRY

To design something means to arrange all the things necessary to achieve some desired end. Design performance here means work, getting stuff done, without getting all hung up in whether something looks like it ought to be allowed into our traditional, organized, formal, conservative business world. Workers—iron-collar workers and blue-collar workers—care about getting the job done. Fancy appearances and drawing-room manners never meant much to a cowboy, and their modern equivalents in designer colors and textures don't count much down on the farm, or out in Valve Works No. 7. What's right is what works. Plastics have had to earn their way in.

Anyone who has to get a difficult physical job done under urgent time requirements is intolerant of what does not work. The operating mindset is "anything that will do the job is adequate." And what has not stood the test of time is not to be trusted, for it may not work. I forgive them the mistrust of plastics, for there is also an open willingness to try new things. The transaction is very direct: 'What the hell. Let the new kid in. If he can do a job, swell. If he can't, then out." And that's that.

The demands of the physical workplace center on performance. When something's been thrown out for nonperformance, the next product down the line that looks remotely like the one thrown out will not get much of a chance. But good works stay. Phenolic—Leo Baekeland's thermosetting resin commercialized in 1910—quickly displaced shellac and tar as an electrical insulator. It soon got a job in automobiles as a distributor cap. It's still a workhorse plastic—that black hard-looking material used in electrical boxes and for handles on hot appliances. Acceptance was quick. The job became permanent.

On the other hand, the very first plastic, cellulose nitrate (1869 patent) had been eking out an effete sort of life outside the workplace in shirt collars, hair combs, buttons, dental plates, novelty items, and as a substitute for elephant tusk ivory in billiard balls. It finally got a real job in pictures under the name of "Celluloid," as the base for film—until something better came along.

This was the problem with the "first" generation of plastics asked "to do a man's job." Some others were successful. In the 1930s urea formaldehyde offered household-bright colors in a thermosetting resin. Injection-molded cellulose acetate replaced nitrate. Then nylon came along, the first he-man thermoplastic for engineering uses (like replacing silk in women's stockings). Then 1958 brought polycarbonate. ABS brought polymer alloys. Today, any resin that "can do a man's job"—that is, perform special feats of strength—is called an "engineering plastic." That entitles it to a special price, differentiating it from the namby-pamby "commodity" kind, the ones that might not do a job (depending on who did the designing/engineering).

Design work occurs on many levels in this physical workplace context. There are molecular designers laboring at their drawing boards, and refinery designers and factory layout persons and tool designers and dittodittoditto laboring at their dittodittoditto. All of them are working hard at coming up with superior solutions to problems that must be solved—to get a job done. But out in the iron-collar/blue-collar workplace, where life is reduced to "It does" or "It doesn't," figuring out whether plastics can do the job is pretty simple. It does. Or it doesn't.

Many successful plastics design solutions —answers to common workplace demands—are invisible. It's a shame they don't lend themselves to being photographed. How about Teflon PTFE, diffused into the axle on a piece of farm/industrial equipment, so that it is truly permanently lubricated, has forever eliminated the need for any human beings to carry thought of its existence around in their heads?

This is true freedom, brought about by plastics. Freedom as defined by not having to do something you don't want to do—like carry around instructions to lubricate Shaft B sticking out at Location J every 28 days (or else).

Plastic water pipes disappear into the walls, or under the ground—polybutylene, polyethylene, PVC, ABS waste drain pipe. Expanded polystyrene foam insulation gets buried in the soil. There is polyethylene vapor barrier film in the walls. Various thermoplastic rubbers are used for roofing membranes. Fasteners everywhere. Out of sight. Out of mind.

Plastics don't corrode. Plastics don't rot. Plastics do a superb job of protecting whatever is behind their surface. These characteristics have gained them a special place in building construction. Exterior finish "paints," metal tank and bridge coatings, electrical and thermal and sound insulation, window frames, office partitions, floor coatings—all tough jobs.

Other "invisible" uses of plastic resins have had huge design impact. Making plywood (and its wood-chip-cousin) on commercial scale would be impossible without thermosetting plastic resin "glue"—but we never credit "plastic" for doing the job. Plastic insulating varnish makes our electric motors reliable. Construction by adhesion, putting things in place with mastic. Scotchlite reflecting road signs. The list goes on and on. Plastic resins have been carefully designed for each of these jobs.

Products and objects in this can-do context tend to be made of the tough engineering resins. Physical demands bring out much more the animal nature in plastics. It doesn't mean we're not thinking, but our focus is on performance-seeking, physical accomplishment. People perspire here. The plastics sweat—work hard and earn a living, or die on the job (or get fired). An outdoors environment adds to the complexity. Outdoors is demanding. Physical work is demanding. Together they are unforgiving. The product

design balance is clearly centered on accomplishment, without overbearing concern for fitting into existing appearances. Not to say appearance is unimportant.

The way these products look has been carefully designed. Every designer wants his product to look its best. But there are two sides to any plastic product: The public appearance side and the technical performance engineering design side—which here is sometimes the outside. I personally cannot believe that rectilinear ribs are the best structural answer for molded plastics, given the variety of alternative structures I see in nature, and given fluid dynamics of flow in viscous media confined in a mold. However, straight rectilinear cuts in a steel mold are certainly what milling machines are set up to do best. Rectilinear reinforcing ribs may not be the best theoretical solution, but certainly here they represent the great advantage in the entire process of the route of least instruction. Performance advantage wins again.

The special properties of plastics have unquestionably altered the ways in which we work. The products here have the common characteristic of universally being directed at avoidance of human labor. From counting votes to monitoring valves at remote locations to driving nails to (not) hoeing beans. This is the place of stress and strain, distortion and creep, of 10,000 different resin formulations. Nearly all of the plastics manufacturing processes are here, from extrusion to rotomolding to film to acoustical foam, each used to best advantage. Design experimentation has led in each of these cases to a combination of material and process and form that gets the job done. As in the Buddhist Law of Cause and Effect: "When you do it right, it works."

Product:	**Sonex acoustical foam**
Client:	**Illbruck Inc.**
Designer:	**Illbruck Inc.**
Process:	**Contour cutting**
Materials:	**Polyester urethane foam;**
	melamine foam

There are two innovations here. The first is the production of a cellular complex of elastic filaments that is completely open-celled. The second is the cutting of deep, anechoic wedge contours in a pattern which alternates 90°. The resulting material presents a surface 450% greater than a flat material of equal square footage. The product is light, easy to install and soaks up sound, converting it to silent kinetic energy through internal scattering on the carefully-engineered contours.

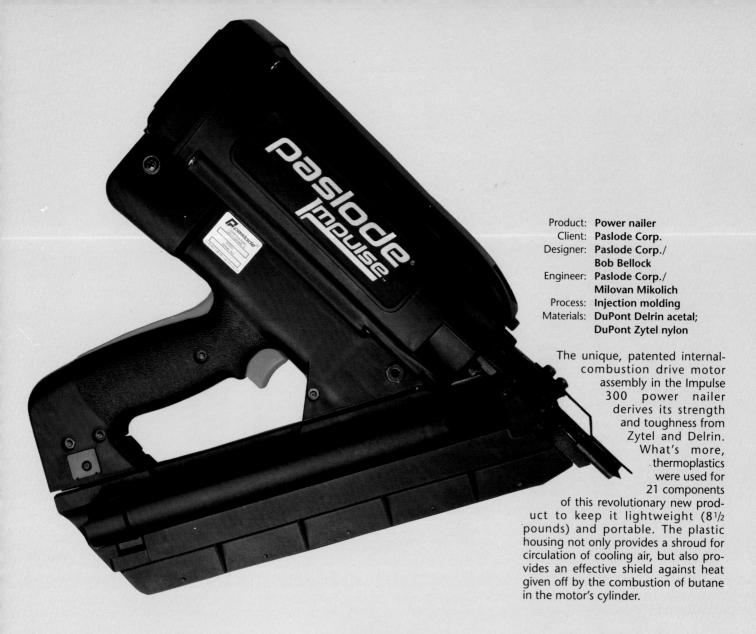

Product: **Power nailer**
Client: **Paslode Corp.**
Designer: **Paslode Corp./
Bob Bellock**
Engineer: **Paslode Corp./
Milovan Mikolich**
Process: **Injection molding**
Materials: **DuPont Delrin acetal;
DuPont Zytel nylon**

The unique, patented internal-combustion drive motor assembly in the Impulse 300 power nailer derives its strength and toughness from Zytel and Delrin. What's more, thermoplastics were used for 21 components of this revolutionary new product to keep it lightweight (8½ pounds) and portable. The plastic housing not only provides a shroud for circulation of cooling air, but also provides an effective shield against heat given off by the combustion of butane in the motor's cylinder.

Product: **Uni-tap nail**
Client: **U.S.E. Diamond Inc.**
Designer: **U.S.E. Diamond Inc.**
Process: **Injection molding**
Material: **DuPont Zytel nylon**

Here's an example of the myriad of specialized plastic fasteners that are the products of fertile minds. This particular fastener exists because of the insulating properties of plastics. Like metal nails, the super-tough nylon won't break under the pressure of a hammer. When used to fasten together the inside of a refrigerated truck trailer, however, metal nail heads collect condensation which later freezes. If enough ice builds up, it can rip or gouge the packages being transported. These nylon fasteners don't.

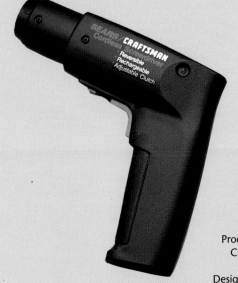

Product: Cordless drills
Client: Sears Merchandise Group;
Singer Motor Products Div.
Designers: American Industrial Design;
Singer Motor Products Div.;
Sears Department 817
Industrial Design
Process: Injection molding
Material: ABS

Shape, color and texture combine to let the consumer know that these power drills are durable and reliable. ABS is a resilient material that stands up to the brutal treatment that a power tool gets. And it's light in weight; a welcome relief for the user's wrists.

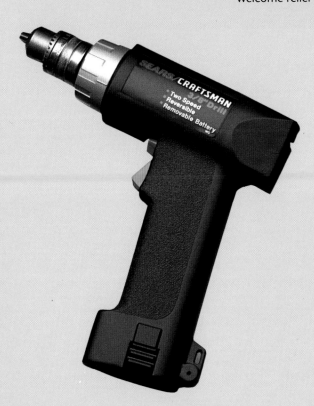

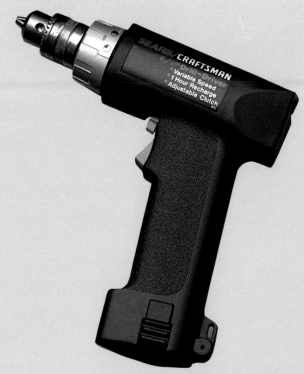

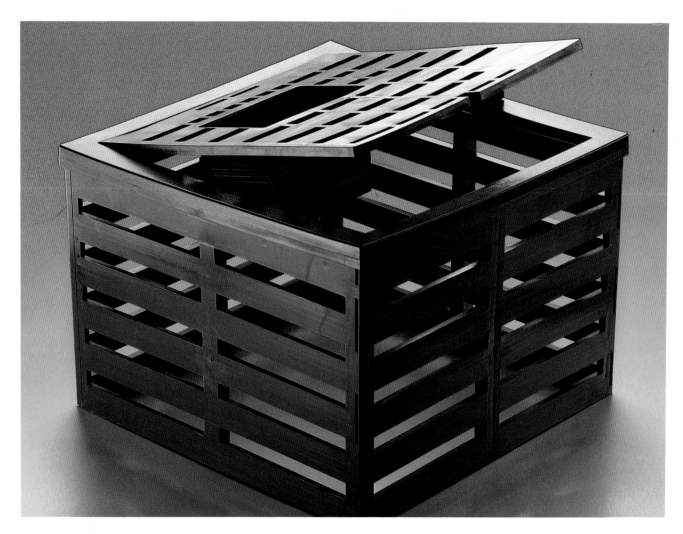

▲ Product: **Crab trap**
 Client: **Martinelli Corp.**
 Material: **Thermofil F-45FG-1100
 45% glass fiber reinforced
 linear polyethylene**

The wood-and-wire crab pot may soon be a museum piece: Saltwater rots wood and rusts the wire. Used for harvesting stone crabs off the coast of Florida, this trap has five panels that snap together without fasteners. Glass reinforced polyethylene has the toughness, dimensional stability to take the abuse of being hauled onto a boat deck and then tossed over again. The material also resists breakdown in sunlight.

 Product: **Concept house** ▶
 Client: **GE Plastics**
Designers: **GE Plastics staff;
 Infill Systems BV**

A bewildering variety of plastics materials and processes will be used to build a full-scale concept house based on this model. While the basic structure of the house is conventional, most components will be modified. The precast cement basement walls, for example, will be clad with rigid foam and a thermoplastic skin. Other innovations: radiant wall panels, baseboard electrical raceway, composite entry doors, polycarbonate windows and skylights, roof panels with photovoltaic cells to produce electricity and rooms which can be reconfigured by moving wall panels as needs change. And while this house will cost GE $4 million US, the designers believe that mass-produced plastic components could result in a house which costs less to build and maintain than a conventional home, while improving the resident's quality of life.

Product: **Glazing for Myriad** ▲
 Gardens Botanical Bridge
Process: **Extrusion**
Material: **Cyro Industries' Exolite**

The Exolite double-skinned sheets used in the place of glass give this building a high-tech look, without compromising the insulating value. The sheets are made from either acrylic or polycarbonate plastic. Each sheet consists of two outer walls, separated and joined by a series of parallel, evenly-spaced integral ribs that run the length of the sheet. Air, trapped in the channels formed by the walls and ribs, provides an insulating value equal to insulating glass units of the same thickness.

These sheets have some obvious advantages over glass: they're lighter, won't break easily and provide thermal and sound insulation at a substantially lower in-place cost than comparable insulating glass units.

Product: **Flat wire cable** ▶
Process: **Extrusion Coating**
Material: **Plasticized PVC**

Here's another application of plastic that is sometimes taken for granted. This colorful PVC insulated ribbon cable contains several dozen fine wires that can drive appliances, computer equipment and home wiring systems—but won't melt in the overheated environment found inside a computer or appliance. Trimellitate plasticizer keeps this cable flexible; other plasticizers become brittle after continuous exposure to high temperatures. A self-tapping connector can be clamped to each end of the cable, thereby eliminating the need to connect each wire separately.

Product: **MERLIN II Small Communications System**
Client: **AT&T Information Systems**
Designers: **Jeff Hiatt; Bill Martin; Mark Millman; Tim Wink**
Process: **Thinwall structural foam**
Materials: **General Electric Plastic Prevex BJA or Noryl FN 215**

AT&T's new generation of MERLIN systems requires 33% fewer parts than comparable systems and can be assembled for about half the cost of a factory-built enclosure. The modules snap together in two simple steps right at the installation site—no screws or fasteners are required. Structural foam was selected for its high strength-to-weight ratio, its excellent dimensional tolerances and extreme flatness. Light pastel colors minimize the typical swirling flow pattern evident on the surface of structural foam. A pale cream color was chosen so that parts wouldn't have to be painted. Because the entire product line is modular, customers' phone networks can be upgraded in the field by simply snapping in new feature modules.

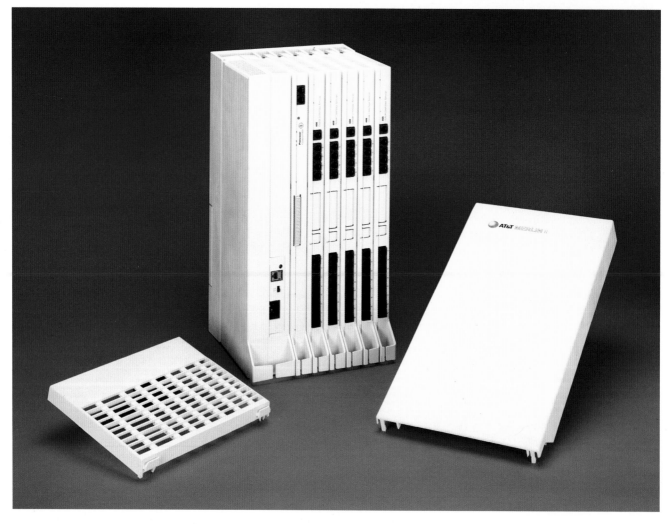

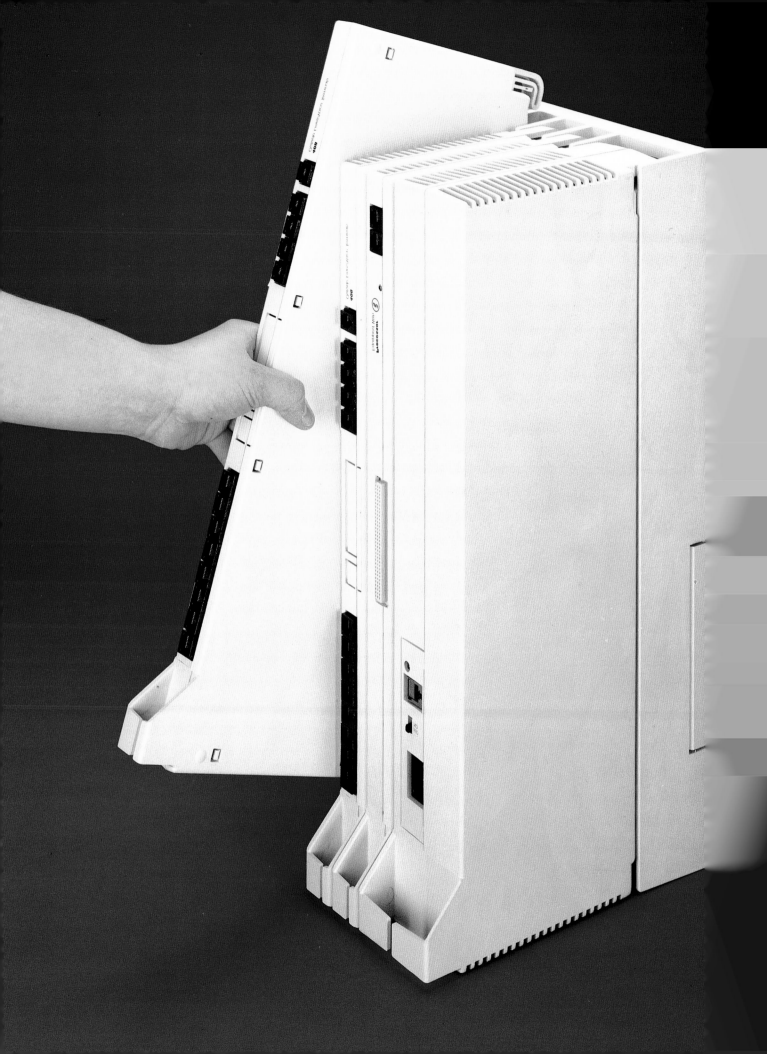

Product: **Self-dumping hopper** ▲
Client: **Rubbermaid Commercial Products Inc.**

These hoppers are used for dumping food ingredients into cooking or mixing vats, for mixing chemical powders and resins and for containing food processing scrap. Until the advent of plastics, the materials of choice were wood and metal.

Product: **Armadrench injector** ▶
Client: **NZ Veterinary Supplies Ltd.**
Designer: **Peter Haythornthwaite**
Processes: **Injection molding; blow molding**
Materials: **High-density polyethylene; polypropylene**

You can't ask a sheep to "say aah" and swallow its medicine; in fact, just getting one to hold still while you try to shove a pill down its throat takes the strength—and hands—of ten men. Instead, this one-piece unit shoots a stream of liquid down the animal's throat. Because the entire apparatus can be strapped to the upper arm, it leaves both hands free; one to steady the patient and one to administer the tonic.

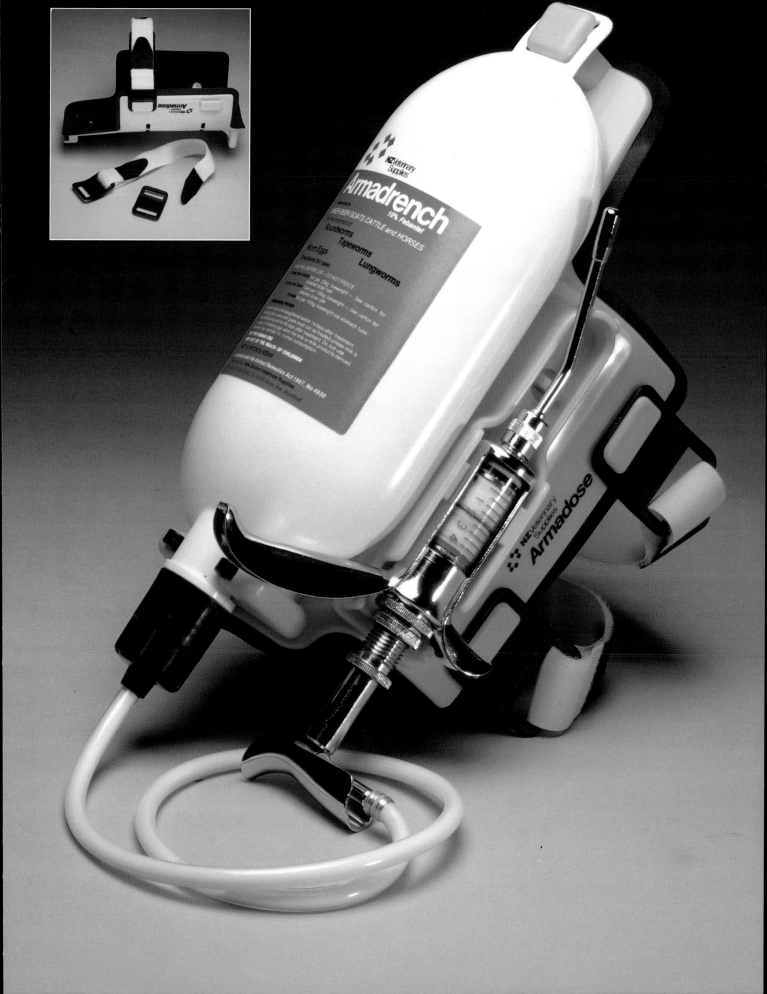

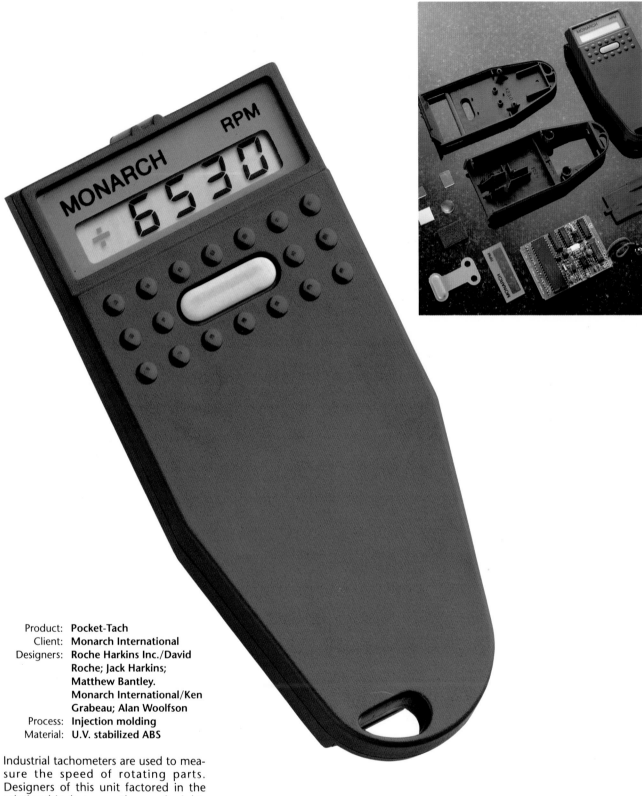

Product: **Pocket-Tach**
Client: **Monarch International**
Designers: **Roche Harkins Inc./David Roche; Jack Harkins; Matthew Bantley. Monarch International/Ken Grabeau; Alan Woolfson**
Process: **Injection molding**
Material: **U.V. stabilized ABS**

Industrial tachometers are used to measure the speed of rotating parts. Designers of this unit factored in the relationship between the user's sightline, hand position and the rotating target. Molded-in features precisely locate the optical parts for quick assembly. The fine texture and smooth raised bumps provide a sure grip and make it easy to locate the trigger. The asymmetric "tear drop" hold accommodates an optional wrist strap.

◄ Product: **Nester pH pen**
Client: **Nester Instruments**
Designer: **Bresslergroup/Duane Adams; Eric Schneider; P.K. Rossi**
Process: **Injection molding**
Material: **ABS**

Injection molded ABS was an ideal material for this high-tech pen (it's built with miniaturized electronics) because of its flexibility. All mounting points for internal components and electrical contacts were integrally molded, as were fastening details. The case halves are joined with a structural adhesive. The sliding cover over the battery compartment was made water resistant by molding a series of groves into which rubber seals were fitted.

Product: **Mini-Master A Flowmeter** ▶
Client: **Dwyer Instruments**
Designer: **Dwyer Instruments**
Process: **Injection molding**
Material: **Emser Grilamid TR55 Nylon 12**

All 14 parts of this flowmeter—plus a hexagonal assembly tool—are injected molded together in a single shot. Nylon was selected over other materials because of its transparency and resistance to hydrocarbon-based solvents, chemicals, fuels and oils. Machined acrylic was ruled out by labor cost, polycarbonate won't withstand hydrocarbons, and polysulfone and SAN suffer from weathering. The flowmeter operates to pressures of 130 PSIG and can be configured by the user for top valve, bottom valve or no-valve operation.

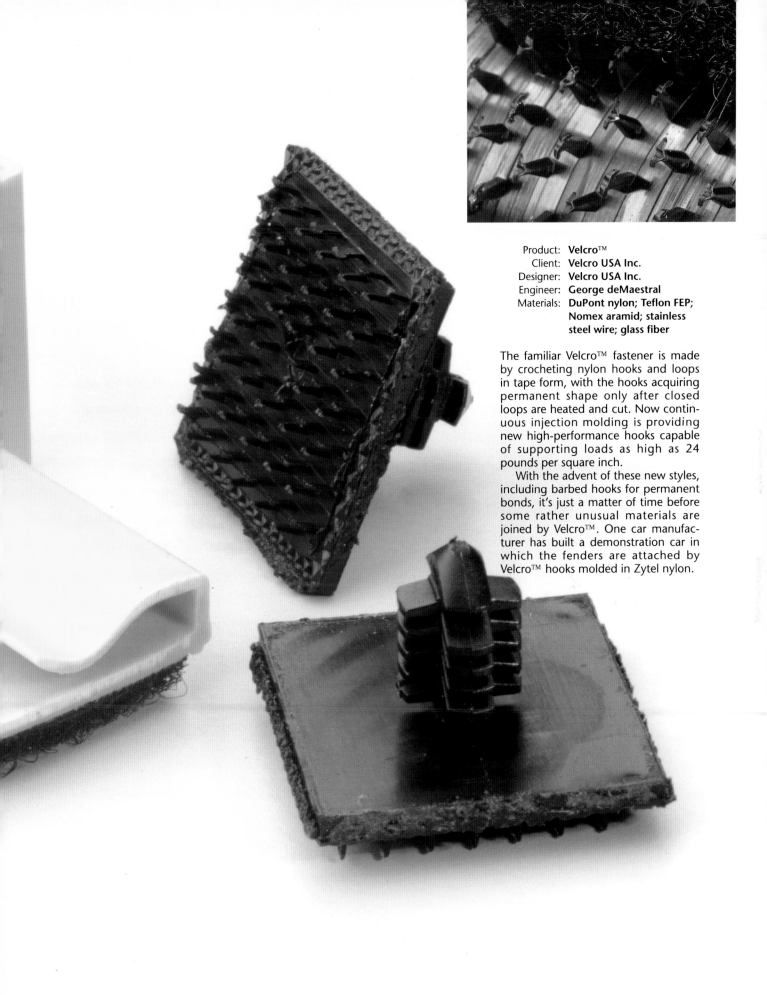

Product: **Velcro™**
Client: **Velcro USA Inc.**
Designer: **Velcro USA Inc.**
Engineer: **George deMaestral**
Materials: **DuPont nylon; Teflon FEP; Nomex aramid; stainless steel wire; glass fiber**

The familiar Velcro™ fastener is made by crocheting nylon hooks and loops in tape form, with the hooks acquiring permanent shape only after closed loops are heated and cut. Now continuous injection molding is providing new high-performance hooks capable of supporting loads as high as 24 pounds per square inch.

With the advent of these new styles, including barbed hooks for permanent bonds, it's just a matter of time before some rather unusual materials are joined by Velcro™. One car manufacturer has built a demonstration car in which the fenders are attached by Velcro™ hooks molded in Zytel nylon.

Product: **Extension cord storage case**
Client: **Noma Inc.**
Designer: **B&B Design Assoc./ Bert Bobrovniczky**
Processes: **Injection molding; structural foam**

The outdoor extension cord storage case (left) is molded with HDPE low-pressure structural foam for strength and impact resistance. The reel is injection molded and carries four grounded power outlets. All elements meet the design goals of a safe, economical unit. All parts of the indoor model (right) are injection molded with flame-retardant grade ABS. The product won the 1981 Design Canada Award for Product Excellence.

▲ Product: **Helmate**
 Client: **Acorn Products Company**
Designers: **Cleminshaw Design Group/
 Doug Cleminshaw;
 Acorn Products Company/
 John Thayer**
Process: **Injection molding**
Materials: **ST nylon; polycarbonate**
Molder: **Acorn Products Company**

The Helmate accessory band keeps a fireman's tools organized for instant use. The nylon band, which fastens to a helmet, features slots and molded adjustable wedges to accommodate tools, while polycarbonate carriers hold two alkaline battery-powered lamps.

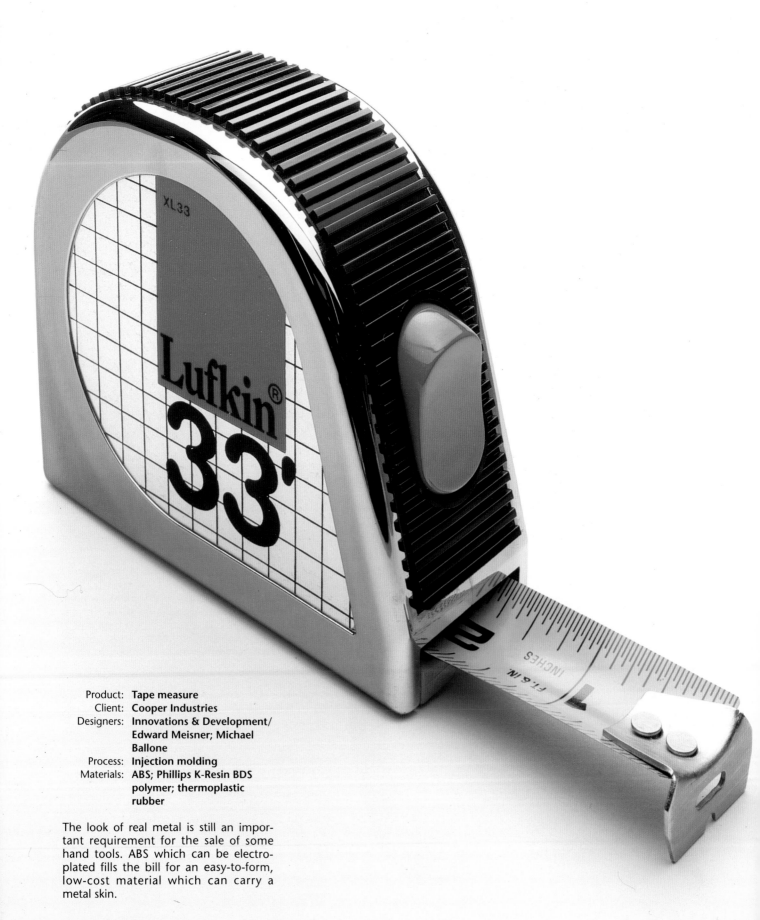

Product: **Tape measure**
Client: **Cooper Industries**
Designers: **Innovations & Development/ Edward Meisner; Michael Ballone**
Process: **Injection molding**
Materials: **ABS; Phillips K-Resin BDS polymer; thermoplastic rubber**

The look of real metal is still an important requirement for the sale of some hand tools. ABS which can be electroplated fills the bill for an easy-to-form, low-cost material which can carry a metal skin.

Product: **PLUM utility marker** ▲
Client: **Communitex Corp.**
Process: **Injection molding**
Materials: **ELVAX ethylene/vinyl copolymer; Delrin acetal**
Molder: **Ram Mold Inc.**

Marking the position of buried utility lines is a tough job: Wooden stakes can be pulled from the ground easily and deteriorate quickly. Metal stakes last longer but can damage the lines they are supposed to mark. These color-coded caps that slide over molded Delrin stakes do the job better. The arrow-shaped stakes offer little resistance when pounded into the ground; however, when they are pulled upward, the fins flare out, making removal very difficult. A snap-on ring supports an extensible mast that can carry a marker flag, while a steel disk permits easy location with a metal detector.

Product: **Brute Trash Can** ▶
Client: **Rubbermaid Inc.**
Designer: **Rubbermaid Inc.**
Process: **Injection molding**
Material: **Dur-X**

Trash containers are generally ignored, but these are especially nice: bright colors, super-tough industrial weight, it stacks, it nests, it has the noticeable draft taper and rounded corners characteristic of injection-molded parts.

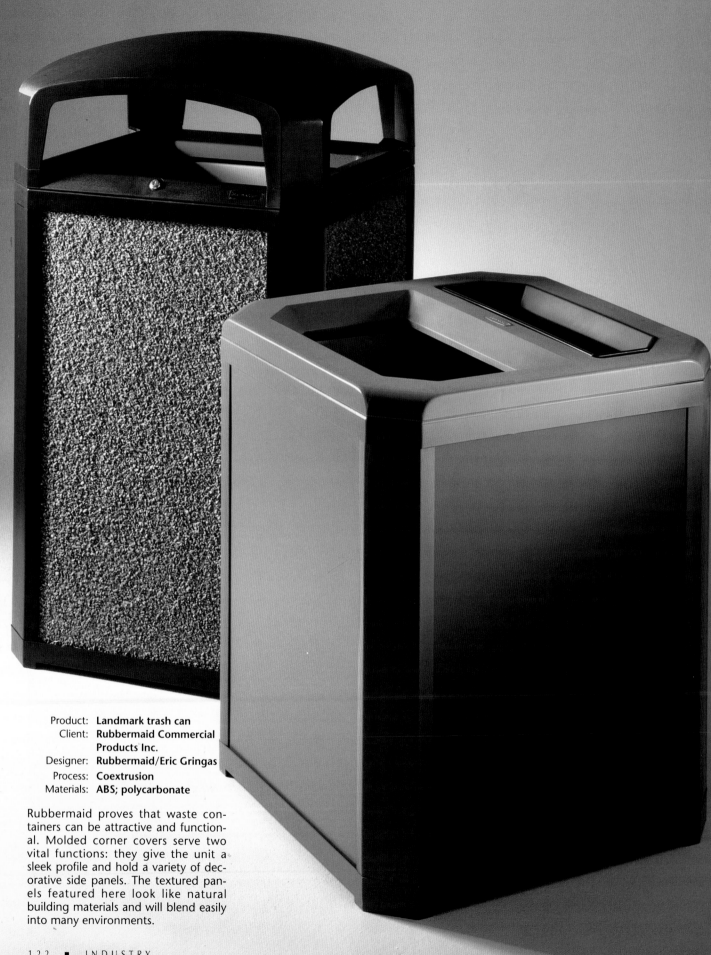

Product: **Landmark trash can**
Client: **Rubbermaid Commercial Products Inc.**
Designer: **Rubbermaid/Eric Gringas**
Process: **Coextrusion**
Materials: **ABS; polycarbonate**

Rubbermaid proves that waste containers can be attractive and functional. Molded corner covers serve two vital functions: they give the unit a sleek profile and hold a variety of decorative side panels. The textured panels featured here look like natural building materials and will blend easily into many environments.

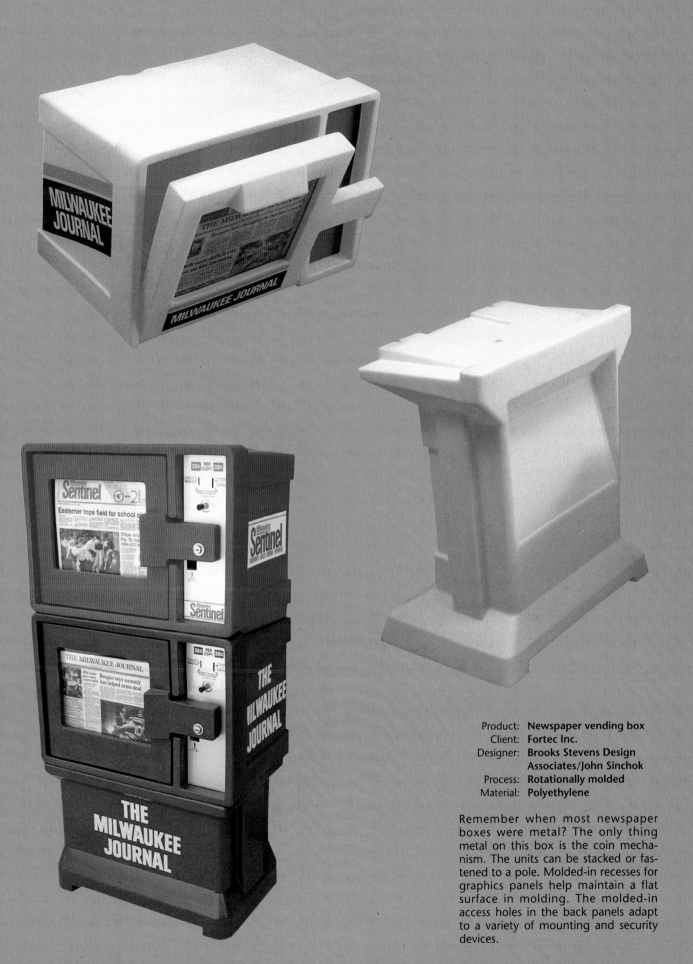

Product: **Newspaper vending box**
Client: **Fortec Inc.**
Designer: **Brooks Stevens Design Associates/John Sinchok**
Process: **Rotationally molded**
Material: **Polyethylene**

Remember when most newspaper boxes were metal? The only thing metal on this box is the coin mechanism. The units can be stacked or fastened to a pole. Molded-in recesses for graphics panels help maintain a flat surface in molding. The molded-in access holes in the back panels adapt to a variety of mounting and security devices.

Product: **Dish dollies and carts**
Client: **InterMetro Industries Corp.**
Designers: **Banko Design/Ron Banko InterMetro Industries/Robert J. Cohn, industrial design; Robert Nattress, engineering**
Process: **Rotomolding**
Materials: **Polyethylene (body); urethane (fill)**

The clean sculptural form of these units has a slightly resilient surface to protect brittle dishes from chipping. The poker-chip style dish dolly encourages personnel to grip the dish with two hands, reducing breakage. Because the units have no crevices for dirt to gather in, they're easy to clean. The plastic is corrosion resistant and won't chip or mar dishes. Plastic dividers on the side-load cart separate dishes and adjust quickly for different applications.

Product: **Omni-Lav**
Client: **The Charles Parker Co.**
Designer: **Henry Robert Kann:
Ind. design consultant**
Processes: **Molded: spray-up initially,
injection projected**
Material: **Owens Corning Fiberglas
with gel coat finish**

Plastics molding was the most efficient and cost-effective way to achieve smooth, rounded corners and edges on this modular lavoratory wall. Designed in response to years of careful research, the unit features a secure place to store personal belongings and divider walls that create a private space for the user while taking up just 18 square feet of wall space per stall.

The use of fiberglass enabled the designers to form the rather deep and narrow "fin" elements. What's more, the material is easy to maintain—a real plus in a public facility.

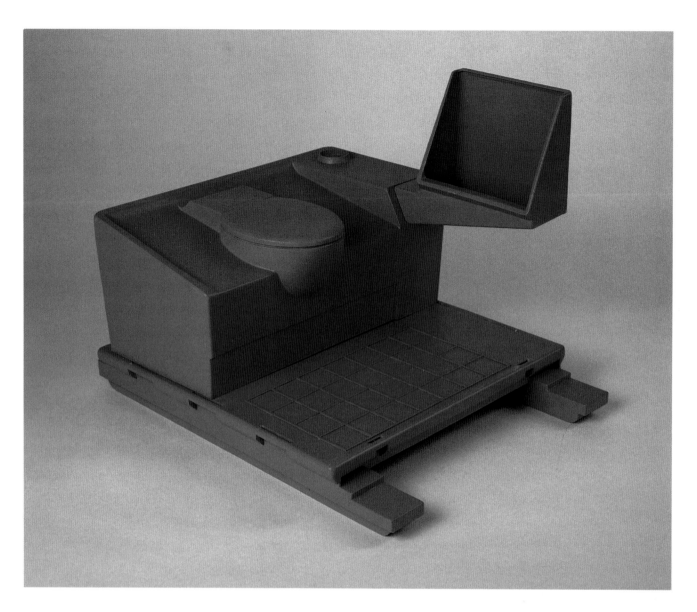

Product: **Portable restroom**
Client: **Synergy III**
Designer: **Polivka Logan Designers**
Processes: **Sheet molding; blow molding; thermoforming**
Materials: **Polyethylene; high-density polyethylene; sheet-molding compound**

The first all-plastic portable restroom, Synergy III exploits the inherent ease of cleaning of its materials. Using a variety of techniques, the units can be produced in modular fashion, the pieces assembling into two main components—base/toilet/pallet and stall. Despite the strictly practical application, the designers have allowed themselves a little post-modern license, utilizing the receptivity of the thermoformed sheets used for the stall panels to mold in decorative designs.

▲ Product: **Advantage Voting Machine**
Client: **Sequoia Pacific Systems**
Designers: **Bleck Design Group/Jim Bleck; Scott Wakefield; John Thrailkill; Steve Wagner**
Processes: **Injection molding; blow molding; structural foam molding**
Materials: **ABS; polyphenylene oxide**

Making the world more convenient for democracy, this fold-away voting machine is a vast improvement over the monstrous metal cabinets commonly used in the exercise of universal suffrage. Adapting the tooling and materials used in the construction of computers, the designers have made these booths very light in weight. And, with their articulated parts, they can be easily folded, making the job of distributing and picking up voting booths a lot less strenuous on election day.

The blow-molded main electronic panel forms both the internal chassis for mounting electronics and the external skin. Legs of structural foam provide enclosed paths for routing power and data cables. Within the modest tooling budget, no process other than blow molding could make fold-out panels of this size with the stiffness required and without unnecessary weight.

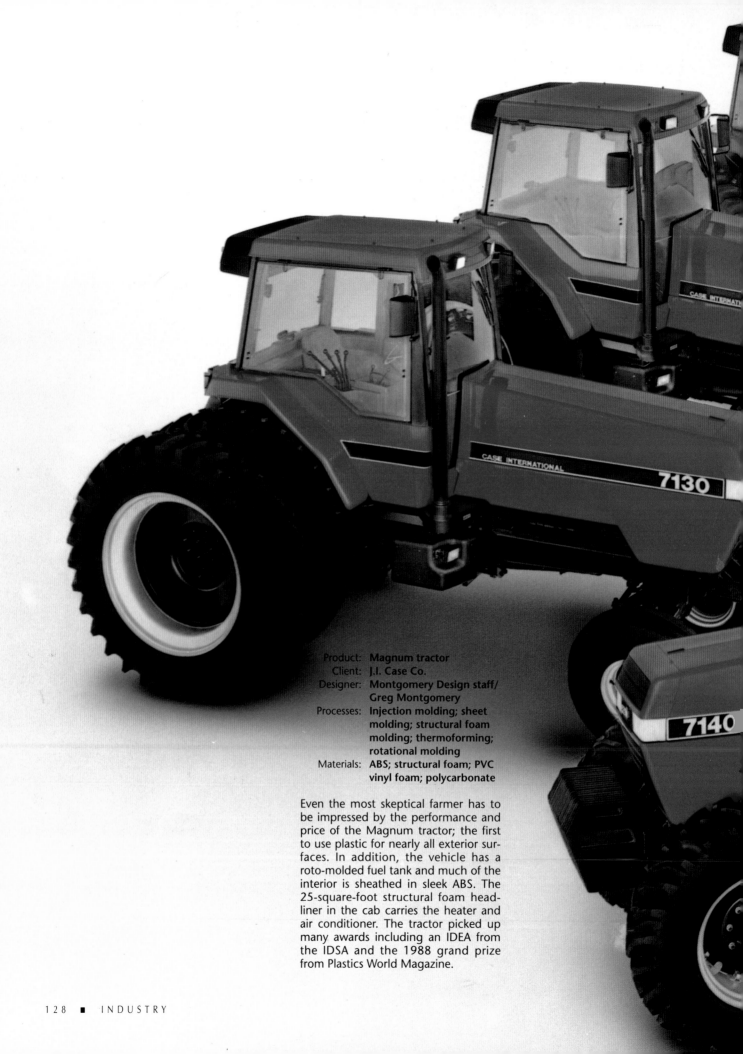

Product: **Magnum tractor**
Client: **J.I. Case Co.**
Designer: **Montgomery Design staff/ Greg Montgomery**
Processes: **Injection molding; sheet molding; structural foam molding; thermoforming; rotational molding**
Materials: **ABS; structural foam; PVC vinyl foam; polycarbonate**

Even the most skeptical farmer has to be impressed by the performance and price of the Magnum tractor; the first to use plastic for nearly all exterior surfaces. In addition, the vehicle has a roto-molded fuel tank and much of the interior is sheathed in sleek ABS. The 25-square-foot structural foam headliner in the cab carries the heater and air conditioner. The tractor picked up many awards including an IDEA from the IDSA and the 1988 grand prize from Plastics World Magazine.

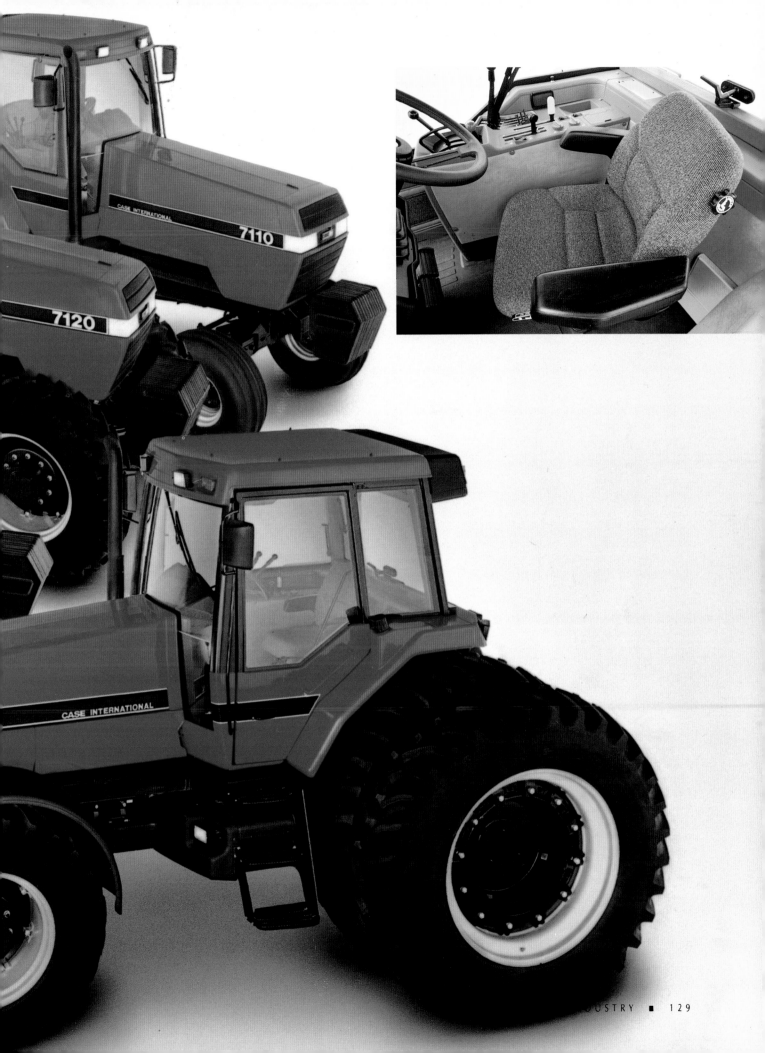

THE HOME

People have been designing objects utilizing plastics for a very small and recent fraction of the time humans have populated this planet.

Other materials such as wood, ceramic, metals, glass and textiles have a long tradition as raw ingredients. Human beings have explored their potential for millennia; the objects created by our forebearers and the precedents set by their individual refinements to the use and manipulation of these materials has given us a collective cultural wellspring, an intuitive sense of each material's intrinsic nature. This knowledge, whether codified or intuitive, is part of our collective unconscious as designers, artists and ultimately, as consumers. As designers, we have also inherited a basic understanding of the "soul" of each of these historically noble materials; an intuitive sense for the emotional and sensual qualities associated with their physical properties and, ultimately, the function of the objects they constitute.

But what of plastics? What, if anything, constitutes a collective and intuitive sense of what constitutes "plasticity?" The understanding of the intrinsic nature of plastics has little historical precedent in the designer's collective cultural experience. Nevertheless, the designer is expected to assist in developing a multitude of objects utilizing this material. Objects which can either contribute to the quality of life or litter the landscape.

The outcome depends on the ability of the designer to develop a similarly intuitive understanding of the nature of this new material without the benefit of historical evolution to establish functional and cultural context. To compensate for this historically unique lack of cultural footings, designers must find the connections between the unique properties of the material, its production processes and its intrinsic potential for establishing satisfying emotional connections with the viewer, user and the consumer.

Plastic has rather humble origins as a substitute material, a simulation of more prized natural materials. As with most substitutes, the attempt was often made to reproduce the superficial characteristics of the original in the hope that the consumer would not notice the difference. Of course, the fact that the physical properties and production process of this new material were quite different from the material it was meant to simulate doomed most such efforts. Worst of all, people came to categorize plastic by those properties in which they were inferior to the materials they were attempting to simulate, rather than appreciating their different and often superior properties.

The unsatisfactory results were not because the material is intrinsically inferior, but because its form and intended function did not coincide with its unique physical properties. In these cases, the user is initially deceived, when seeing the object from a distance, into expecting characteristics which cannot be reproduced by the plastic when the object is actually handled and used.

The same product, if it had expressed its plasticity from the start, and if its forms and functions maximized all of the positive aspects of the material, would not have established false expectations which could only be followed by vaguely unsatisfactory performance.

So, if history provides no valid roadmap to emulate, and if surface simulation has proved to be a dead end, how do we proceed in a search for the intrinsic truth and beauty of plastics?

First, is the designer's concern for the conformance of the user's sensory experience with the object's functional performance. The second, which assumes that the former issues are well in hand, requires consummate wit and artistry and is the conscious decision to be playful and to parody without attempting to deceive.

The process begins with judicious selection, and at times rejection, of a specific plastic as an appropriate material for the object to be designed. Plastic can make a wonderful razor handle but a terrible razor blade.

This fundamental decision of appropriate selection must be followed by a deep understanding of the material, what our collective intuition associates with it, and what actually happens to it within the confines of the molding tool or forming process.

We know, for example, that plastic, although at times it's machined or used as a thin veneer to cover other materials, is ideally suited to be formed. The very name, plastic, means capable of being molded or modeled; capable of being deformed continuously and permanently in any direction. It is synonymous with pliable, ductile, malleable and adaptable. These are both tactile and sculptural qualities which need to be emphasized in the form and technical characteristics which must be facilitated in the forming process.

The material is fluid and, as will all fluids, it prefers to flow around curves and radii, and prefers to avoid sharp turns. This is true whether the material is injected or poured in a liquid state, or whether it is deformed from a semi-solid sheet. As with all liquids, plastic is subject to surface tensions and differential cooling, invisible forces which become locked in as stress patterns in the resultant solid shape. Large planar surfaces and sharp angles fight against such intrinsic physical forces. Articulated surfaces which both physically and visually, fluidly integrate transition details between planes help reduce the negative effect of these forces.

Ribbing can be added to assist in the flow of molten material and, if honestly and sensitively orchestrated, such stiffening ribs can become visual manifestations of the structural dynamics of the object.

Once the nature of the material is understood, the process must be extended to include an understanding of the often subtle interactive relationships between the plastic object, its mechanical performance and its perceptual points of contact with the user.

The goal is to synthesize the object's functional essence, the selected constituent material's strength and limitations, and the need to meet the user's sensory and cultural expectations. This synthesis goes beyond the manipulation of abstract visual form and may include the introduction of visual symbolic archetypes. All while considering all of the other sensual perceptions the user will experience in contact with that object.

In other words, the designer must not focus only on the most obvious questions such as how can the design conform to ergonomic parameters? How should it work? And what could it look like? Rather, the designer must realize that the object will be experienced at various levels and that each succeeding level must conform or purposely contrast with the expectations created by the former. The visual perception of the object at a distance is at some point augmented or superseded by tactile perceptions as the object is handled and used. The sounds it makes, its mass and weight, its temperature to the touch, all of the qualities of the object must be in conformance, there must be no disappointing surprises as the user's interaction becomes more intimate.

And most importantly, once this congruence is met, the designer can focus on the potential for art. This can be done in an infinity of ways; by masterfully articulating the plastic's potential through appropriate line, planes, volumes, colors and textures; by adding elements of whimsy and surprise which can play off of the expectations of congruence; by accentuating the plastic nature of the material and contrasting it to other component parts made by utilizing non-plastic materials; by historical, cultural and even anatomical allegory.

The Fiskars scissors, for example, reflect the fact that steel remains the best material for making a long-lasting cutting edge but that plastic is a far superior material to conform to the human hand. From a distance, the nature of the two materials is evident. The metal blades are flat, their cutting edges are ground and honed; while the handles reflect both the shape of the hand and the fluid quality of the molten plastic. The coldness of the metal is contrasted with the warmth of the plastic, a characteristic further reinforced by the warm color of the handles. The hand is invited to slip into the handles and is discouraged from touching the stainless steel cutting edges. As the hand grips the scissors, the metal provides a satisfying feeling of mass while the plastic reduces the overall weight. No edges of the mold parting lines are felt and finger pressure is evenly distributed over the sculptural surfaces of the handles. The monolithic construction of the handles firmly grips the metal blade inserts, there are no thin plastic sections to flex and rub against each other.

The characteristics of all materials are emphasized, and as the user becomes more intimate in their contact with the object, their initial expectations are reinforced through congruent detailing.

Form, function and fantasy are not mutually exclusive.

—*Gianfranco Zaccai*

Product: **Cuisinart kitchen appliances**
Client: **Cuisinarts Inc.**
Designer: **Marc Harrison Associates/**
Marc Harrison
Process: **Injection molding**

A clean, simple design is the trademark the Cuisinart line of kitchen appliances. The items featured here are made of a various resins injection molded into simple geometric shapes. (Can you imagine a food processor designed with a lot of cracks and crevices? It would be a nightmare to clean).

Designer Marc Harrison has made the appliances look uncomplicated and user-friendly by minimizing unnecessary design details. But inside, each unit—be it the high-powered Little Pro Food Processor (bottom right) or the compact Mini-mate chopper/grinder (top right)—is a complex machine.

All Cuisinart products, including the scale (top) and pasta machine (right) are known for their durable construction, even though some parts, such as the plastic pasta machine attachments, get quite a workout in a busy kitchen. The products are so tough, in fact, that they're the appliances of choice in many professional kitchens.

Product: **Coffee/tea/sugar dipenser** ▶
Client: **Merryware Industries Ltd.**
Designer: **Peter Haythornthwaite Design Ltd./Peter Haythornthwaite**
Process: **Injection molding**
Materials: **ABS; SAN; polypropylene**

Peter Haythornthwaite achieved several technical innovations in the design of this dispenser in an effort to make the unit easy to take apart. The hopper locks onto the body via a bayonet lock. To assemble, simply snap the two body halves together. The entire unit can be dissassembled in just 15 seconds!

Product: **Food dehydrator** ▶
Client: **Alternative Pioneering Systems Inc.**
Designer: **Worrell Design Inc.**
Process: **Injection molding**
Material: **ABS**

When identical parts are used in multiples, like the circular modular stacking trays of this dehydrator, injection molding is the most efficient production process. In this case, the manufacturer was able to both amortize his tooling costs over several product line extensions and boost after-market sales and profits.

Product: **Fast Touch coffee mill**
Client: **Krups**

Coffee mills are a byproduct of the Eurostyle design movement that took the home appliance industry by storm in the mid-80s. The most striking quality of these units, besides their bold colors, is the sloped base. The transparent cup also appears sloped, but it's not. It fits snugly into the base unit to prevent coffee grounds from shooting all over the kitchen.

Product: **Cordless hand mixer**
Client: **Krups**

It's hard to decide which is the better quality of this three-speed mixer: the sleek white ergonomically-designed base or the fact that the designers sculpted one hole in the base unit to accommodate a variety of beaters. Sure, other portable mixers are engineered in the same way. But this design is different. It's so attractive, that consumers won't want to stash the appliance in some dark cabinet.

▼

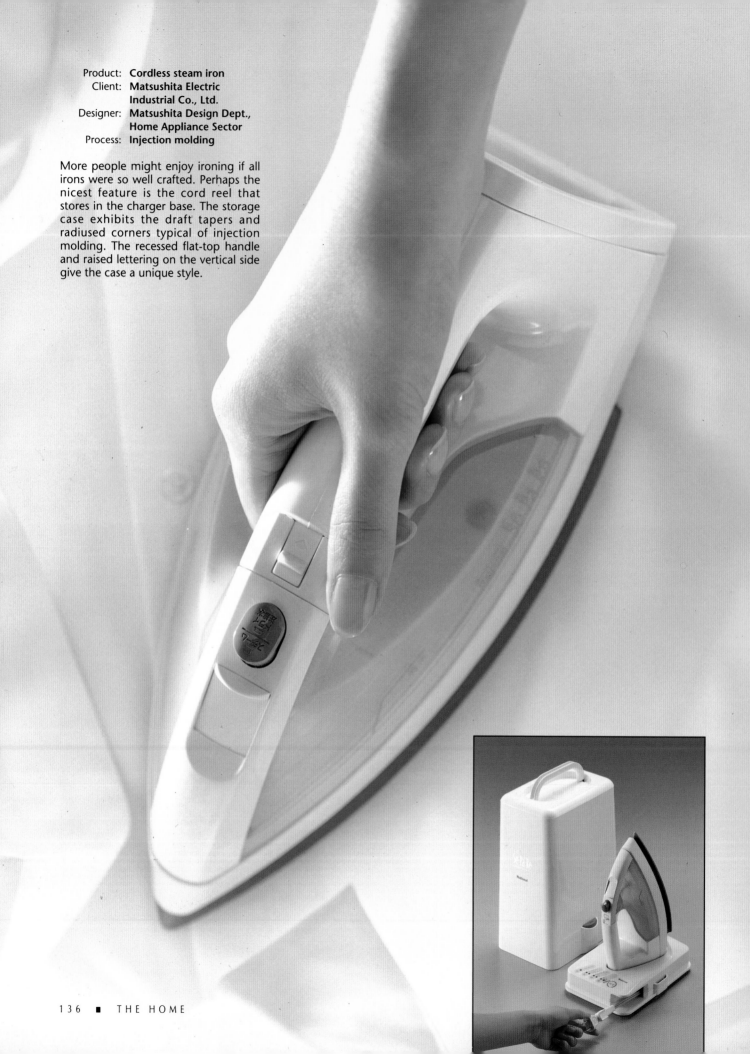

Product: **Cordless steam iron**
Client: **Matsushita Electric Industrial Co., Ltd.**
Designer: **Matsushita Design Dept., Home Appliance Sector**
Process: **Injection molding**

More people might enjoy ironing if all irons were so well crafted. Perhaps the nicest feature is the cord reel that stores in the charger base. The storage case exhibits the draft tapers and radiused corners typical of injection molding. The recessed flat-top handle and raised lettering on the vertical side give the case a unique style.

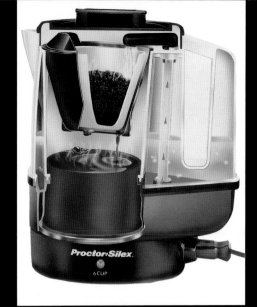

Product: **Li'l Drip coffeemaker**
Client: **WearEver-Proctor Silex Inc.**
Designers: **WearEver-Proctor Silex/
Donald C. Grome; Terry
L. Myers. Ryan Design/
Thomas Ryan**
Processes: **Injection molding; com-
pression molding; roll-
formed warmer plate**
Materials: **Polypropylene; phenolic;
stainless steel**

This design required that two contain-
ers, one fully enclosed within the
other, be injection molded and joined
in one piece. The outer compartment
is the cold water reservoir while the
inner vessel is the carafe for hot
brewed coffee. A look at the cross sec-
tion suggests that neither the concept
for space usage nor the technical
achievements are trivial.

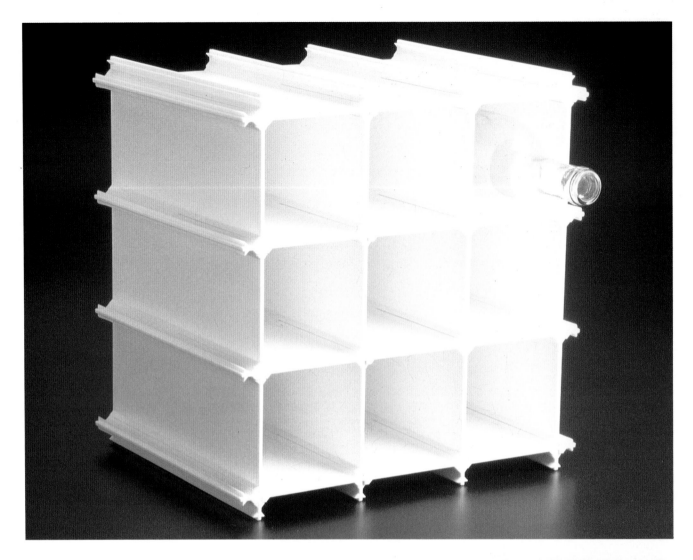

Product: **Wine rack**
Client: **Crown Corning**
Designer: **William Prindle Design/ William Prindle**
Process: **Injection molding**
Material: **High-impact polystyrene**

Designed to ship knocked-down, this wine rack slips together easily to hold 12 bottles. The rack is formed of eight identical modular pieces made in a simple flat-parting mold. Racks can be joined with molded clips and stacked either vertically or horizontally to create a storage system for many bottles.

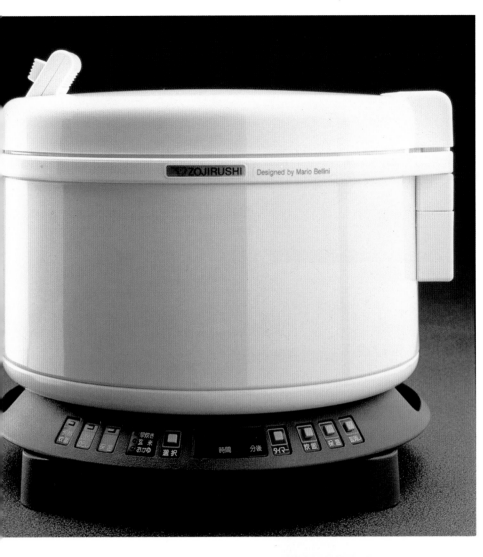

Product: **Automatic rice cooker**
Client: **Zojirushi Corp.**
Designers: **Design Continuum Inc./Mario Bellini; Dario Bellini**
Process: **Injection molding**
Material: **Polypropylene**

The ability of injection-molded polypropylene to take a rich, mirror-like finish makes this electric pot elegant enough to be carried direct to the dining or serving table instead of being hidden in the kitchen.

Product: **Hot water dispenser**
Client: **Zojirushi Corp.**
Designers: **Design Continuum Inc. / Mario Bellini; Dario Bellini**
Process: **Injection molding**
Material: **Polypropylene**

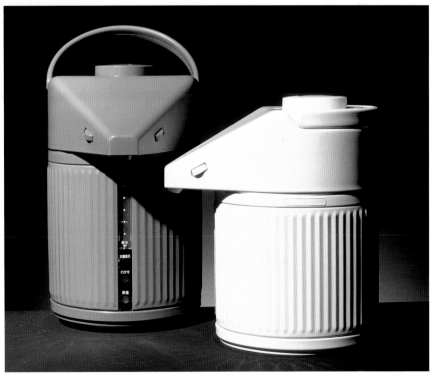

While the business part of this appliance—the hot water pot—is stainless steel, that fact has been disguised by a coating of resin colored to match the all-plastic dispenser assembly on top.

Product: **Pasta tongs**
Client: **Crown Corning**
Designer: **William Prindle Design/
William Prindle**
Process: **Injection molding; sonic
welded locking stud**
Material: **ABS**

Now here's an novel approach to the old-style pasta tong: They can be used separately, one tong in each hand, or together as spring tongs. The pieces snap apart easily and can be nested for easy storage.

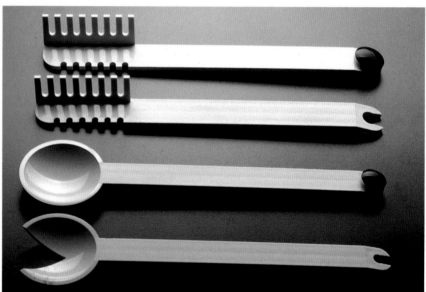

Product: **Kitchen timer**
Client: **Wilton Enterprises/
Copco Division**
Designer: **Herbst LaZar Bell Inc./
Randall Bell**
Process: **Injection molding**
Material: **Polystyrene**

Kitchen timers come in a lot of shapes and sizes. The Copco timer is square—a very practical shape—and is manufactured with a minimum number of parts to streamline production and make cleanup easy. The injection-molded knob is sandwiched between two halves of polystyrene, which are welded together chemically. Designer Randall Bell added another nice touch by kiss-printing the Copco name and time indicator line on raised lettering.

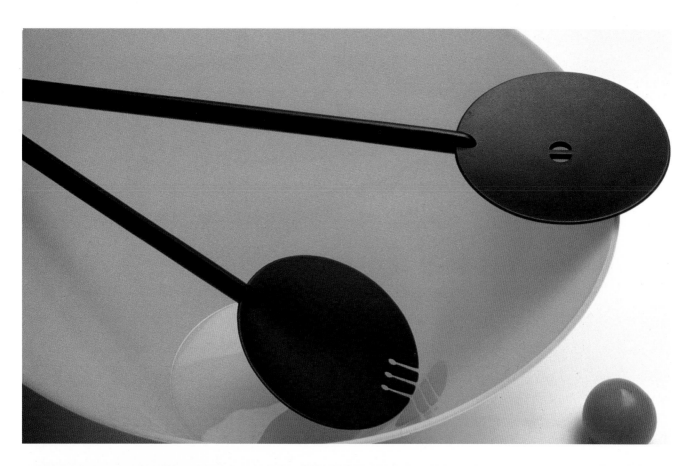

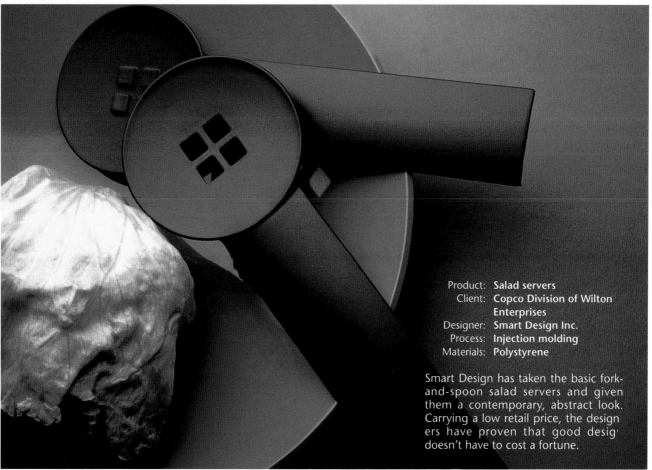

Product: **Salad servers**
Client: **Copco Division of Wilton Enterprises**
Designer: **Smart Design Inc.**
Process: **Injection molding**
Materials: **Polystyrene**

Smart Design has taken the basic fork-and-spoon salad servers and given them a contemporary, abstract look. Carrying a low retail price, the designers have proven that good design doesn't have to cost a fortune.

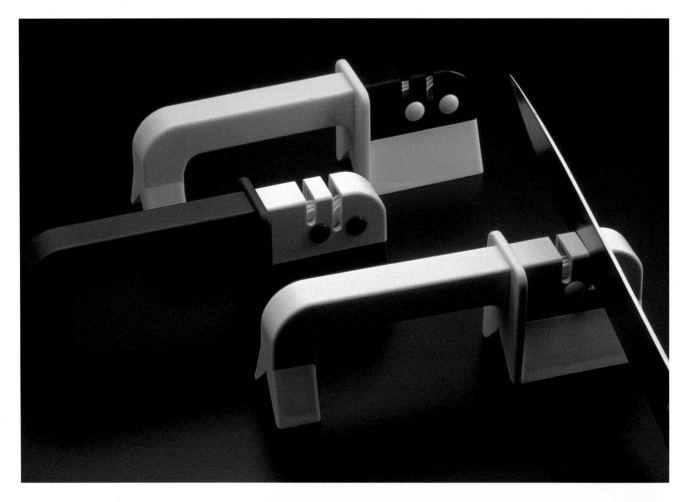

Product: **Knife sharpener** ▲
Client: **Crown Corning**
Designer: **William Prindle Design/
William Prindle**
Materials: **High-impact polystyrene;
ceramic wheels**

Two small ceramic wheels—excellent
sharpening devices—are nestled into
the molded handles of this knife sharp-
ener. Another nice design feature: The
large handle, molded of polystyrene,
can be gripped with either the left or
right hand, a plus for southpaws.

Product: **Funnel set with strainer** ▶
Client: **Crown Corning**
Designer: **William Prindle Design/
William Prindle**
Process: **Injection molding**
Material: **Polypropylene**

What could be more appealing than a
shiny bright red set of plastic funnels
that nest together for easy storage and
are dishwasher safe? As an added
bonus, William Prindle Design has used
a strainer to contain the various pieces
of these eye-catching kitchen acces-
sories.

Product:	**Microwave containers**
Client:	**Rubbermaid Inc.**
Designers:	**Innovations & Development Inc./Michael Ballone; Roland Charriez; Edward Meisner. Rubbermaid Inc./Joseph F. Fiore**
Processes:	**Injection molding; compression molding**
Materials:	**Fiberglass-reinforced polyester; low-density polyethylene**

Rubbermaid's Microwave Servin' Saver 400° containers go from freezer to a microwave or conventional oven without cracking. The color compounds that are incorporated into the fiberglass-reinforced polyester base retain their color under high temperatures. The low-density polyethylene used for the lid creates a tight seal and is transparent enough for the user to see the contents of the container.

Product: **Bouncer beverage set** ▲
Client: **Rubbermaid Commercial
Products Inc.**
Process: **Injection molding**
Material: **Polycarbonate**

Rubbermaid achieved extreme thickness in critical parts of the mold for these glasses and pitchers (especially where the handles meet the sidewalls) without trapping air bubbles that would degrade both the appearance and the structural strength.

Product: **Spatulas** ▶
Client: **Merryware Industries Ltd.**
Designer: **Peter Haythornthwaite
Design Ltd./Peter
Haythornthwaite**
Process: **Injection molding**
Materials: **Polypropylene;
thermoplastic rubber**

Gourmands may favor wooden cooking tools, but there's no better way to scrape batter from a mixing bowl than with a plastic spatula. The brightly-colored handles lock into the rubber blade to keep it secure.

Product: **Melamine dinnerware**
Client: **Copco Division of Wilton Enterprises**
Designer: **Smart Design Inc.**
Process: **Compression molding**
Material: **Melamine**

When melamine dishes were first intro-
duced in the 1960s, avocado green
and harvest gold were the rage. How
things have changed. Smart Design
used solid colors and in-mold patterns
so that consumers could mix and
match several sets. Since melamine is
dishwasher safe, they made sure that

Product: **Tableware**
Client: **Ingrid Division of Sevko Inc.**
Designers: **Innovations & Development Inc./Michael Ballone; Edward Meisner; Edward Levy**
Processes: **Injection molding; silk screening**
Materials: **ABS; polystryene**

Festive tableware is a must for any special occasion, and plastic goods are a must for pool-side entertaining. But the bold hues of these plates, goblets and ice buckets would enhance any table setting.

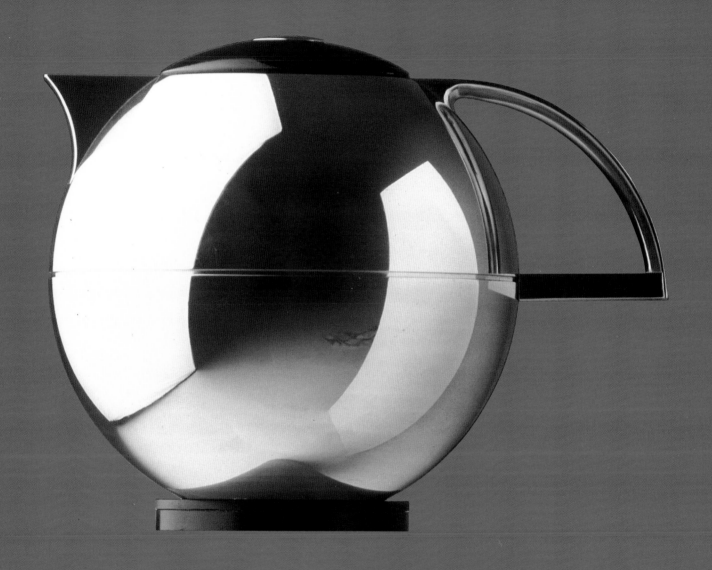

Product: **One-quart round thermal server**
Client: **Crown Corning**
Designer: **William Prindle Design/ William Prindle**
Process: **Injection molding**
Materials: **ABS; polypropylene**

Despite the fact that this thermal server is made of affordable plastic, its contemporary design calls to mind a formal silver tea service or an Art Deco pitcher. Pure class. Crown Corning has named it the Madison Avenue server. Perhaps Park Avenue would be a more appropriate title.

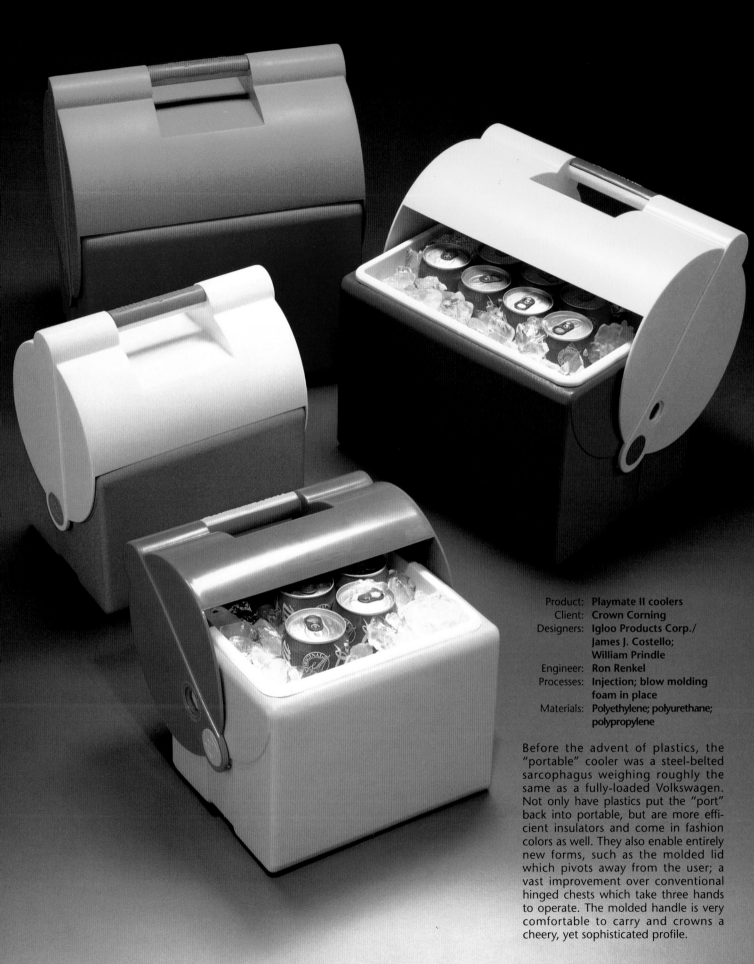

Product: **Playmate II coolers**
Client: **Crown Corning**
Designers: **Igloo Products Corp./**
James J. Costello;
William Prindle
Engineer: **Ron Renkel**
Processes: **Injection; blow molding**
foam in place
Materials: **Polyethylene; polyurethane;**
polypropylene

Before the advent of plastics, the "portable" cooler was a steel-belted sarcophagus weighing roughly the same as a fully-loaded Volkswagen. Not only have plastics put the "port" back into portable, but are more efficient insulators and come in fashion colors as well. They also enable entirely new forms, such as the molded lid which pivots away from the user; a vast improvement over conventional hinged chests which take three hands to operate. The molded handle is very comfortable to carry and crowns a cheery, yet sophisticated profile.

Product: **Serengetti Sunglasses**
Client: **Corning Glass Works**
Designer: **Smart Design Inc.**
Process: **Milling**
Material: **Laminated cellulose acetate blocks**

This sunglass collection was developed around special "block" materials produced by Mazzucchelli, SA, one of the oldest plastics companies in the world. Mazzucchelli started its business in the 1920s, producing plastic tortoise shell material for combs and brushes.

Each frame style was designed to encompass a base color with inlay sections. The collection utilizes plastics which range from patterns resembling stone or agate to iridescent foils and metals.

Here is a very exciting and different effect in plastics: controlled geometric patterns in full-through color, in contrast to the now-familiar monochrome or swirling-flow multi-color effects.

GOLDSTAR

The 1988 Summer Olympic Games, held in Korea, prompted Korean manufacturer Goldstar to commission a set of travel accessories that would commemorate the event. Taking the five interlocking rings of the Olympic logotype as the theme, designer An Kyu Sung used extensive computer-aided analysis to optimize the fit of the rounded shapes to the human hand. Five products are included: a shaver, hair dryer, alarm clock, clothes iron and dual-voltage electrical adapter.

While using rounded cases for a clock and shaver may seem somewhat obvious, Kyu Sung ingeniously adapted the mechanisms of the hair dryer and iron, creating an unexpected but completely appropriate new visual form for these items.

The resulting accessories almost qualify as portable, hand-sized sculpture. The Nautilus-like form of the iron and hair dryer and clam-shell cases of the shaver and voltage adapters echo the shape of familiar marine mollusks. The lightly-textured exterior warms quickly to the touch, providing a welcome tactile relief from the cold, slick, high-density surface commonly found on personal grooming items.

The five accessories come packaged in a low-profile molded rectangular carrying case designed to fit easily into the rounded corners of either soft or hard shell luggage.

Product: **Travel accessories**
Client: **Goldstar Co. Ltd.**
Designer: **An Kyu Sung**
Process: **Injection molding**

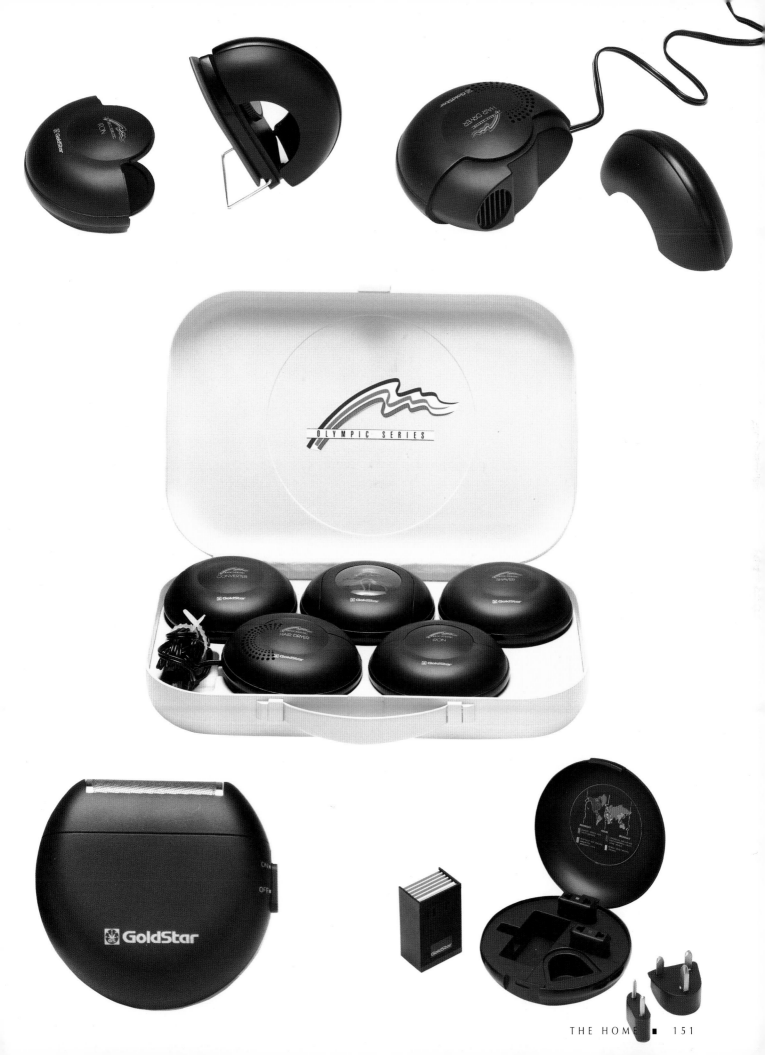

Product: **Universal remote control**
Client: **CL-9**
Designer: **Interform/Peter H. Muller**
Process: **Injection molding**
Material: **ABS**

The assembly is designed as a sandwich using a printed circuit board with dome switches and a keypad molded in one injection. The finished package is a mere five millimeters thick. The keypad incorporates living hinge keys and rockers to give the user appreciable tactile feedback, and the sandwich construction kept the number of parts to a minimum.

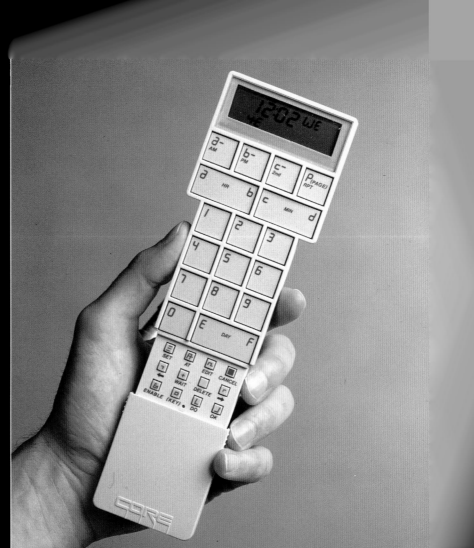

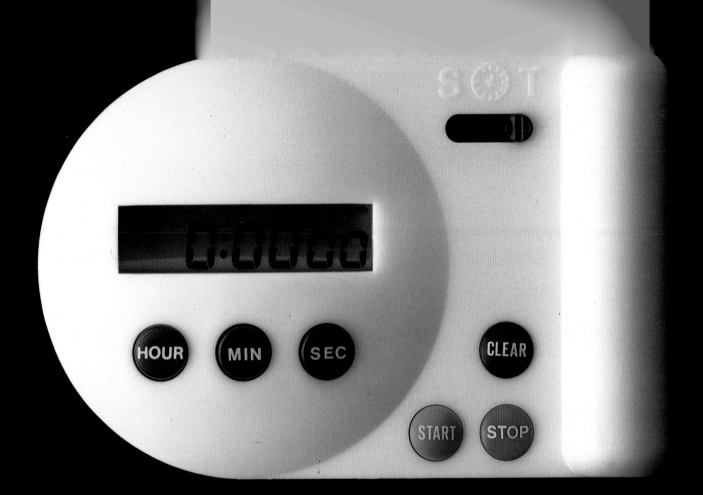

Product: **Timer/clock** ▲
Client: **Crown Corning**
Designer: **William Prindle Design/**
William Prindle
Process: **Injection molding**
Material: **ABS**

William Prindle has taken simple geo-
metric shapes and crafted them into
an incredibly eye-catching kitchen
timer/clock. The circular shape of the
"face" is reminiscent of the old-fash-
oned kitchen wall clock, but it's been
brought into the 90s with brightly col-
ored buttons and an LCD readout.

Product: **Sentry 1100 Fire-Safe™** ▶
security safe
Client: **Sentry Group**
Designer: **Chase Design Inc.**
Process: **Double wall blow molding**
Material: **Polyethylene**

When most people think of a fireproof
safe, they think of a heavy steel unit
with thick walls. Not this product. In a
fire, the exterior of the double wall
blow moldings melts or burns, while
moisture encapsulated in the compos-
te insulation filling is slowly released as
vapor. As the interior walls of the top
and bottom sections soften, they weld
together in an airtight seal to keep
oxygen out, protecting the contents
nside.

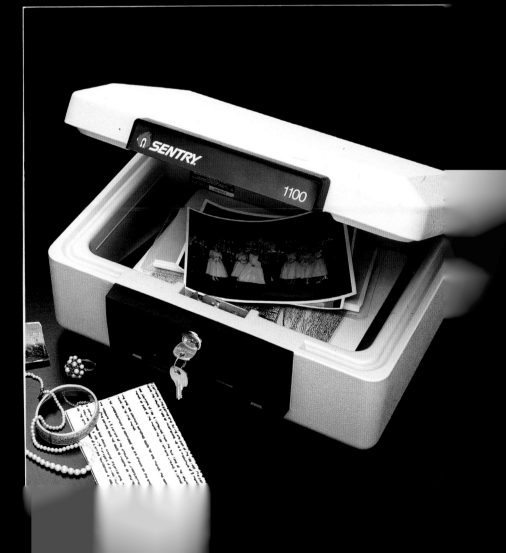

Product: **Emulator III Synthesizer** ▲
Client: **Emu Systems**
Designer: **Lunar Design Inc./
Robert Brunner**
Process: **Injection molding**
Materials: **GE Noryl polyphenylene;
oxide structural foam**

A complete facelift—new color, graph-
ics, panel layout and keycaps, along
with minor tooling modifications to
the existing structural foam enclo-
sure—turned the Emulator II music
synthesizer into this sleek, sophisticat-
ed keyboard package. The tooling was
modified so that material was removed
from the tool and simple inserts were
added, keeping modification costs to a
minimum.

Product: **Television antenna** ◀
Client: **Channelmaster (NZ) Ltd.**
Designer: **Peter Haythornthwaite Design Ltd./Peter Haythornthwaite**
Process: **Injection molding**
Materials: **ABS; nylon**

An attractive alternative to the common "rabbit ears" style of antenna, the geometric lines of the ABS case suggest sophistication and are easy to mold. The round knobs cover adjustable nylon drums which are held in various indexed positions by the springy moldings.

Product: **Headphones** ▶
Client: **Nippon Gakki Co. Ltd.**
Designer: **Yamaha staff**
Process: **Injection molding**
Materials: **DuPont Hytrel polyester elastomer; DuPont Delrin acetal; DuPont Zytel nylon**

The spring-like flexibility of thermoplastic rubber—a hallmark of many plastic resins—is used here to full advantage, replacing the traditional steel springs in this headphone set. Acetal, which is stiff and offers very little friction, works well for the size adjuster, sliding into a sleeve of nylon. The result is a product that's colorful, light, corrosion-proof and looks good in the store and in the consumer's pocket.

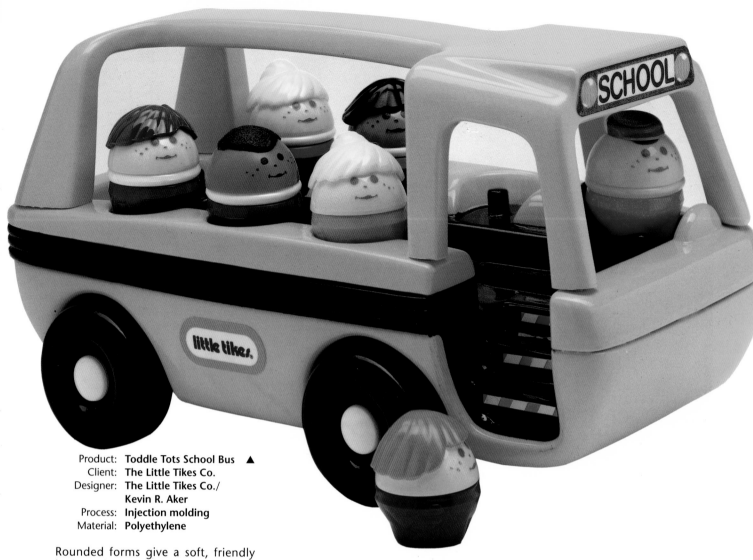

Product: **Toddle Tots School Bus** ▲
Client: **The Little Tikes Co.**
Designer: **The Little Tikes Co./**
Kevin R. Aker
Process: **Injection molding**
Material: **Polyethylene**

Rounded forms give a soft, friendly
look to this toy schoolbus. There's a
molded-in well to hold each of the
"children," a door for going in and out
and a carrying handle molded right
into the top.

Product: **Sure grip safety gate** ▶
Client: **Fisher-Price Div. of**
Quaker Oats Co.
Designer: **Fisher-Price staff**
Process: **Injection molding**

Large injection moldings provided this
one-step solution to the problem of
keeping toddlers away from stairs and
other hazards. The safety gate has a
lock mechanism that can be opened or
closed with one hand, allowing adults
to keep a firm grip on baby while
entering or exiting.

◄ Product: **Port-A-Care Table**
Client: **The Little Tikes Co.**
Designer: **The Little Tikes Co./**
Robert L. Houry
Process: **Rotational molding**
Materials: **Polyethylene; PVC**

This portable device turns any flat surface into a convenient changing table. Extra diapers, powder, wipes and other supplies store neatly in the drawer underneath. The mattress drops into the molded hollow and a safety belt keeps the baby from rolling off the table while mom has her hands full.

Product: **Hide-away cupboard** ►
Client: **The Little Tikes Co.**
Designer: **The Little Tikes Co./**
Robert L. Houry
Process: **Blow molding**
Materials: **Polyethylene; polyurethane**
foam

Sized to hold anything up to phonograph records and stereos, this furniture is designed to be used for household storage long after the child has grown up and moved out. A recess in the top of the cupboard is sized to hold the portable changing table shown above.

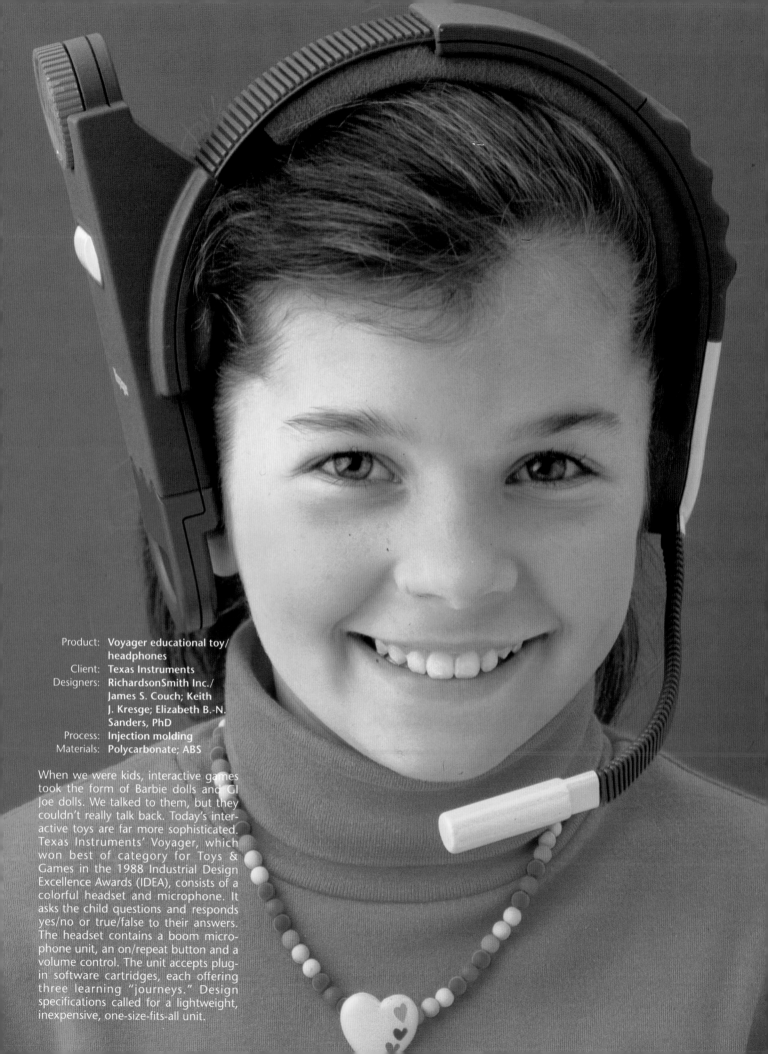

Product: **Voyager educational toy/ headphones**
Client: **Texas Instruments**
Designers: **RichardsonSmith Inc./ James S. Couch; Keith J. Kresge; Elizabeth B.-N. Sanders, PhD**
Process: **Injection molding**
Materials: **Polycarbonate; ABS**

When we were kids, interactive games took the form of Barbie dolls and GI Joe dolls. We talked to them, but they couldn't really talk back. Today's inter- active toys are far more sophisticated. Texas Instruments' Voyager, which won best of category for Toys & Games in the 1988 Industrial Design Excellence Awards (IDEA), consists of a colorful headset and microphone. It asks the child questions and responds yes/no or true/false to their answers. The headset contains a boom micro- phone unit, an on/repeat button and a volume control. The unit accepts plug- in software cartridges, each offering three learning "journeys." Design specifications called for a lightweight, inexpensive, one-size-fits-all unit.

Product: **Compact disc file case** ▲
Client: **Shape Inc.**
Designers: **Shape Inc./Anthony Gelardi; Craig Lovecky; Alan Lowry**
Process: **Injection molding**
Materials: **ABS; polycarbonate; cellulose acetate**

Compact discs (CDs) are usually packed in individual "jewel boxes." The Portofino, which is just five inches square, holds 12 CDs in the space needed for just four boxes. The discs slip into flexible acetate spring levers which keep the CDs separated and flip them out of the case for easy handling.

Product: **Child's table** ▶
Client: **Rubbermaid Inc.**
Process: **Injection molding**
Material: **Expanded copolymer polypropylene**

If parents can have a home office setup, it stands to reason that children should have their own special work station too. This one features four pencil/crayon trays molded into the tabletop. Additionally, the table legs have been designed so that the hollow portion is on the outside, clearly admitting that this product was molded, rather than coyly hiding the void by turning it inward.

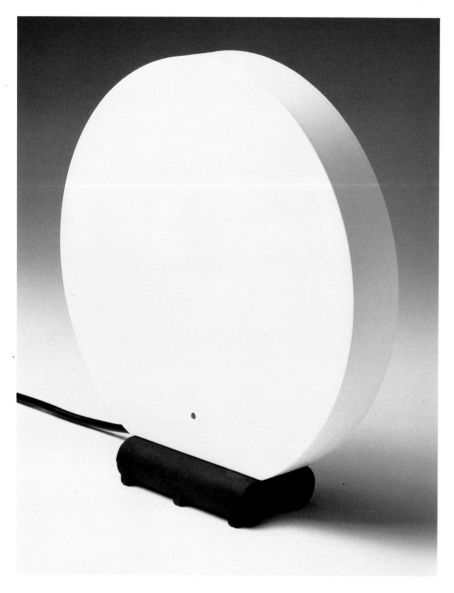

▲ Product: **FM radio antenna**
Client: **Terk Technologies**
Designer: **John Lonczak Design**
Engineer: **Larry Schotz**
Process: **Injection molding**
Materials: **ABS; Santoprene®**

Product: **Portable color television** ▶
Client: **Matsushita Electric Co.**
Designer: **Kyushu Matsushita Electric
Co. Ltd./Design Center**
Process: **Injection molding**

Almost anything would look better than the loops of TV antenna wire commonly used as FM antennas, but this sleek appliance goes beyond just looking better. It looks right at home beside an expensive stereo system or nestled in among the knick-knacks on a bookshelf. Santoprene® was used to give it soft, pliable feet that won't mar fine furniture.

With a shape more suggestive of an electric razor than a conventional television set, the soft, amorphous curves of the molded case are a visual invitation to pick this up and carry it anywhere. The designers have also done the sensible thing, ganging the controls together on top of the set where non-technically adept users can find—and fiddle with them—unencumbered by access doors or deeply recessed knobs.

piedra 8

personal visual life for you.

Panasonic

Power
CH — On

TV/Color Looming

Search
Skip/Slow

Channel Call

VHF
UHF
—

Volume
+

<
Channel
>

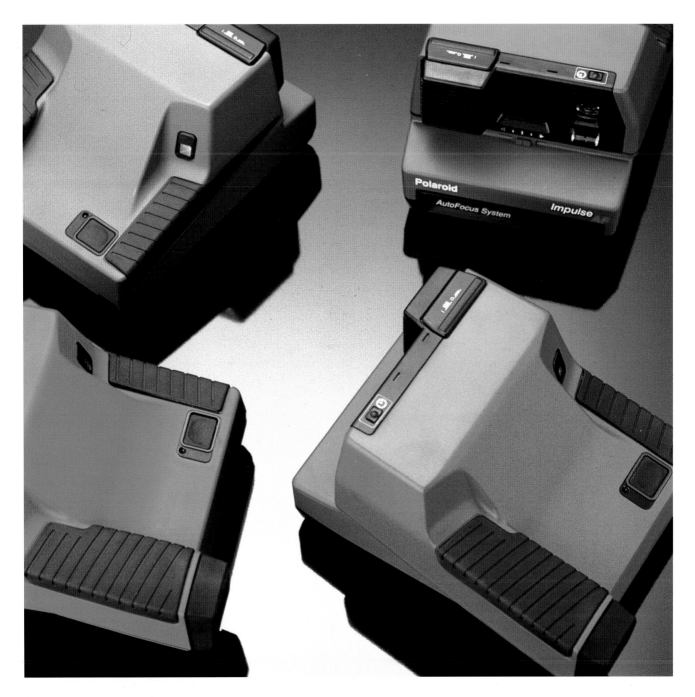

◄ Product: **Stacking chairs**
 Client: **Rubbermaid Inc.**
 Process: **Injection molding**
 Material: **Expanded co-polymer**
 polypropylene

Plastic chairs are among the most popular outdoor accessories. They're attractive, they won't yellow and they won't rust. Rubbermaid's version features gentle flowing curves that beckon the user to sit—in comfort—on this durable, stacking chair.

▲ Product: **Impulse camera**
 Client: **Polaroid Corp.**
 Designers: **Henry Dreyfuss Associates/**
 James M. Ryan; John H.
 Betts
 Process: **Injection molding**
 Materials: **Polyphenylene oxide;**
 thermoplastic rubber; LIM
 silicone

Henry Dreyfuss Associates chose thermoplastic resins to wrap the revolutionary innards of Polaroid's Spectra cameras. Assembly is all snap-fit with no screws at all; in fact, the pull-up viewfinder assembly—which contains four lenses and four mirrors—is put together by robots.

Product: **Mini Mite**
Client: **The Eureka Co.**
Designers: **The Eureka Co./Joyce K. Thomas; Samuel E. Hohulin**
Process: **Injection molding**
Materials: **ABS; polypropylene; styrene; PVC; textured nylon**

Not only does a handheld vacuum have to be lightweight and easy to use, it has to look the part. Various resins were injected molded to create the smooth contours of the case. The angled nose of the vacuum—protected by a black tip that won't show dirt—and simplified graphics contribute to the streamlined appearance.

Product: **Auto vacuum**
Client: **Dynamic Classics**
Designer: **Cousins Design/Michael Cousins**
Processes: **Injection molding**

What could be more minimal for a vacuum cleaner than a straight cylinder with a handle on it? The design is as functional as it is pleasing, with a clever hollow tube molded into the body laterally to hold the power cord for neat and convenient storage. ▼

Product: **QuickUp vacuum**
Client: **The Eureka Co.**
Designers: **The Eureka Co./**
Samuel E. Hohulin;
Joyce Thomas
Process: **Injection molding**
Materials: **High impact polystyrene;**
ABS; PVC; textured nylon

The QuickUp was the first cordless/
rechargeable vacuum with a floor noz-
zle and handle for upright use. Women
use vacuums more often than men, so
light weight was a must. The soft con-
tours reflect this bias and make the
product easier to mold as well: Convex
shapes like these resist the tendency of
injection moldings to warp. If any
slight flaws occur, they usually aren't
noticeable.

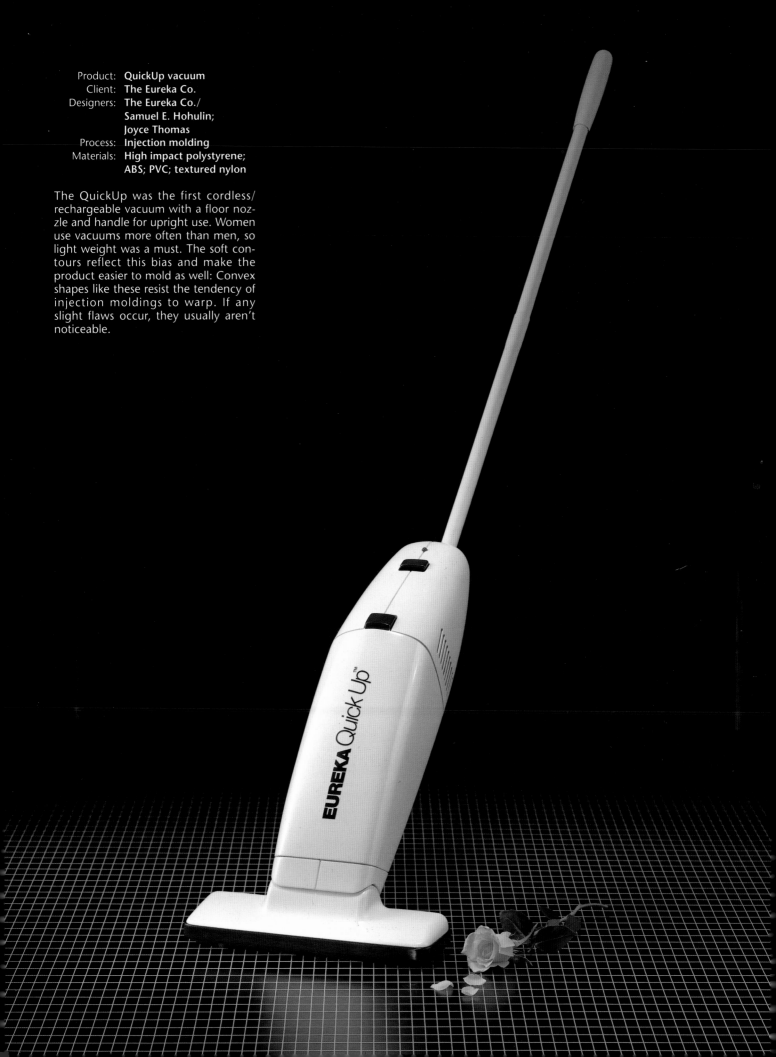

EUREKA *Quick Up* ™

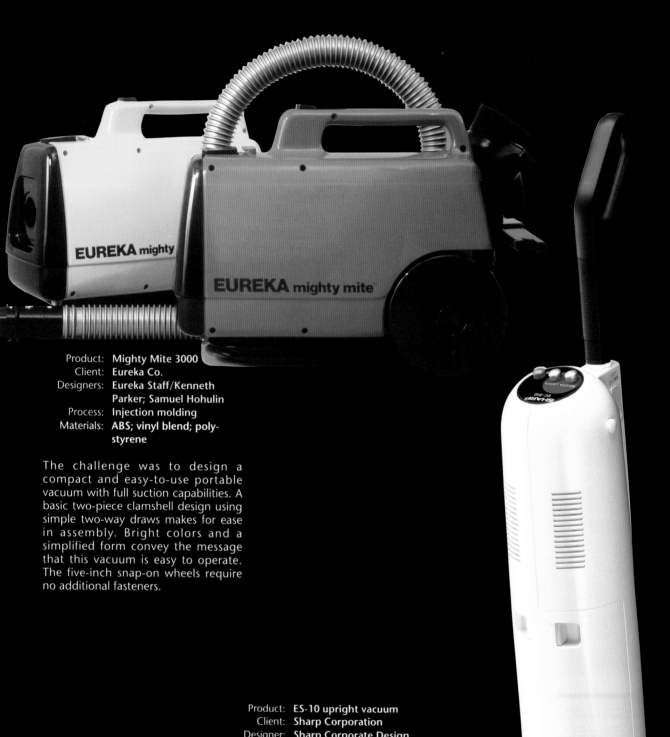

Product: **Mighty Mite 3000**
Client: **Eureka Co.**
Designers: **Eureka Staff/Kenneth Parker; Samuel Hohulin**
Process: **Injection molding**
Materials: **ABS; vinyl blend; poly-styrene**

The challenge was to design a compact and easy-to-use portable vacuum with full suction capabilities. A basic two-piece clamshell design using simple two-way draws makes for ease in assembly. Bright colors and a simplified form convey the message that this vacuum is easy to operate. The five-inch snap-on wheels require no additional fasteners.

Product: **ES-10 upright vacuum**
Client: **Sharp Corporation**
Designer: **Sharp Corporate Design**
Process: **Injection molding**
Materials: **ABS; vinyl blend; polystyrene**

Although upright vacuums are not common in Japan, the design of this model breaks new ground. Instead of the flattened, low-profile case so often seen in American and European machines, this one has a rounded, almost canister-like upper casing.

Product: **Dustbuster XL vacuum**
Client: **Black & Decker**
Designers: **Innovations & Develop-
ment Inc./Michael Ballone;
Roland Charriez; Gary
Grossman; Edward
Meisner; Black & Decker
staff**
Process: **Injection molding**
Materials: **ABS; polypropylene**

The ribbed handle provides a sure grip
when in use, yet retracts into the body
of this cordless rechargeable vacuum
for compact storage. The simple
planes which make up the silhouette
suggest cleanliness and ease of use.

Product:	**Bath accessories**
Client:	**Zenith Products Corp.**
Designers:	**Bresslergroup/Peter W. Bressler; Richard Jaffee; P.K. Rossi**
Process:	**Injection molding**
Material:	**ABS**

Historically, plastic bath accessories were low-end retail goods; they were inexpensive and looked it. Bresslergroup collaborated with Zenith Products Corp. to design and market a new line of plastic bath accessories for J.C. Penney that combine the utilitarian qualities of plastics and the aesthetic values of ceramics. These pieces were molded of high-gloss, thick ABS, a material that resists breaking and is dishwasher safe.

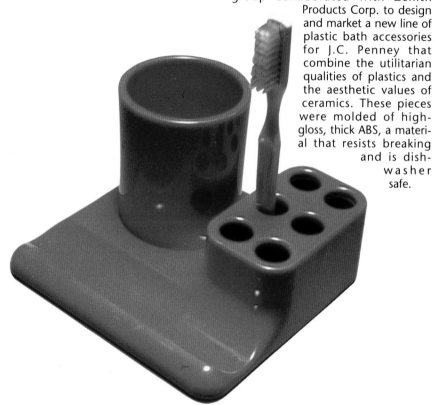

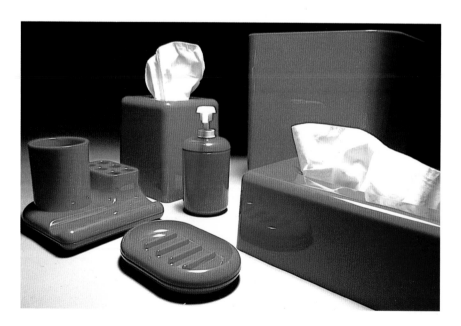

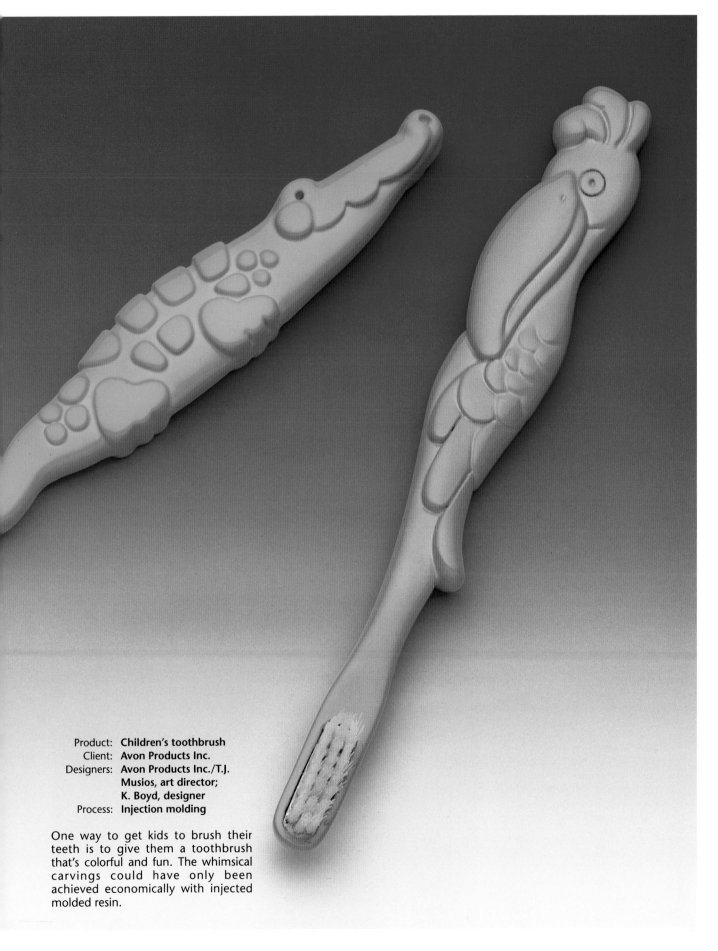

Product: **Children's toothbrush**
Client: **Avon Products Inc.**
Designers: **Avon Products Inc./T.J.**
Musios, art director;
K. Boyd, designer
Process: **Injection molding**

One way to get kids to brush their teeth is to give them a toothbrush that's colorful and fun. The whimsical carvings could have only been achieved economically with injected molded resin.

Product: **Tribel hand shower** ▲
Client: **Hansgrohe**
Designers: **Frogdesign/**
Harmut Esslinger Inc.

Other materials such as aluminum or cast metal could have been used for these hand-held shower heads. But plastic enabled the designers to create a Eurostyle appliance in bright colors.

Product: **Sassoon blow dryer** ▶
Client: **Helen of Troy**
Designers: **Herbst LaZar Bell Inc./**
Randall Bell; Ralph LaZar
Process: **Injection molding**
Material: **Polycarbonate**

Polycarbonate not only stands up to intense heat, but is easily shaped and dyed in bright colors. The piston-style design—accented by the slated vents on the side and loops on the cord—convey the message that this is a professional styling tool.

Product: **Lumex shower head** ▶
Client: **Lumex, Inc.**
Designers: **Tanaka Kapec Design Group/Jeffrey Kapec; Kazuna Tanaka**
Process: **Injection molding**
Materials: **ABS; Delrin**

Though this hand-held shower head is intended for use primarily by the aged and handicapped, Tanaka Kapec sought a design that wouldn't call attention to the handicapped user and would appeal to non-handicapped consumers as well. One of the most outstanding design elements is the plastic handle, which can be gripped or slipped on the wrist. Operating the shower requires no hand strength or fine coordination; the user controls the spray and turns the water on and off by slipping it on the wrist, arm or even an artificial limb.

Product: **Bath accessories**
Client: **Ingrid Div. of Sevko Inc.**
Designers: **Innovations & Development Inc./Michael Ballone; Edward Meisner; Edward Levy**
Process: **Injection molding**
Material: **ABS**

Plastics are well accepted in the bath as bare skin is so vulnerable to sharp edges. Plastic shapes such as these can be cleaned easily and thoroughly, making it easier to keep a cap on the bacteria prevalent in the wet, humid confines of the bathroom.

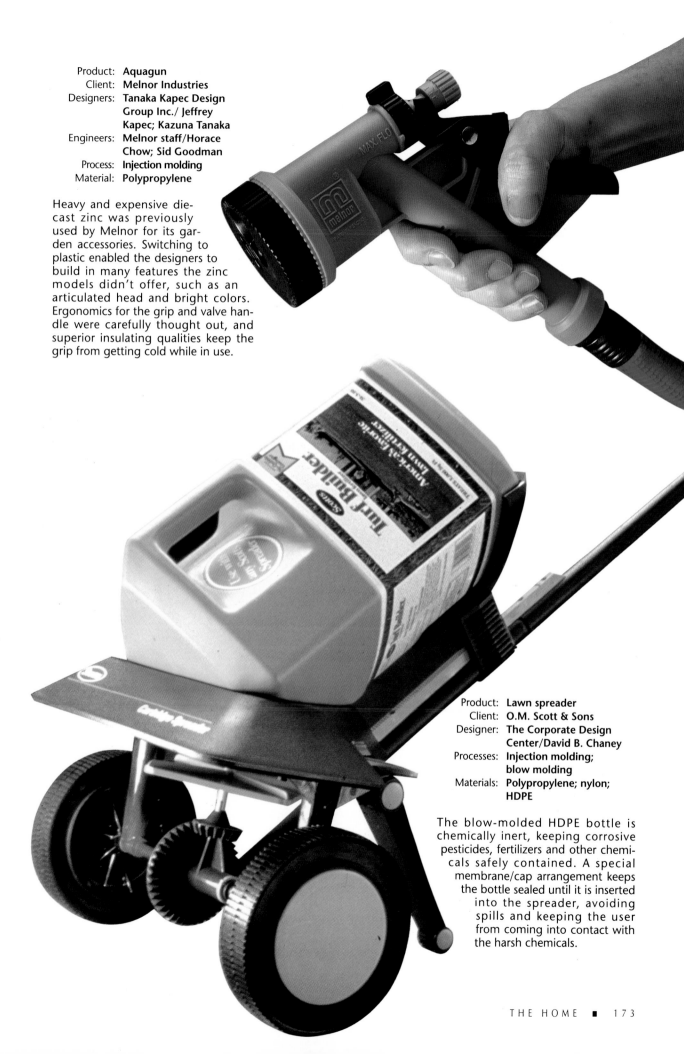

Product: **Aquagun**
Client: **Melnor Industries**
Designers: **Tanaka Kapec Design Group Inc./ Jeffrey Kapec; Kazuna Tanaka**
Engineers: **Melnor staff/Horace Chow; Sid Goodman**
Process: **Injection molding**
Material: **Polypropylene**

Heavy and expensive die-cast zinc was previously used by Melnor for its garden accessories. Switching to plastic enabled the designers to build in many features the zinc models didn't offer, such as an articulated head and bright colors. Ergonomics for the grip and valve handle were carefully thought out, and superior insulating qualities keep the grip from getting cold while in use.

Product: **Lawn spreader**
Client: **O.M. Scott & Sons**
Designer: **The Corporate Design Center/David B. Chaney**
Processes: **Injection molding; blow molding**
Materials: **Polypropylene; nylon; HDPE**

The blow-molded HDPE bottle is chemically inert, keeping corrosive pesticides, fertilizers and other chemicals safely contained. A special membrane/cap arrangement keeps the bottle sealed until it is inserted into the spreader, avoiding spills and keeping the user from coming into contact with the harsh chemicals.

Product: **Shop organizer** ▶
Client: **Arrow Group Industries**
Designers: **King-Casey Inc./David Miller; Thomas Pendleton; Robert Dawson; Corbett Stone**
Process: **Structural foam injection molding**
Material: **Talc filled polypropylene**

A lot of nice features were incorporated into the design of the Shopkeeper. A pegboard back supports add-on shelving and drawers. A tool box, mounted under the swing-down shelf, can be removed. The shelf contains a cog mechanism which assures that the vises on its top close at the correct angle.

Product: **Zipper disposable paint** ▶ **brushes**
Client: **Paint Aids Ltd.**
Designer: **Peter Haythornthwaite Design Ltd./Peter Haythornthwaite**
Process: **Injection molding**
Material: **Polypropylene**

For any product to be accepted as disposable, it has to be inexpensive and not look cheap. A subtle difference, and one that the designer was able to make. Snap-together assembly satisfied two important design parameters—low tooling cost and minimal assembly. This keeps the price competitive with Asian products, without having to sacrifice good looks.

Product: **Dust pan/brush pack** ▶
Client: **Kellogg Brush Company**
Designer: **Group Four Design/Robert Staubitz**
Process: **Injection molding**
Material: **Polypropylene**

What's worse than a dented metal dust pan that has lost its rubber edge, allowing dirt to scoot underneath? It's got to be an orphaned dust pan, whose companion brush is long gone. There's no chance of that happening with Kellogg Brush Company's package. Designed in bold primary colors, the brush and pan snap together at the handle for easy storage. Careful tuning of material thickness and selective texturing allow the two molded parts to snap together without using undercuts.

TRANSPORTATION

We endow our transportation (vehicles) with mystical powers. Always have. We traditionally lavish great care and decoration on them. Name them, as ships and airplanes (and many private automobiles) get christened. Back in Roman times, we applied beautiful carvings and gilt decoration to chariots. Roman children marvelled at them, then went home from the excitement of the chariot races to draw elaborate pictures of chariots. In late medieval times, the carriages of royalty carried all the forms that were considered exquisite and good, displayed as a pageant to the loyal citizenry. Little kids went home to draw the king's royal carriage, right down to the sculptured gold buttons on the harnesses. Today it's spaceships and sports cars. Our romantic fascination and attachments go back a long way.

We particularly love our automobiles. The shapes are stylish and excite us anew, model year after model year. They look like they're traveling a hundred km/h (sixty mph) standing still. We even talk about them in terms of technical jargon of the aerodynamics of airplanes, citing numeric coefficients of drag, pounds of downforce, negative lift and the like.

They look the way they do because they're designed to go through a fluid medium—the atmosphere. Streamlined. We worship aerodynamic shapes; at least for our vehicles.

It's a manufacturing oddity that our land vehicles—automobiles especially—come out looking as if they could fly. Their exteriors are made out of sheet metal (except for a very few, like Chevrolet's Corvette, BMW Z1 and Pontiac's Fiero). The shapes are double-curved sculptured surfaces, very plastic, very slippery through the air. (It's understandable for airplanes—the difficulties of forming sheet aluminum are outweighed by the benefits of aerodynamic efficiency.) These sculptured automobile pieces are turned out boom-boom-boom on very expensive tooling, turning stiff, flat material into curved. But the natural character

of sheet metal is to make sheer-edged plane geometric things, like the file cabinets and boxes for hard-fact electronics in our offices—now being made of molded plastics.

Metal grains under a powerful microscope look something like a pile of interlocked stones, no more likely to spontaneously get out of place than a masonry wall. Polymer molecules contrast by looking more like a nest of earthworms, long curvy wiggly things, ready to slide into movement.

The dichotomy of molding plastics into severe, hard-edged geometric contours while persuading flat rolled sheets of stiff metal into increasingly exotic shapes is a cultural anomaly. The natural character of plastics is to make things that move, rounded double-curved things, things that might have lives of their own—like our automobile bodies and airplanes. We can see it used that way in many items of personal transportation, like the shapely fairings on motorcycles, bicyclists' helmets, boats.

We'd like to make more of these shapes that move, shapes that have been endowed with the animal spirit, out of plastics. Indeed, there have been many steps made along the path. The Pontiac Fiero was a superb and courageous leap into forcing the traditional system of car-building materials to change. (The Fiero is no more, but not for the shortcomings in plastic.)

The problem is two-fold. We don't trust plastics to take over a job that has been performed well by metal. And plastics aren't yet up to some of the demands.

Transportation must be trustworthy. So we make it out of materials we trust, those we've had long experience with. Trials of new materials are made on a piecemeal substitution basis. As the new material proves itself, is better understood, and grows in strength, like a child it is allowed to grow into adult's work. So it was with iron and steel in wooden ships. Both played roles of ever-increasing importance

and trust, until eventually the huge vault was made to reliable ships with hulls made of steel.

Plastics are now the new material, being given walk-on roles in the serious performance of great transportation. Thus far they have been allowed to do the light work, carry the noncritical portions. The roles played have been those where, if the part weren't performed quite to perfection, no one really noticed. If the plastic part let go without hurting anyone, it was of no major consequence. And good performance was rewarded.

The roles are getting more important. Especially in low production items. Especially with a little internal help from plastic's current best ceramic friend, fine strands of glass fiber. The examples of successful laid-up and matched-die reinforced thermoset parts are everywhere. Front air dams under the bumpers of trucks and cars. Aerodynamic fairings on rail cars and locomotives. Wind deflectors on tractor-trailer roofs. Subway seats. Entire tractor-trailer cabs and bodies. Side closure panels on buses. Fairings to smooth intersections of aircraft structures.

In high production, too, we've been letting specialized engineering-grade plastics in to do the work of metal on a case-by-case basis. There is careful choice in the assignment of roles, suiting the player to the role played. We make sure there is even special dress, to make the differences obvious. The plastics are naturally or brightly colored, so we are never deceived as to the true nature of the material. We can see that the part is not metal. We don't expect it to act exactly like metal. This is honest substitution.

Beneath the bonnet—hood—of any motor vehicle plastic parts are everywhere. Some of them in important jobs. The extreme example is an entire lightweight 237 kw (318 hp) 2.0 liter Torlon polyamide-imide racing engine by Polimotor Research. Most drivers have at least seen their own plastic

windshield washer fluid bottle. Maybe even the molded brake fluid reservoir. There are lots of other examples, like plastic insulation on the electrical wires. We recognize that plastics are doing their newly-assigned jobs well, fulfilling the basic criterion of utter reliability—critical in transportation.

On the outside, there are all sorts of light-duty tasks carried by plastics. Jobs taken over from other materials, on a piecemeal bases. Like taillight lenses, and mirror housings, and rear-end spoilers. From a manufacturing point of view, all such parts are accessories, bolted on after the vehicle is built. Easy to change to another material, or back to the old reliable one.

When it comes to car bodies, we're in a different environment. As far as the people who make cars are concerned, the working environment for the vehicle includes the production line. Cars have a basic structure of steel. And the steel has its own requirements for heating to receive coatings on the production line. Attaching plastic body parts would work out well if there were no requirement for taking the process heat for the steel underbody. It would be almost easy to have a plastic-bodied automobile if we didn't have to match the finish and color of all the parts together. Automakers everywhere are working on it. The promise of high production—meaning inexpensive—auto bodies is too great to ignore.

The potential exists for nearly immortal plastic automobiles. We know that plastics don't go away of their own accord. The Polimotor engine demonstrates plastics being used for highly-stressed critical working parts. The concept demonstrated in GE Plastics' System for Automation and Manufacture (SAM) vehicle—starting with a reinforced polymer chassis—shows the way.

The designers of polymers are hard at work. Beyond the glory of the Corvette and Fiero and BMW Z1 are unsung advances, exciting developments that may sound unimpressive to

those on the outside—like a molded body panel that can take the heat of a paint oven. One of DuPont's Bexloy PET-based compounds has a system of reinforcements and modifiers that makes impact-resistant parts with a Class-A surface as-molded. These same parts hard-bolted to the unpainted auto body survive thirty minutes at 205°C (400°F) in the bake ovens, then show no damage after being subjected to 16.9 km/h (10.5 mph) impacts—well above the USA standards.

The high performance version of Ford's Taurus automobile has an all-plastics body forward of the windshield—fenders and bumpers injection molded of thermoplastic alloys, plus a thermosetting sheet molding compound (SMC) hood. The BMW Z1 roadster has plastic everywhere on the outside. General Motors' GM 200 van has a body of thermosetting RIM-molded polyurea and compression-molded SMC.

A lot of experimentation is going on. Including the stamping of plastics, handled in the manner of sheet metal. In the composites, there are many interesting possibilities. Many of the techniques touched on in the final chapter will be filtering into your daily transport. Beautifully shaped. For no matter what, we carry on the romance with transportation. It's important for our vehicles to express our feelings about their magical powers.

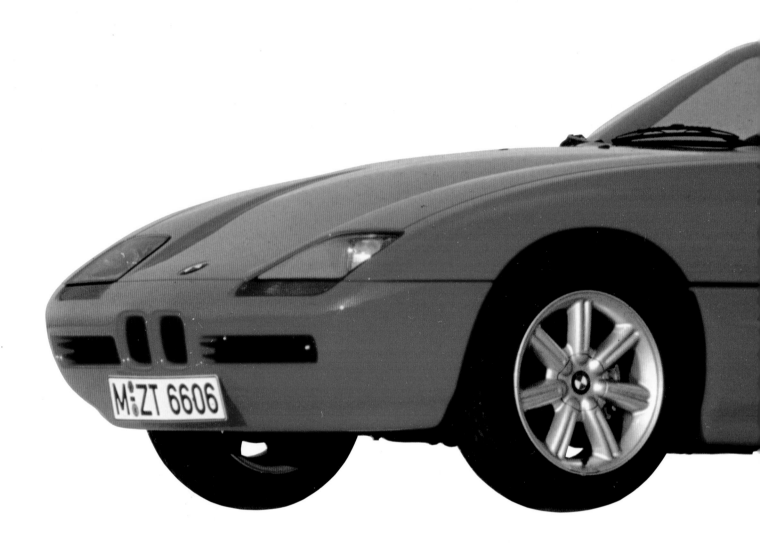

Product: **BMW Z1 Roadster**
Client: **BMW**
Designers: **BMW; GE Plastics**
Processes: **Injection molding; resin transfer molding**
Materials: **Polycarbonate-polyester alloy; thermoplastic elastomer; glass reinforced epoxy; steel**

BMW's Z1 car is part of a pilot program in which advanced plastics technology is being researched for application to mass-produced vehi-

cles. The body will include approximately 120 pounds of thermoplastics and less than 300 pounds of steel. This means light weight, increased performance and better fuel economy. The plastics chosen also offer a host of other advantages: They won't corrode and the vertical body panels have more impact resistance than metal, making them much less likely to dent when they come into contact with other car doors or road gravel.

Like its predecessor, the Pontiac Fiero, the Z1 is built up of molded

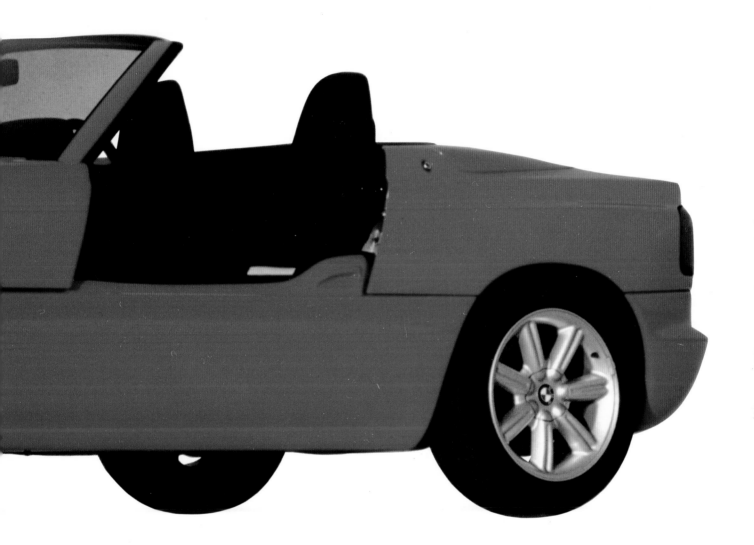

plastic body panels secured to a steel space frame.

The front fenders, doors, rear quarter panels and rocker panels are molded of Xenoy resin. The front and rear facings are molded of Lomod thermoplastic elastomer. Both are easy to mold, resist impact damage even in very cold weather and come out of the mold with a Class A finish. The bumper system consists of an energy-absorbing subassembly of filament-wound annular springs and a vacuum-injected bumper beam. Both are made of glass-fiber-reinforced epoxy. The structural floor pan consists of a polyurethane foam core sandwiched between facings of glass-fiber-reinforced epoxy. Horizontal panels made by resin-transfer-molding are a sandwich of glass-mat-reinforced epoxy over a polyurethane foamed core.

Use of these plastics has resulted in fewer total parts, which translates into fewer squeaks and rattles a few years down the road.

Product: **Pontiac Fiero** ▶
Client: **General Motors Corp.**
Designer: **General Motors Corp.**
Processes: **SMC; RRIM; injection molding; blow molding**

While the Pontiac Fiero was not the first car with a body made of plastics, it was the first to convince large numbers of consumers that an ordinary automobile can be made of something other than sheet metal. It also inverted the traditional car-building process. Instead of stamped sheet-metal pieces bolted to a welded chassis, the Fiero is made of injection-molded panels hung on a steel space frame. This gives the car more crash resistance than a conventionally-built auto of the same size. After the first year of production, GM switched to Bexloy nylon resin for the body panels, significantly reducing the number of parts damaged during assembly.

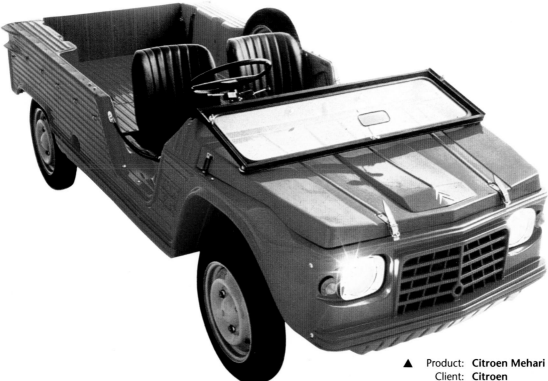

▲ Product: **Citroen Mehari**
Client: **Citroen**
Designer: **Jean-Louis Barrault/Seab**
Process: **Vacuum forming**
Material: **Borg Warner Cycolac ABS**

This vehicle was designed to go anywhere and do just about anything except carry the Rose Bowl Queen on parade day. The body of this Citroen was executed in thermoformings in sizes that were unheard of at the time of its inception—1968.

◄ Product: **MAX concept car**
Client: **General Electric Plastics**
Designer: **General Electric Design**

The MAX concept car, designed by GE Plastics, proves that a truly modular line of plastic autos is possible. A single steel space frame will accept interior and exterior thermoplastic components that turn it into a sedan, station wagon, hatchback, mini-pickup or sports coupe. These components could even be retrofitted at a dealer, allowing a young man to start out with a sports coupe, upgrade to a sedan when he gets married and upgrade again to a station wagon a few years later. Or, for the fashion-conscious, as new body styles appear, new exterior panels could be purchased to keep the car's styling up to date.

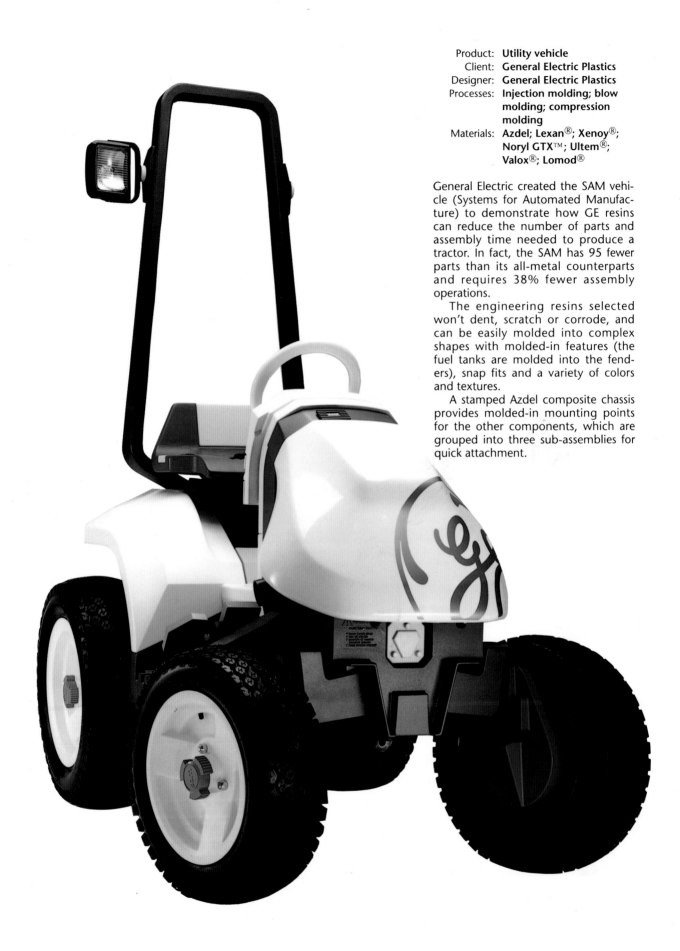

Product: **Utility vehicle**
Client: **General Electric Plastics**
Designer: **General Electric Plastics**
Processes: **Injection molding; blow molding; compression molding**
Materials: **Azdel; Lexan®; Xenoy®; Noryl GTX™; Ultem®; Valox®; Lomod®**

General Electric created the SAM vehicle (Systems for Automated Manufacture) to demonstrate how GE resins can reduce the number of parts and assembly time needed to produce a tractor. In fact, the SAM has 95 fewer parts than its all-metal counterparts and requires 38% fewer assembly operations.

The engineering resins selected won't dent, scratch or corrode, and can be easily molded into complex shapes with molded-in features (the fuel tanks are molded into the fenders), snap fits and a variety of colors and textures.

A stamped Azdel composite chassis provides molded-in mounting points for the other components, which are grouped into three sub-assemblies for quick attachment.

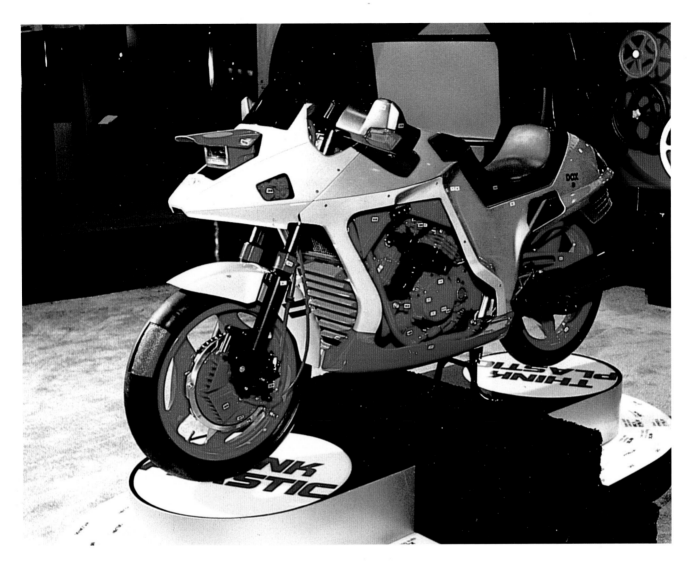

▲ Product: **Hybrid motorcycle**
 Client: **K.K. Dox**
Designer: **K.K. Dox**

Designed to demonstrate how many metal parts can be made of plastic, this hybrid cycle incorporates a molded composite frame, injection-molded wheels, plastic gears, bushings, sprockets, radiator tank and carburetors, among other things.

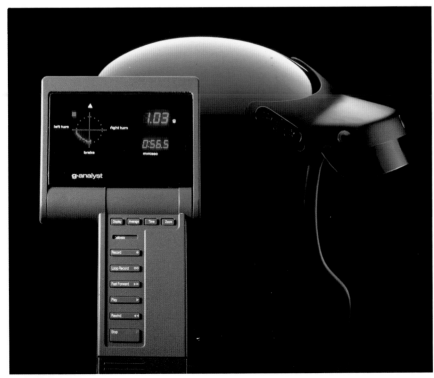

◄ Product: **G-force analyst**
 Client: **Valentine Research**
Designers: **RichardsonSmith Inc./**
 Thomas J. David; Peter A.
 Koloski; Robert J. Hayes
Process: **Injection molding**
Material: **ABS**

The G-force analyst is an affordable and accurate instrument for car enthusiasts. Made from high impact ABS, the unit takes continuous g-measurements for acceleration, braking and cornering and gives an instant readout or records them in its 8-minute memory.

This product is both an air compressor/tire inflator and an emergency flashlight. It just wouldn't be practical to incorporate all these functions into such a small shape in any material other than in ABS.

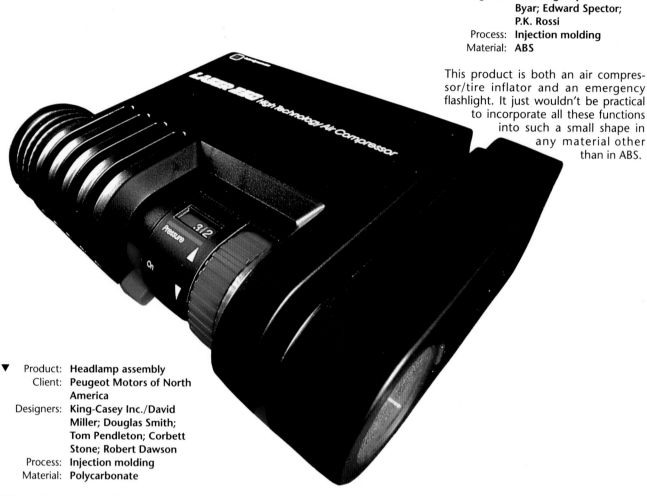

▼ Product: **Headlamp assembly**
Client: **Peugeot Motors of North America**
Designers: **King-Casey Inc./David Miller; Douglas Smith; Tom Pendleton; Corbett Stone; Robert Dawson**
Process: **Injection molding**
Material: **Polycarbonate**

This polycarbonate headlamp was designed for use in U.S. and European models of the Peugeot 505. Polycarbonate is tough and can be molded into good optical lenses.

Product: **High-speed rail train** ▶
Designer: **Neumeister Design**
Process: **Layup**
Material: **Fiberglass-reinforced polyester**

InterCity Experimental is Germany's newest high-speed train. Neumeister Design was commissioned to make the environment of this tube-shaped rail car comfortable. The walls and ceiling are constructed of various resins, painted neutral colors to blend well with the fabric of the seats. Plastic supports extend the length of the car to prevent the roof from collapsing if the train rolls over.

Products: **Magnetic levitation train** ▶
Designer: **Neumeister Design**
Process: **Hand layup**
Material: **Glass-reinforced polyester**

The Transrpaid 07 magnetic levitation train, a West German innovation, is made out of Legural f-30, a non-flammable polyester. The bullet-shape design can't be mistaken for something out of the past. It looks plastic. It looks high-tech. It looks futuristic. The streamlined forms were molded in flame-retardant resins to meet stringent safety regulations.

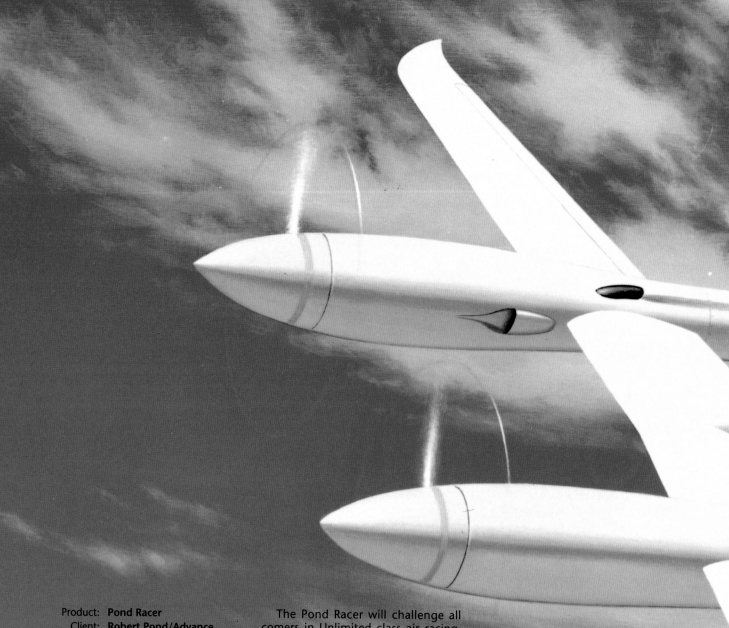

Product: **Pond Racer**
Client: **Robert Pond/Advance Machine Co.**
Designer: **Scaled Composites/ Burt Rutan**
Processes: **Layup and wrap**
Materials: **Graphite-reinforced epoxies over PVC foam**

Despite advances in the design of jet aircraft over the last three decades, many speed records for piston-powered planes are still held by combat fighters designed and built during World War II. This craft, scheduled to fly for the first time in 1989, should break those records, approaching 600 mph ground speed.

The craft was designed by Burt Rutan, who also designed the well-known Voyager. Voyager, piloted by Dick Rutan and Jeanna Yeager, circumnavigated the earth without landing or refueling.

The Pond Racer will challenge all comers in Unlimited class air racing, which is currently dominated by P-51 Mustangs, P-47 Lightnings and other vintage fighters. It will exceed their performance while using less fuel. Powered by two Nissan VG-30 six-cylinder auto racing engines developing 1000 horsepower each, the craft has a wingspan of 25 feet and weighs about 3,000 pounds. Bending, torque and thrust loads generated by the engines are carried by a steel suspension system into composite spars which extend back to the composite tail structure. Bending loads of the booms are resisted by the main wing spar and the horizontal tail spar.

The spars are one-piece composite carbon fiber roving caps and bi-directional carbon fiber cloth over PVC foam core for the shear webs.

The racer will also be used to test new materials which could make general aviation aircraft faster and safer.

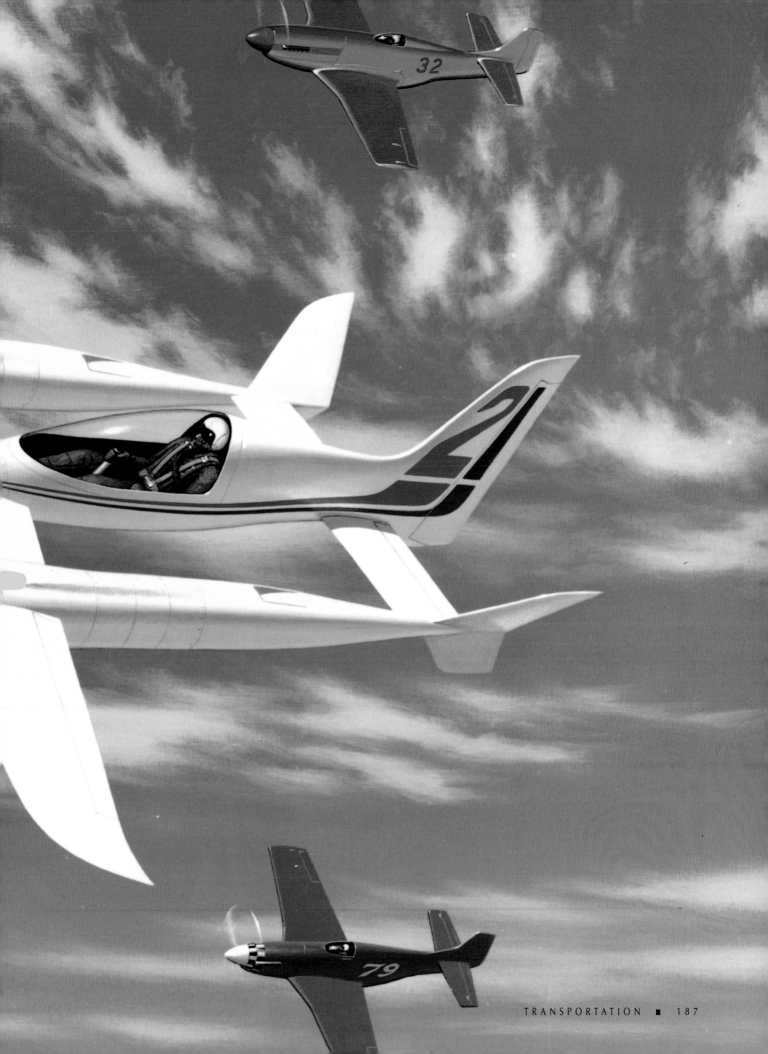

Product: **Stratoquest balloon**
Client: **Thunder & Colt Ltd.**
Designer: **Thunder & Colt Ltd./**
Per Lindstrand
Process: **Lamination**
Materials: **ICI Films Melinex® Type**
S aluminized polyester
film; ICI Films Type
143.33 DTEX rip-stop
nylon

The gaily-colored fabric hot-air balloons that float tourists over California's wine country have little in common with this 120-foot tall monster which hauled pilot Per Lindstrand more than 60,000 feet in the air, setting a new world record. The previous altitude record for a hot-air balloon was 55,134 feet.

Aluminized polyethylene terephthalate film was used because of its excellent thermal properties. The aluminized exterior absorbs heat from the sun while it conserves heat inside the envelope, reducing the amount of heat required to keep the balloon aloft and minimizing the size and weight of the fuel tanks and heating element. It was also able to withstand extremes of temperature during the flight.

The balloon was launched from the desert north of Laredo, Texas, where ground temperatures—though hot —came nowhere near the aluminized film's upper tolerance of 200°C. At 65,000 feet, the outside temperatures fell to -71°C, almost a hundred below on the Fahrenheit scale. Despite these low readings, Lindstrand reported that solar heat alone kept the balloon floating, and that he could not descend below 42,000 feet without releasing heated air from inside the envelope. The metallized coating was held to only 12 microns to maximize heat absorption.

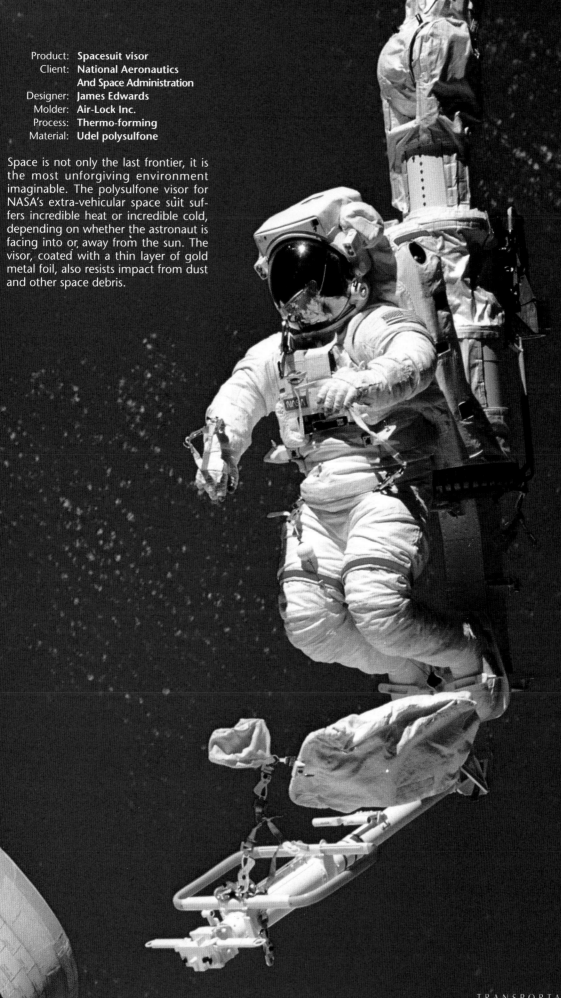

Product: **Spacesuit visor**
Client: **National Aeronautics And Space Administration**
Designer: **James Edwards**
Molder: **Air-Lock Inc.**
Process: **Thermo-forming**
Material: **Udel polysulfone**

Space is not only the last frontier, it is the most unforgiving environment imaginable. The polysulfone visor for NASA's extra-vehicular space suit suffers incredible heat or incredible cold, depending on whether the astronaut is facing into or away from the sun. The visor, coated with a thin layer of gold metal foil, also resists impact from dust and other space debris.

MEDICAL

Science and medicine are practiced as any other kind of work, but in a specialized workplace. The designs of this chapter are the tools used there.

The environments of science are no-nonsense places. The focus is intensely on the subject being studied, with the goal of finding out the true nature of factual material. Equipment and its design are important in facilitating the critical work at hand.

Designers of various kinds work here. Polymer designers. Mechanism designers. Industrial design teams, with human factors specialists—to make objects work better in these demanding environments.

Equipment here is used with a primary focus as a working tool, getting a job done, not as a medium for making statements about the surroundings. Outside housings for machines have essentially two jobs only: Protecting the machinery within, and instructing and leading an operator in its use. But that's not to say there is no consciousness of how these objects fit into their surroundings.

Scientists and doctors of all kinds have high levels of education. This often brings well-developed aesthetic tastes, so many of their possessions have handsome styling. The income level of medical doctors (at least in the United States) additionally permits them to acquire the taste for being surrounded by objects expressing a high level of taste and sensitivity.

But all are serious about their tools, and doing the job comes first in the priority of things—which sometimes doesn't leave anything left over for styling. In all product design there is a three-way balance among performance, manufacturability and aesthetic appearance. The seriousness of scientific and medical environments makes performance the overriding criterion. And yet, appearance has its place, if only the appearance of competence in doing the appointed job. There is also the powerful aesthetic of the rightness of an idea, of the sense of optimization of a delicate balance of factors that created the resulting object.

Performance of a tool for science or medicine far outweighs considerations for ease of manufacture. Collecting and accurately interpreting information is difficult enough on its own, without errors introduced for the sake of expediency in making the basic tool. When the tool in use is a pediatric leg brace, the way it works comes first. When the process going on is a human heart operation, the tool must not fail. When the plastic product is a pneumatic artificial heart, performance is everything.

And yet, for the hard-fact electronic appliances of science and medicine, plastics are used much as in any other workplace of information. Designs based on computer parts show up everywhere in the form of printers, keyboards with buttons of various shapes and types, and information screens for read-outs.

An additional challenge for designers of laboratory equipment is to give it an appearance of flawlessness; meeting the ideal of automated, machine-built, high-quality production in low production quantities. This is the same challenge as is met in any other workplace of information. Fortunately, the plastics molding processes which use low pressure are capable of delivering parts to meet this ideal of form.

Appearance shows up consciously, as an imposed quality, in several other ways. This is where the designer can and does make statements about the character of the workplace, its spirit, its nature, its psychological makeup. A formal appearance of competence, in leading an operator flawlessly through a complex procedure, can be added, an example being the ACL 100 series coagulation analyzer designed by Design Continuum for Instrumentation Laboratory. Psychological "friendliness" can be a valuable quality added to products used in taking competent and compassionate care of a patient. And there is the serious look of technical excellence, of error-free competence, expressed as tastefully as possible in shapes adhering to that cliché of precision appearance, severe simple geometric shapes.

If there is any common thread running through plastics in the scientific and medical workplace, it is the requirement for sterilization. There are many methods: gas sterilization, live steam, gamma ray, electron beam and chemical sterilization. All of them are hard on polymers. In science and medicine, getting rid of contaminants is the starting point; the first important capacity in any material is the capacity for sterility. How interesting to note that the prime requirement for sterility shows a tendency to carry over into the product forms as well, with much crisp-edged straight-line geometry.

We reserve rounded shapes for those things in intimate contact with the body, whether they are items of precision or not. In business offices, there are many hard-looking geometric tools and objects broadcasting error-free performance; but the chairs we sit on are rounded, soft. In the medical workplace, the roundness of objects that are in intimate contact with our bodies is not just for the psychological effect of friendliness or solid touchy-feely comfort. This is for real. These things penetrate us. They must be as soft and comfortable as possible.

Plastics are invaluable in medical uses as performers. They can be flexible, transparent, inert (to both microbes and body fluids), come out as-manufactured in sterile conditions, and are cheap to boot. Silicone, for instance, is biologically inert, so tissue will not attach itself to implanted tubes or catheters. Also, being soft and flexible, it causes minimum discomfort when it is inserted. The property of transparency of plastics combined with toughness and flexibility—unlike glass—allows us to see what is going on, what is flowing in, what is flowing out. Acrylic, the senior member of the transparent moldable set, has an interesting new job as tamper-evident material for filled narcotics syringes—it stress-whitens if penetrated by a thief.

Health care and medicine concern themselves with matters of life and death. Every object here works magnificently. We insist on it. Extrusion blow molded angioplasty balloons of polyethylene terephthalate clear obstructions in blood vessels. Composite dental fillings. Polyester fiber mesh used for patching blood vessels. Contact lenses. Replacement joints in hips, knees, elbows. Artificial limbs. Joint prostheses, softly padded and post-formed to custom fit.

Quality is not an issue. All-electric molding machines, built especially to operate in clean-room environments turn out parts free from contamination. Statistical process control and part quality control ensure adherence to what the designers intended; all in the pursuit of error-free performance.

Quantity is an issue. At the other end of the scale are millions of disposable laboratory and medical products. Vials, jars, bottles, tubing, surgical equipment, plastic gloves. One factor driving the use of protective disposables is fear of the AIDS virus. Another is the labor cost involved in re-use. The common thread here is sterility of those products. Because plastics have made the cost of so many items so low, the cost of re-sterilizing once-used products is now much more than the cost of replacing them.

On the other hand, cost has always been an issue in science laboratories. The cost of the objects used in health care and medicine has been an active issue. The pressure is on all designers for careful specification of all materials. But the materials selection will remain performance-driven. There is a push to use commodity resins in place of engineering-grade materials where possible for disposables, to use lower-cost composites in prostheses, to use lower cost bio-compatibles where possible. In other words, to design to the limits of the resins.

But performance will always be the deciding design criterion, especially when one considers the legal and human costs of a single failure.

Product: **Lifeline Cart**
Client: **InterMetro Industries**
Designers: **Robert Welch; Robert Natress; Al Kolvites**
Process: **Rotational molding**
Materials: **Polyethylene; epoxy-coated steel tubing**

The Lifeline Cart literally saves money as it saves lives. Designed for use in hospital emergency rooms and intensive-care wards, it carries everything a medical team needs to deal with a heart attack victim. Well thought-out design and use of processes with low tooling costs permit full use of plastics for a product made in small quantities while keeping the price low.

The fold-out, rotationally-molded push handle incorporates a caster lock for push steering or for turning the cart in a full circle within its own footprint. See-through side-bins carry vital supplies where they can be identified and reached instantly.

Product: **Bedside glucose testing** ▶
 station
Client: **Boehringer Mannheim**
 Diagnostics
Designer: **Boehringer Mannheim**
 Diagnostics
Process: **Injection molding**
Material: **Cycolac T ABS**

Accu-Chek II was designed by nurses to hold the variety of supplies and instruments necessary for repeated blood sugar testing. Not only does the system have a professional appearance, but it can also withstand the impacts, chemical spills and staining that occurs during daily hospital use. Cycolac T general purpose grade of ABS thermoplastic has an exceptional balance of toughness, rigidity, high flow and gloss at an economical cost.

◀ Product: **Reagent vials**
 Client: **Ciba-Corning**
 Designers: **Henry Rahn; John Bucholz;**
 Robert Potts
 Process: **Injection molding**
 Material: **Polyethylene**

Used to package reagents for magnetic immuno chemistry (MagIC), these containers (above and left) are shaped like the letter "D" to better fit the hand. A molded-in window shows the fluid level inside while the tapered cone section aids in drawing the liquid out with a pipette. The large perimeters relative to volume provide excellent stability as well.

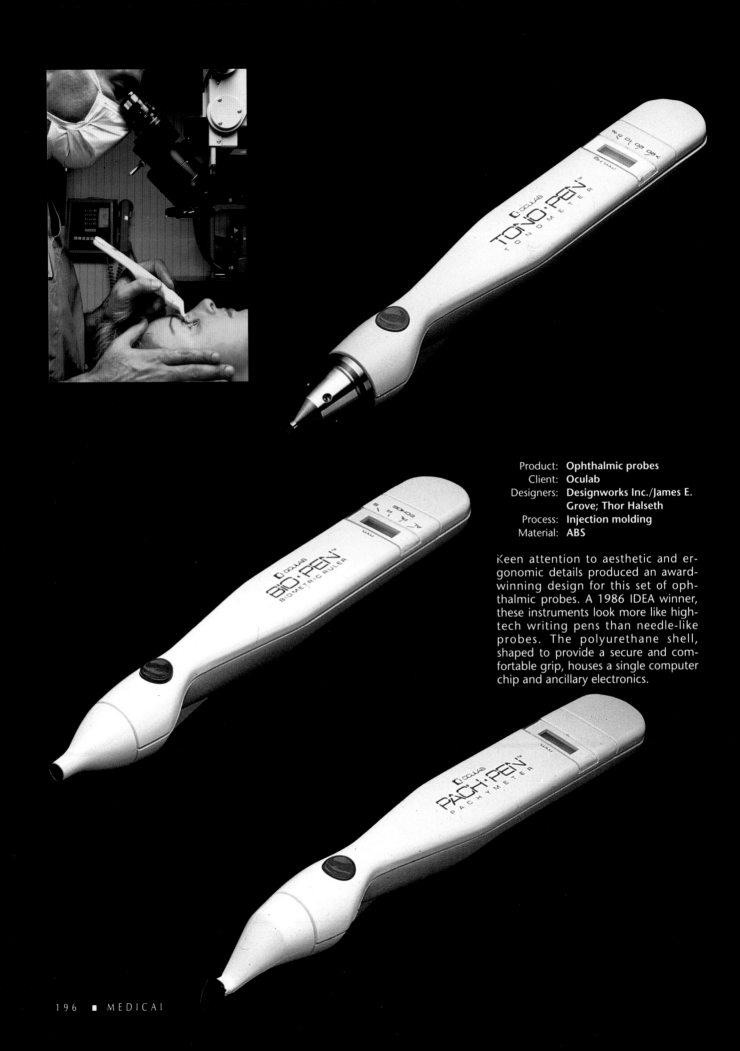

Product: **Ophthalmic probes**
Client: **Oculab**
Designers: **Designworks Inc./James E. Grove; Thor Halseth**
Process: **Injection molding**
Material: **ABS**

Keen attention to aesthetic and ergonomic details produced an award-winning design for this set of ophthalmic probes. A 1986 IDEA winner, these instruments look more like high-tech writing pens than needle-like probes. The polyurethane shell, shaped to provide a secure and comfortable grip, houses a single computer chip and ancillary electronics.

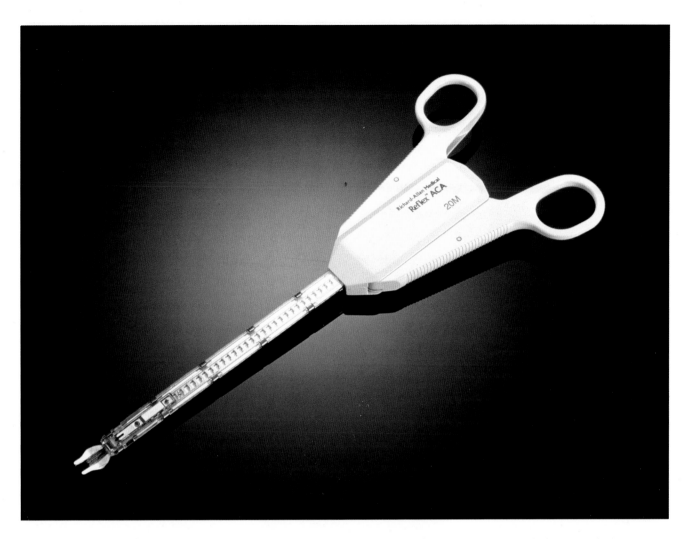

Product: **Surgical clip applicator**
Client: **Richard-Allan Medical**
Designers: **Human Factors Industrial Design Inc./Chris Brooks; Paul Mulhauser; Jeff Stein**
Process: **Injection molding**
Materials: **ABS; SAN; acetal; polycarbonate 20% glass filled**

This tool feeds, places and closes a series of ligating clips around blood vessels prior to cutting. Side-moving steel was used in the mold to form the grip areas of the handle.

Product: **Coagulase 100 Laser**
Client: **Minnesota Laser Corp.**
Designer: **Polivka Logan Designers/ Eugene Reshanov**
Process: **Pressure forming**
Materials: **ABS; neoprene; polyurethane paint**

While sheet metal is the material of choice for packaging the electronic components, ABS is flexible enough to be thermoformed for the control panel and grille.

Product: Electronic scalpel ▲
Client: MD Engineering
Designer: Lunar Design Inc./
Jeff Smith
Process: Injection molding
Material: ABS

This surgical cauterizing scalpel is electronic. The patient is electrically grounded and a charge is applied to the cutting blade, cauterizing the wound as it cuts. The design incorporates a funnel-like chamber that, when attached to a vacuum, pulls away the smoke produced by the cauterization. The process allowed molded-in details which locate and hold internal components during assembly.

Product: Surgical footswitch ▶
Client: CooperVision
Designer: S.G. Hauser Associates
Inc./Allan Cameron
Engineer: CooperVision/William T.
Cleminshaw
Processes: Injection molding;
hand-loaded casting
Materials: Polycarbonate foam; 30%
glass-filled nylon; textured
soft urethane over aluminum; solid polycarbonate

This footswitch controls a handpiece used in eye surgery that performs several key functions. The designers were commissioned to reduce the size of the unit, decrease manufacturing and assembly costs and improve the unit's ergonomics. A mid-foot pivot keeps the physician's leg close to the ground and enables him to control the pedal easily with his heel and toe. The circular pivoting heel plate eases leg and foot strain and makes it easy to reach the switches on either side of the main unit.

Product: Disposable instruments ▶
Client: Ethicon Inc.
Designers: Tanaka Kapec Design
Group/Jeffrey Kapec;
Kazuna Tanaka
Engineers: Ethicon Inc./Don Golden;
Jim Bedi
Process: Injection molding
Material: Glass-filled polycarbonate

Glass-filled polycarbonate—a top-grade engineering resin—isn't usually selected for disposable products. But these disposable microsurgery instruments, designed to replace titanium surgical tools costing hundreds of dollars each, required the kind of precision tooling that can't be achieved in a lesser material.

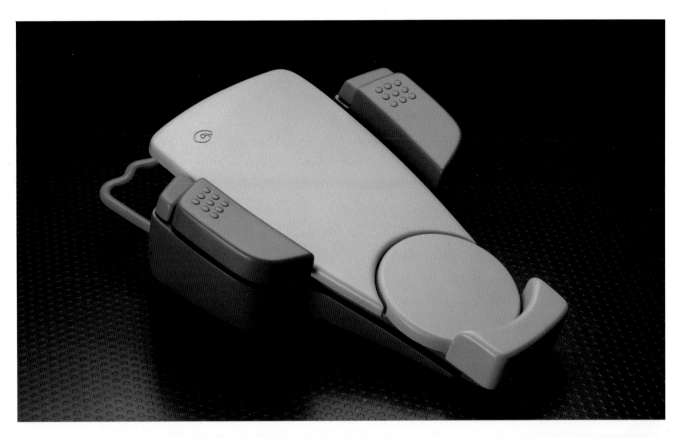

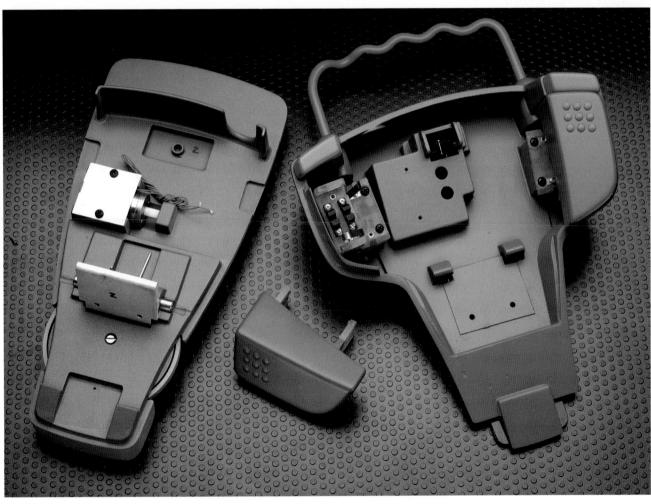

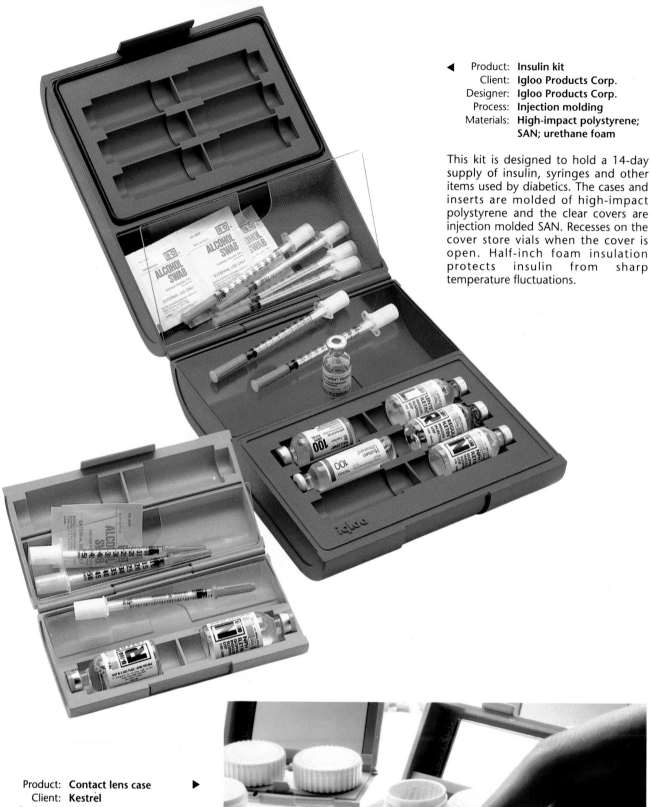

Product: **Insulin kit**
Client: **Igloo Products Corp.**
Designer: **Igloo Products Corp.**
Process: **Injection molding**
Materials: **High-impact polystyrene; SAN; urethane foam**

This kit is designed to hold a 14-day supply of insulin, syringes and other items used by diabetics. The cases and inserts are molded of high-impact polystyrene and the clear covers are injection molded SAN. Recesses on the cover store vials when the cover is open. Half-inch foam insulation protects insulin from sharp temperature fluctuations.

Product: **Contact lens case** ▶
Client: **Kestrel**
Designer: **Kestrel**
Process: **Injection molding**
Material: **Amoco Performance Products Mindel S-1000**

Kestrel's standard contact lens cases, molded in Mindel S-1000 resin, come in attractive designer-styled carrying cases. Removable, they snap-fit into a heating unit for thermal disinfection. Mindel holds up to high temperatures and the saline solution used in the cleaning process.

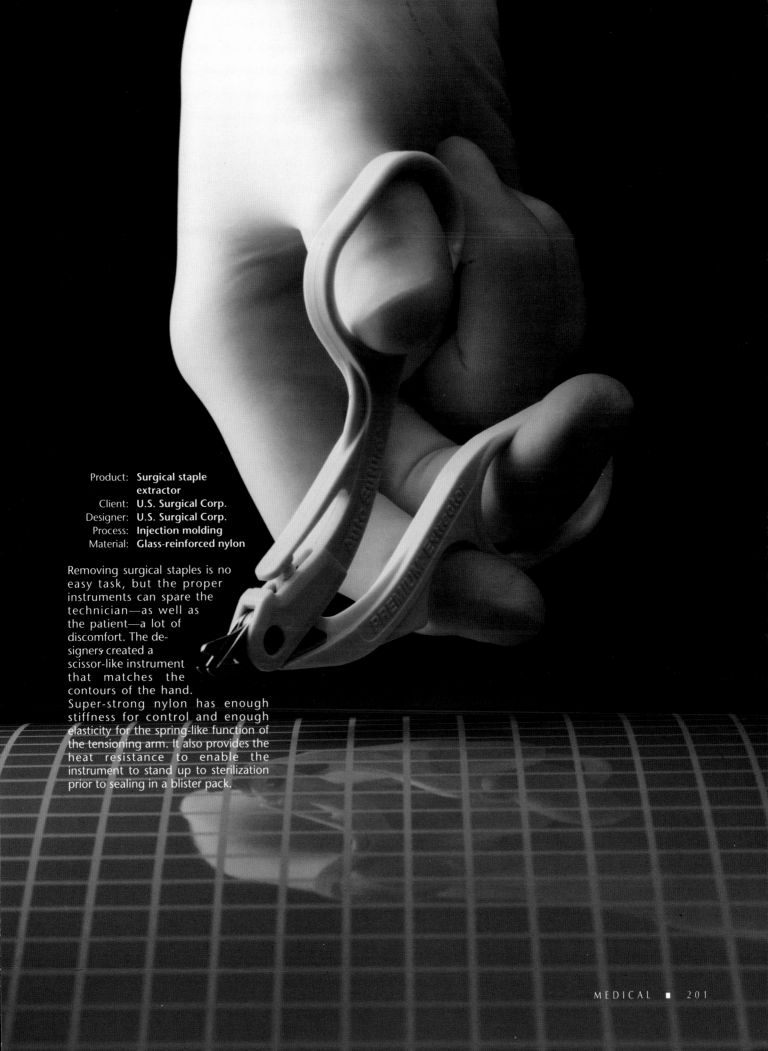

Product: **Surgical staple
extractor**
Client: **U.S. Surgical Corp.**
Designer: **U.S. Surgical Corp.**
Process: **Injection molding**
Material: **Glass-reinforced nylon**

Removing surgical staples is no
easy task, but the proper
instruments can spare the
technician—as well as
the patient—a lot of
discomfort. The de-
signers created a
scissor-like instrument
that matches the
contours of the hand.
Super-strong nylon has enough
stiffness for control and enough
elasticity for the spring-like function of
the tensioning arm. It also provides the
heat resistance to enable the
instrument to stand up to sterilization
prior to sealing in a blister pack.

Product: **Needle-less injector**
Client: **Advanced Medical Technologies Inc.**
Process: **Injection molding**
Material: **Amoco Udel polysulfone**

To millions of diabetics, the pain of injecting themselves with insulin using a hypodermic needle is a daily reality. As a result, most tend to take one or two large doses each day, rather than several small doses, which is medically more effective. Instead of a needle, the Preci-Jet 50 uses the pressure generated by a small stainless steel piston to force a pre-measured dose of insulin through the patient's skin. The steel piston and cylinder are encased in Udel polysulfone, selected for its ability to withstand the high pressures generated by the piston and the rigors of frequent sterilization in boiling water. The pressure can be adjusted to match the resistance of the user's skin and the unit is easy to carry, fill and operate, even for those with impaired vision—a common side-effect of severe diabetes.

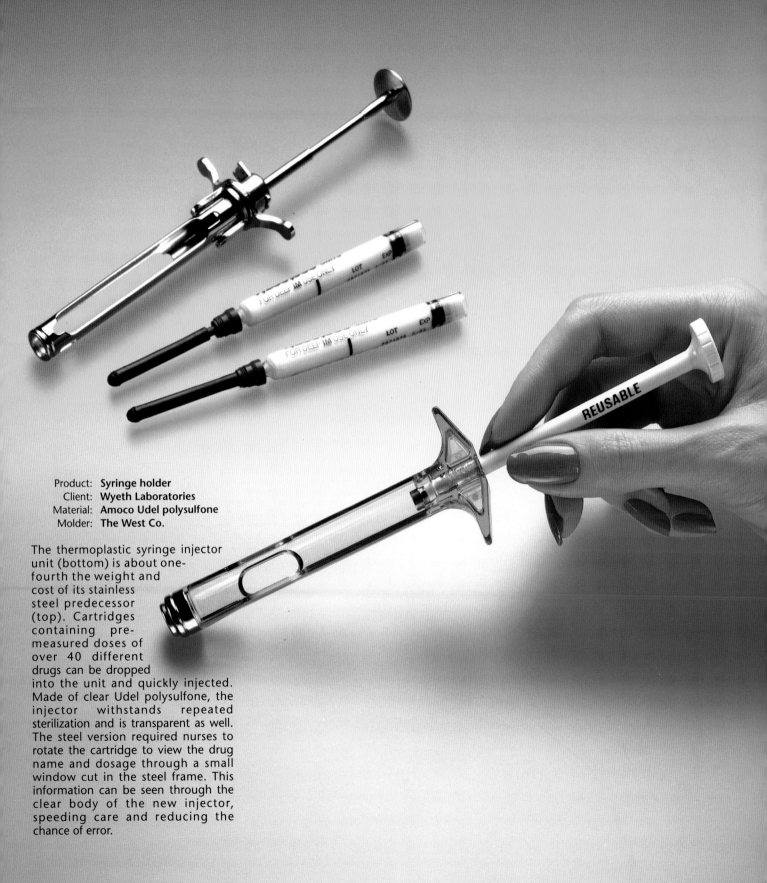

Product: Syringe holder
Client: Wyeth Laboratories
Material: Amoco Udel polysulfone
Molder: The West Co.

The thermoplastic syringe injector unit (bottom) is about one-fourth the weight and cost of its stainless steel predecessor (top). Cartridges containing pre-measured doses of over 40 different drugs can be dropped into the unit and quickly injected. Made of clear Udel polysulfone, the injector withstands repeated sterilization and is transparent as well. The steel version required nurses to rotate the cartridge to view the drug name and dosage through a small window cut in the steel frame. This information can be seen through the clear body of the new injector, speeding care and reducing the chance of error.

Product: **Hormone implanter**
Client: **Syntex Agribusiness**
Designer: **GVO Inc.**
Process: **Injection molding**
Materials: **Polycarbonate; acetal; polyester**

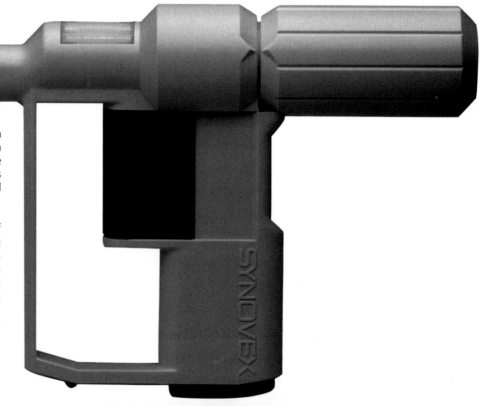

The feed lot, where this implanter is used to inject growth hormones into cattle, is a very harsh environment. Temperatures can range from -30°F to 120°F. Moisture is created by rain, sweat and animal fluids. Contaminants are everywhere—in animal hair, dirt, mud, insecticides.

The hormones are pushed out of the clip by a rod. Injection molding could certainly create the complex shape of this part; however, finding a material stiff enough for the job was the challenge. The solution: The part was investment cast in metal using an injection-molded polystyrene master as the "lost wax."

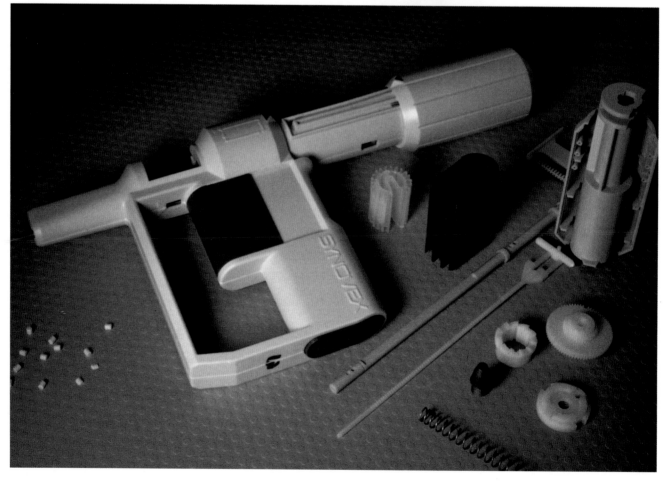

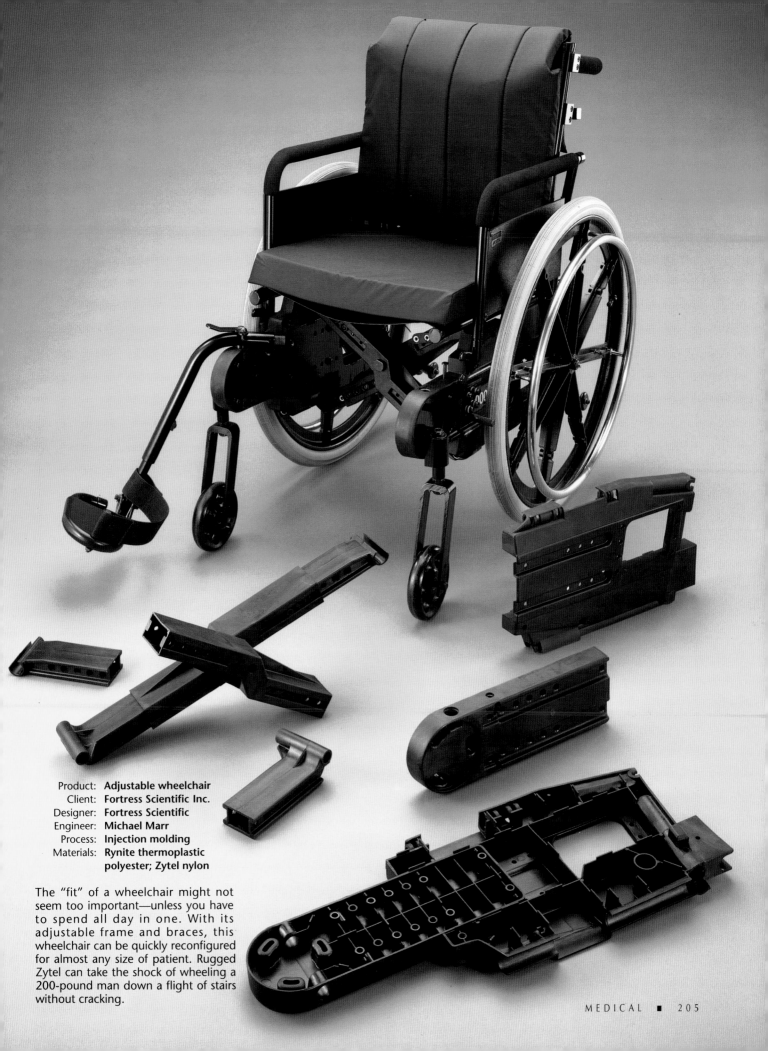

Product: **Adjustable wheelchair**
Client: **Fortress Scientific Inc.**
Designer: **Fortress Scientific**
Engineer: **Michael Marr**
Process: **Injection molding**
Materials: **Rynite thermoplastic
polyester; Zytel nylon**

The "fit" of a wheelchair might not seem too important—unless you have to spend all day in one. With its adjustable frame and braces, this wheelchair can be quickly reconfigured for almost any size of patient. Rugged Zytel can take the shock of wheeling a 200-pound man down a flight of stairs without cracking.

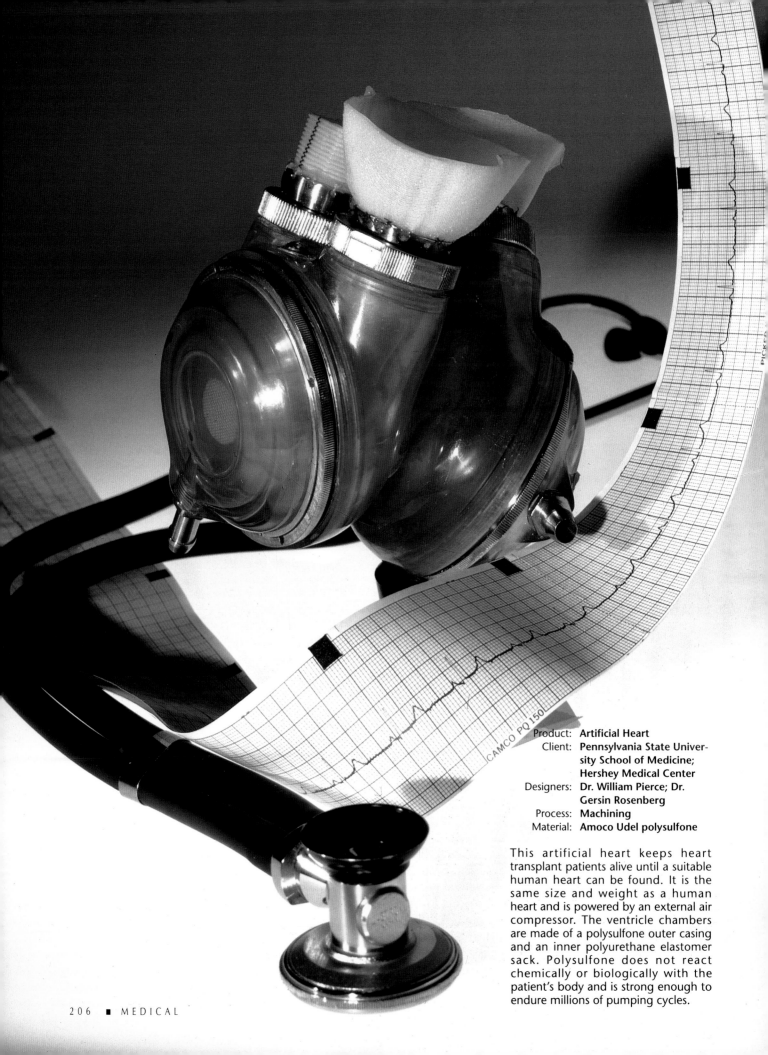

Product: **Artificial Heart**
Client: **Pennsylvania State University School of Medicine; Hershey Medical Center**
Designers: **Dr. William Pierce; Dr. Gersin Rosenberg**
Process: **Machining**
Material: **Amoco Udel polysulfone**

This artificial heart keeps heart transplant patients alive until a suitable human heart can be found. It is the same size and weight as a human heart and is powered by an external air compressor. The ventricle chambers are made of a polysulfone outer casing and an inner polyurethane elastomer sack. Polysulfone does not react chemically or biologically with the patient's body and is strong enough to endure millions of pumping cycles.

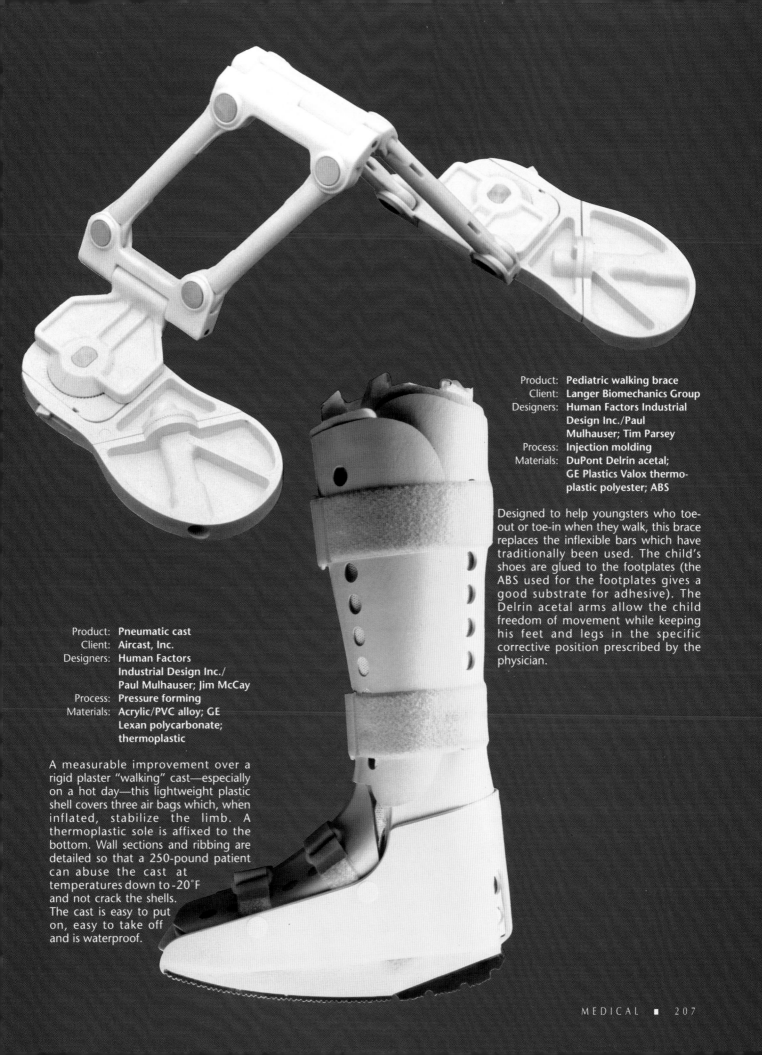

Product: **Pediatric walking brace**
Client: **Langer Biomechanics Group**
Designers: **Human Factors Industrial Design Inc./Paul Mulhauser; Tim Parsey**
Process: **Injection molding**
Materials: **DuPont Delrin acetal; GE Plastics Valox thermo-plastic polyester; ABS**

Designed to help youngsters who toe-out or toe-in when they walk, this brace replaces the inflexible bars which have traditionally been used. The child's shoes are glued to the footplates (the ABS used for the footplates gives a good substrate for adhesive). The Delrin acetal arms allow the child freedom of movement while keeping his feet and legs in the specific corrective position prescribed by the physician.

Product: **Pneumatic cast**
Client: **Aircast, Inc.**
Designers: **Human Factors Industrial Design Inc./Paul Mulhauser; Jim McCay**
Process: **Pressure forming**
Materials: **Acrylic/PVC alloy; GE Lexan polycarbonate; thermoplastic**

A measurable improvement over a rigid plaster "walking" cast—especially on a hot day—this lightweight plastic shell covers three air bags which, when inflated, stabilize the limb. A thermoplastic sole is affixed to the bottom. Wall sections and ribbing are detailed so that a 250-pound patient can abuse the cast at temperatures down to -20°F and not crack the shells. The cast is easy to put on, easy to take off and is waterproof.

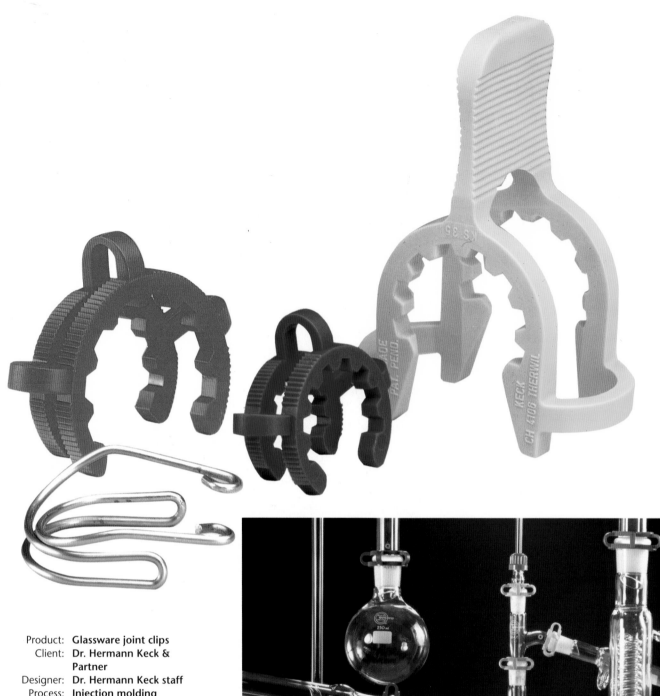

Product: **Glassware joint clips**
Client: **Dr. Hermann Keck & Partner**
Designer: **Dr. Hermann Keck staff**
Process: **Injection molding**
Material: **DuPont Delrin acetal**

Though the low initial cost of formed steel clips usually used to join laboratory glassware is hard to beat, these new plastic clips do not rust, corrode, bend out of shape or scratch expensive glassware. The clips are formed of two rings, one above the other. The upper ring has a slightly smaller diameter and is joined to the lower ring by three bows. Delrin was chosen because of its spring-like characteristics, strength, dimensional stability and its resistance to solvents.

Product: **Breathing exerciser**
Client: **MBA Health Care Products Inc.**
Designer: **Chase Design Inc.**
Process: **Injection molding**
Materials: **Polyethylene; ABS**

The Aerobica is a lung exerciser for breathing-disabled patients which offers both inhaling and exhaling functions in a featherweight, pocket-size device that requires no disassembly or conversion during use. Molded of white, low-density polyethylene and ABS, the sides are slightly textured to provide a comfortable grip.

Product: **Blood analyzer rotor** ▶
Client: **Cyro Industries**
Process: **Injection molding**
Material: **Acrylic**

An integral part of a blood analyzer, this rotor holds up to 18 samples. The need for optical clarity, intricate molding and the ability to withstand heat and extreme centrifugal force during analysis dictated the use of acrylic.

◀ Product: **Laboratory ware**
Client: **NiPro**
Process: **Injection molding**
Material: **Mitsui TPX polymethyl-pentene**

The outstanding transparency, stability under steam sterilization and chemical resistance of polymethlypentene make this non-glass laboratory ware durable, shatterproof, light and easy to handle. With a melting point of 460°F and a high Vicat softening point, TPX lends itself to applications calling for high service temperatures.

Product: **MR-300 Microplate Reader** ▶
Client: **Dynatech Laboratories Inc.**
Designer: **Lesko Design/Jim Lesko**
Process: **Injection molding**
Materials: **Noryl polyphenylene oxide; polyurethane paint**

The clean, uncomplicated form helps make this microtiter plate reader easy to use and cheap to manufacture. The controls, located together on the sloping front panel, are large and recognizable at a glance. All fasteners are accessible without turning the unit over; molded-in ribs and bosses correctly locate the parts during assembly; and great economy is achieved by producing the components in a seven-cavity mold.

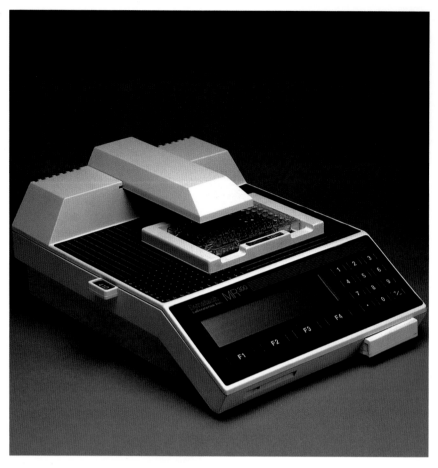

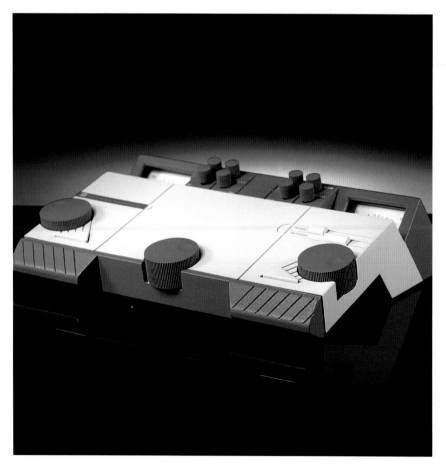

◀ Product: **Audiometer**
Client: **Maico Hearing Instruments**
Designers: **Polivka Logan Designers Inc./ E. Reshanov; L. Runquist**
Processes: **Injection molding; pressure forming**
Materials: **ABS; polycarbonate; polyurethane paint**

Molded-in details make two statements here; one functional, the other visual. The main control knobs have finger wells at the index points and ridged sides, making it easy for the technician to adjust sound frequency and intensity by touch alone. Ledges extending from the top of the case provide a convenient resting place for the user's wrists during a test. The sculptural form and geometric grooves in the top are a welcome change from the cold "black box" look of conventional audiometers.

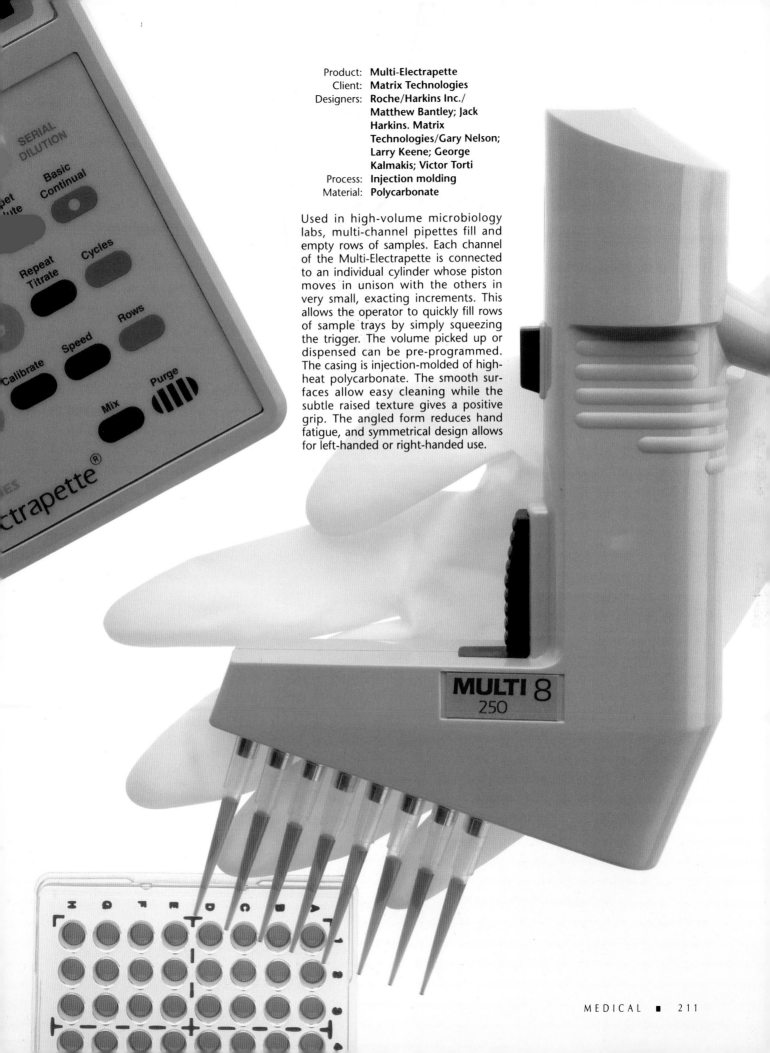

Product: **Multi-Electrapette**
Client: **Matrix Technologies**
Designers: **Roche/Harkins Inc./**
Matthew Bantley; Jack
Harkins. Matrix
Technologies/Gary Nelson;
Larry Keene; George
Kalmakis; Victor Torti
Process: **Injection molding**
Material: **Polycarbonate**

Used in high-volume microbiology labs, multi-channel pipettes fill and empty rows of samples. Each channel of the Multi-Electrapette is connected to an individual cylinder whose piston moves in unison with the others in very small, exacting increments. This allows the operator to quickly fill rows of sample trays by simply squeezing the trigger. The volume picked up or dispensed can be pre-programmed. The casing is injection-molded of high-heat polycarbonate. The smooth surfaces allow easy cleaning while the subtle raised texture gives a positive grip. The angled form reduces hand fatigue, and symmetrical design allows for left-handed or right-handed use.

Product: **Diagnostic tester** ▶
Client: **Eastman Kodak Co.**
Designers: **Gerstman+Meyers Inc./**
Herbert Meyers; David
Pressler; Richard Edstrom;
Ric Hirst
Process: **Injection molding**
Materials: **High-impact polystyrene;**
rubberized polymer

This disposable test kit can be used to
check for a number of conditions from
pregnancy to bacterial infection. A
standard gray body is used for a
number of tests; the rubberized
activating bar is then color-
coded for each different test
type. By producing in high
volume these tests can be
performed at about a tenth
the cost of
traditional
tests.

STREP A NOT PRESENT
STREP A PRESENT
SAMPLE CONTAMINATED
WRONG PROCEDURE

CLOSE
OPEN

K ACCUCHEK ✓✓ STREP A

◀ Product: **Medical air filter**
Client: **Fluid Energy**
Designer: **Machen Montague Inc.**
Process: **Injection molding**
Materials: **Polycarbonate; Delrin**
acetal

This medical/dental air filter protects
against viral infection. A sophisticated
filter element fits in-line with an air
compressor used in examination
rooms. The canister is changed
periodically by simply pushing the
gray pressure release valve and
unscrewing the base handle. The
canister and base are made of
polycarbonate; the base is constructed
of acetal.

Product: **LungCheck** ▶
Client: **Cytosciences Inc.**
Designer: **Theta Resources/**
Marty Watts
Process: **Injection molding**
Materials: **Polyethylene;**
polypropylene

The LungCheck, made of
thermoplastic materials,
transports lung fluids to a
medical laboratory for
analysis. A test tube is
contained with the plastic
housing, keeping a specimen
uncontaminated. The lab
technician uses a special tool to
cut the housing apart.

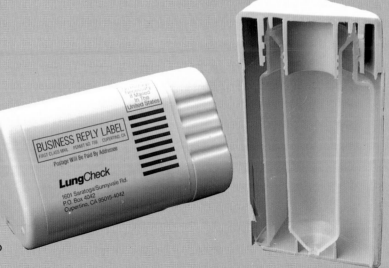

BUSINESS REPLY LABEL
FIRST CLASS MAIL PERMIT NO. 799 CUPERTINO, CA

Postage Will Be Paid By Addressee

LungCheck
1601 Saratoga/Sunnyvale Rd.
P.O. Box 4042
Cupertino, CA 95015-4042

Product: **Automated coagulation laboratory**
Client: **Instrumentation Laboratory S.p.A.**
Designer: **Design Continuum Inc.**
Process: **Injection molding**
Material: **Polyphenylene oxide**

All major parts of this unit perform the dual roles of highly detailed exterior covers and intricate internal component mounting structures, virtually eliminating the need for any internal brackets.

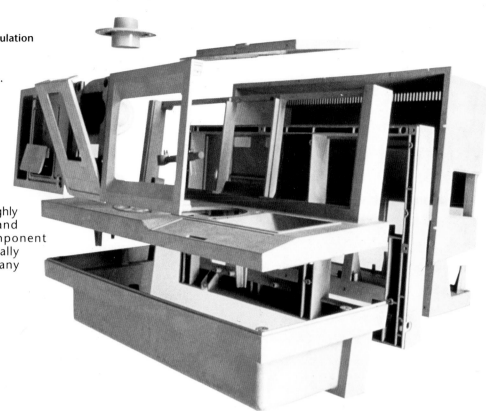

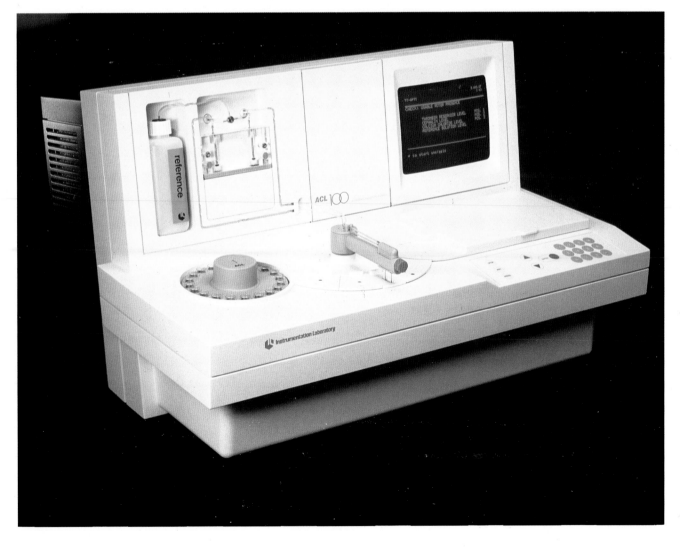

Product: **Blood gas system**
Client: **Ciba Corning Diagnostics**
Designer: **Ciba Corning Diagnostics/**
John Buchholz
Processes: **Injection molding;**
compression molding;
machined
Materials: **Valox; Delrin acetal;**
melamine phenolic

All materials for this analyzer had to be chemically resistant to both cleaning solutions and to the acidic reagents used in testing blood gasses. Polane polyurethane paint provides a highly-resistant surface and the one-part covers are light, durable and easy to clean. Plastics also help insulate the sensitive machinery from electrical noise and interference. The patented reagent bottles have molded-in finger grips for sure handling. The mouth of each bottle has a built-in silicone septum. This septum opens when pushed over a feeder tube leading into the analyzer. When the bottle is removed, the septum closes before the reagent can spill or be contaminated.

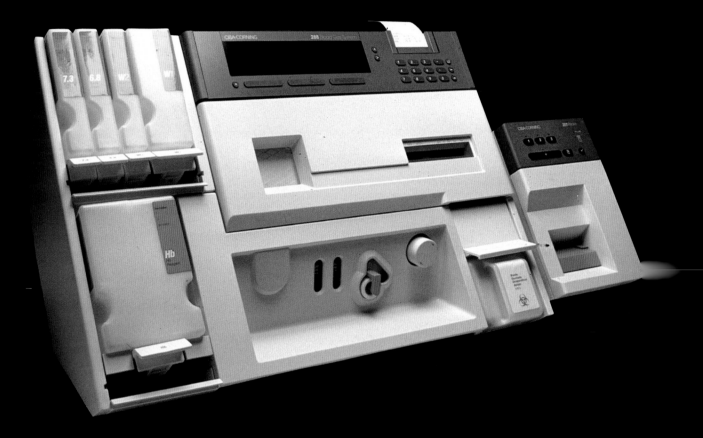

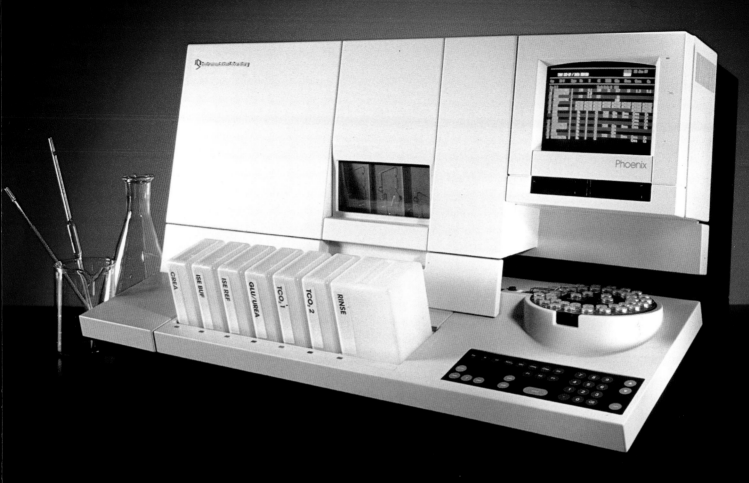

Product: **Phoenix Electrolyte Analyzer**
Client: **Instrumentation Laboratory**
Designers: **Design Continuum Inc./ Philip Swift; Stephen Guerrera; Elizabeth Goodrich**
Processes: **Reaction injection molding; blow-molding**
Materials: **Urethane; polyethylene**

Once again, the look of competency comes from the crisp preciseness of the shapes almost like a piece of building architecture that has been shrunk to fit on a countertop. RIM produces flat surfaces to complement shapes made in simple bent sheet metal.

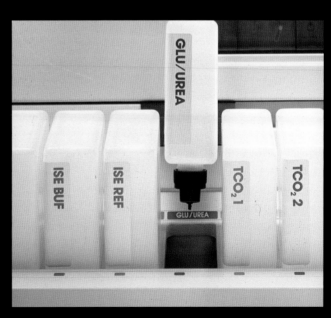

Product: **Blood glucose meter**
Client: **Lifescan Inc., Div. of Johnson & Johnson**
Designer: **GVO Inc.**
Process: **Injection molding**
Material: **ABS**

Glucoscan meters are used by diabetics to monitor their blood glucose levels. Because the device becomes an integral part of a person's daily routine, it needed to be small and lightweight—yet extremely rugged— while remaining attractive and very easy to use.

Designers devised an injection-molded enclosure with a large display and only two controls. The silver and gray color scheme keeps the product from looking too clinical or complex. A two-piece housing allowed the optical components to be snapped into place without adjustments. A polycarbonate resin reinforced with short glass fibers was used to provide adherence to very tight tolerances and thermal stability.

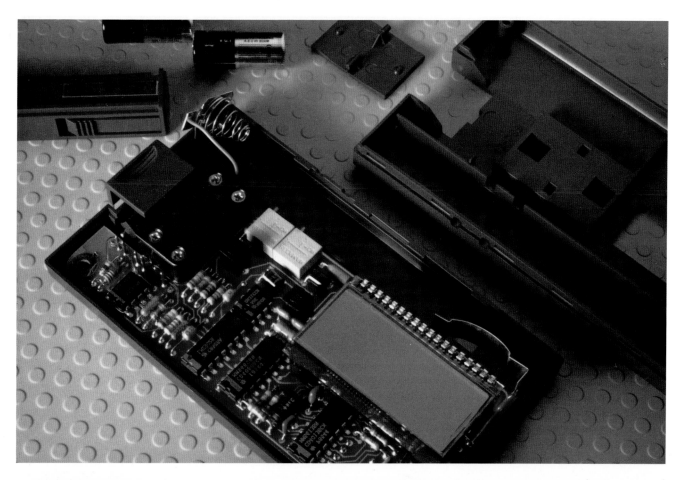

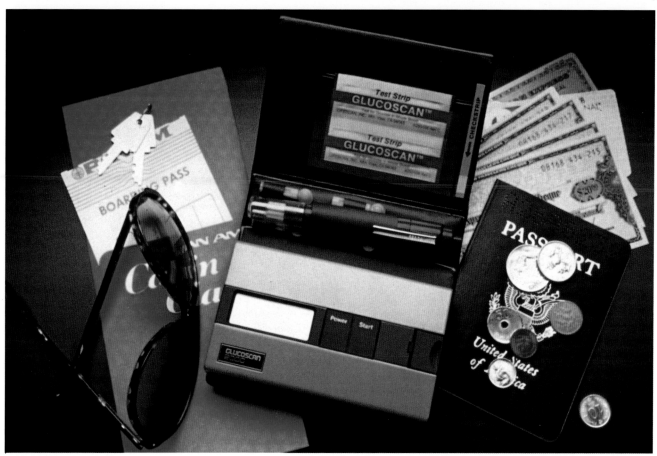

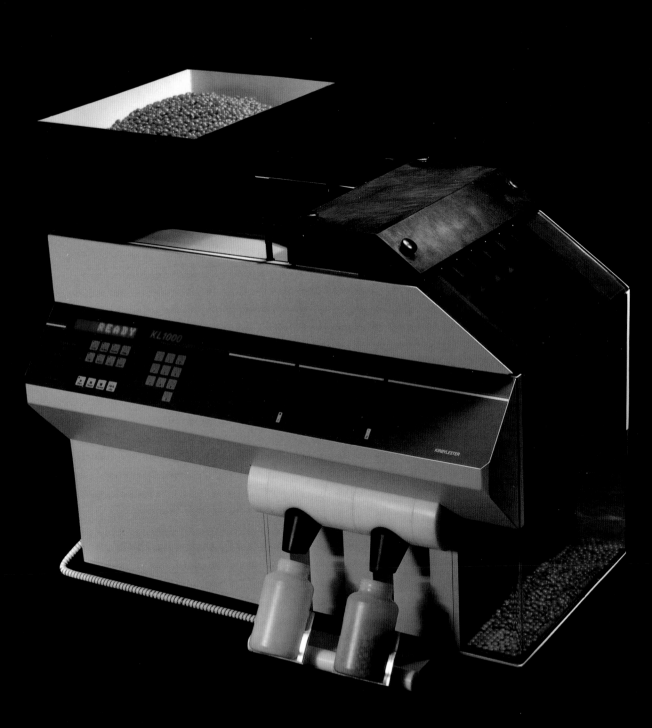

Product: **KL1000 tablet counter** ▶
Client: **Kirby-Lester**
Designer: **Product Genesis Inc./
Matthew Haggerty**
Processes: **Injection molding; potting;
impregnation**
Materials: **Epoxy; polyester; Teflon™;
polycarbonate; acetal**

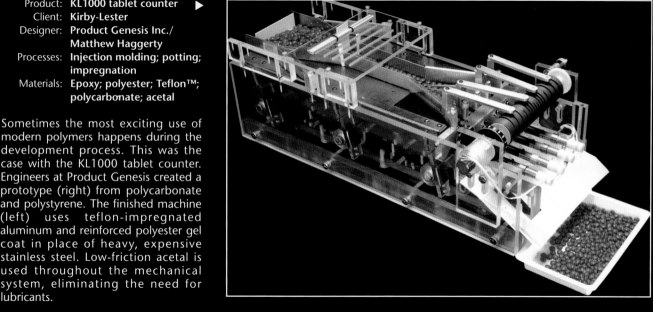

Sometimes the most exciting use of modern polymers happens during the development process. This was the case with the KL1000 tablet counter. Engineers at Product Genesis created a prototype (right) from polycarbonate and polystyrene. The finished machine (left) uses teflon-impregnated aluminum and reinforced polyester gel coat in place of heavy, expensive stainless steel. Low-friction acetal is used throughout the mechanical system, eliminating the need for lubricants.

◀ Product: **In-office blood analyzer**
Client: **Photest Diagnostics**
Designer: **Design Continuum Inc./
Michael Arney**
Process: **Structural foam molding**
Material: **Polyphenylene oxide**

Its high-relief detailing molded in structural foam, the Quantichem blood analyzer enables non-skilled operators to automatically program the machine to run complex blood tests. Reagents for each test are packaged separately. A magnetic card or bar code included with the package is fed into the machine, programming it to run the specified test. The machine then leads the operator through the test, eliminating the need for clinics or small doctor's offices to employ skilled lab technicians.

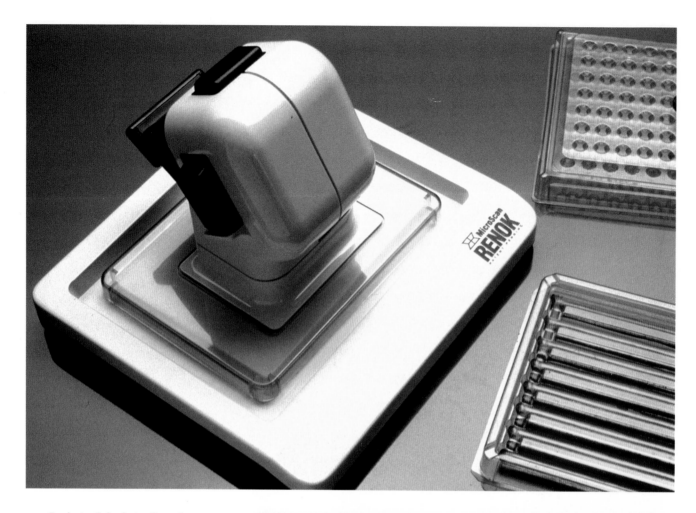

Product: **Rehydrator/inoculator**
Client: **Baxter Healthcare Corp./
MicroScan Division**
Designer: **S.G. Hauser Associates Inc./
Allan Cameron**
Processes: **Injection molding;
machining**
Materials: **Polysulfone; fluorocarbon**

The RENOK™ was designed to enable
a lab technician to fill a 96-well tray in
one step. The technician's hand rests
on a palm grip, allowing the device to
be moved easily and freeing the fingers
and thumb to work the two buttons
and one lever which control it. A trans-
parent bottom allows the technician to
see that the tray is filled successfully.
Polysulfone was selected for its ability
to withstand autoclave temperatures of
250°F. for 30 minutes during steriliza-
tion. The material also provides resis-
tance to many chemicals.

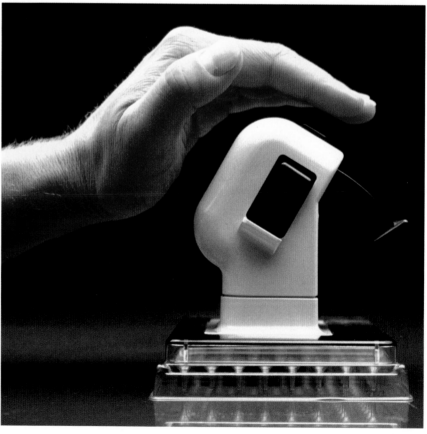

Product: **Portable malaria centrifuge and microscope**
Client: **Becton Dickinson**
Designers: **S.G. Hauser Associates Inc./ Stephen G. Hauser; Mark Schoening**
Processes: **Injection molding; machining**
Material: **ABS/polycarbonate blend**

This centrifuge and microscope were designed to be portable and rugged for field use in the detection of malaria in Third World countries. The ABS/polycarbonate blend was chosen for the external housing because it meets the impact specifications required for the centrifuge and is 30% lighter in weight than die cast aluminum.

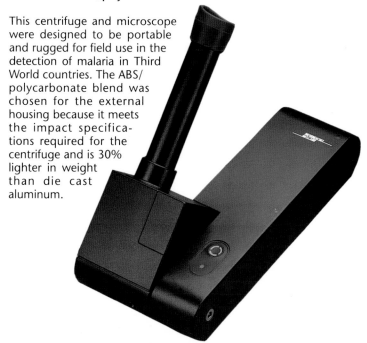
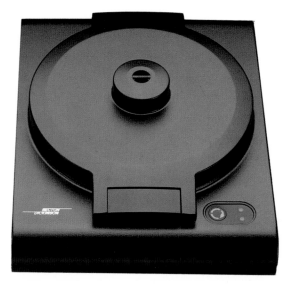

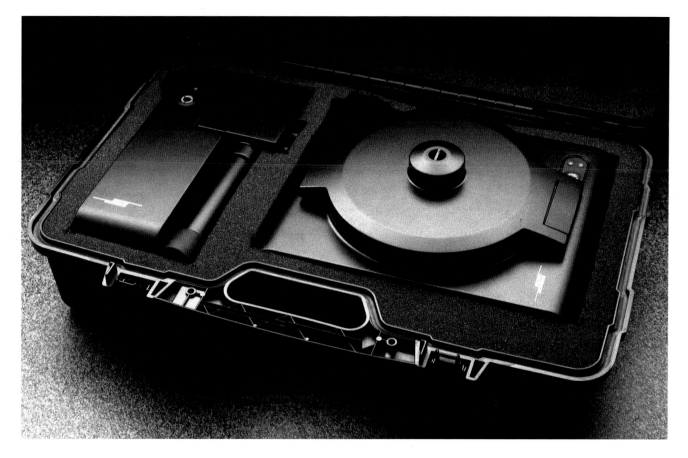

PACKAGING

We used to have to live where things were made or grown. Down on the farm. All of us. Modern inventions and modern techniques—particularly in transportation and packaging of foods—have freed us to live where we wish.

The miracle of the distribution society is in no small part due to plastics, because plastics are good for packaging wet things. Like milk. Old-fashioned glass milk bottles got replaced with paper boxes coated with wax. Then we used plastic resin in the paper instead of wax. The next big change was to blow-molded plastic containers. Now, in Canada at least, milk is delivered in sealed plastic bags, which are then placed in plastic pitchers for pouring at the table.

Paper wipes moistened with lotion—so handy for cleaning up—need waterproof, sanitary, sealable packages for delivery; they need plastic. Ultimately, all of these packaging materials wind up in garbage cans—as often as not, plastic—in plastic garbage bags.

For all of these distribution uses, we need something that is durable, doesn't rot, doesn't wet through and stays biologically inert. Plastic does all those things. It makes for a neat package, but unlike paper, it won't decompose after it's done its job.

When we call something a package, we imply that it is disposable. When we speak of a delivery system, we suggest that parts of it may be disposable. When we say product, or product exterior, we imply permanence. Throw it away? Never! Yet, they all do get thrown away.

Junk has happened in my lifetime. It is a tribute to mankind's ingenuity in making so many of us so rich in material goods. Even in the industrialized nations there never was anything cast off but what some other person could, and did, use it. When an automobile finally became no longer repairable and was abandoned, pushed off into an unoccupied woodlot, someone soon came along and took the hood off to use as a screen for the fireplace. At one time, there were a lot of Model T Ford firescreens in use.

There is no such thing as disposal. The earth as a closed system is just too small. Nothing can simply be cast aside.

We try to make our junk go away with degradation and with incineration. But "not visible to the naked eye" is not the same thing as "gone."

Degradation—of plastics in particular—is focused on litter. There is no question of the importance of bio- and photo-degradation techniques in outdoor housekeeping. But for plastics, it is not feasible or practical as a bulk disposal method.

The only way to maintain our riches, this richness of material goods, is to recycle materials that have already been extracted and refined from their sources on the planet.

There are two generalized ways to recycle. One is at the alloy level, separately handling steel, bronze, aluminum, clear glass, brown glass, newsprint, and such plastics as PET, HDPE and so on. The second is at the material component level. For plastics, this means recovery of the molecular building blocks—benzene for instance—that are used to make polymer resins. The implication is for cooking our leftover plastics in something that might look like a coke oven or petroleum refinery. This would amount to closed-system pyrolysis as opposed to the current open-to-the-atmosphere incineration.

Either way, the need for recycling is something responsible design in plastics must take into consideration. In contrast to mankind's usual disregard for the universe, it's most encouraging to see increasing awareness and active involvement in attempts to solve the problems of no-longer-wanted products, especially those made of materials that will not die.

—Douglas Cleminshaw

The following comments are the thoughts of world expert, widely-known guru and molecular tinkerer Dan Gilead

The mounting cost of urban garbage disposal, the rapidly diminishing sites for landfills and the general increasing awareness of the damage the industrial countries are causing to the environment has put the spotlight on plastics. Modern society cannot continue its way of life without plastics, and it becomes imperative to analyze the problem and evaluate the possible solutions. Plastic materials have had a phenomenal rise in importance. Plastics have not only replaced traditional natural materials, they have created new products and altered the way of life and commerce in an irreversible manner.

As a packaging material, plastics have been instrumental in changing our society into a distributional one. Plastic materials have made it possible to pack, transport and preserve any food product produced far from the place of consumption. Plastic flexible and transparent films and sheets have made the transition from the neighborhood grocery to the supermarket possible. The package today sells itself. You can see inside. It is attractively printed outside. And it can be economically made of a suitably small volume for the "shop and eat" society we have become. Because of the light weight of plastics, transportation costs are held at a minimum and one-way packaging does away with returned containers and their concomitant storage and stock requirements.

These are the physical aspects of plastic packaging materials, but it is their chemical properties which make them so supremely useful. And yet these same properties are the main cause of the problems we encounter in their final disposition. Plastic materials, especially those used in packaging, are chemical inert, waterproof and insoluble, unaffected by bacteria or fungal growth, impermeable physically and selectively impermeable chemically.

Plastic production will soon exceed 100 million metric tons per year. A large part of this astounding quantity will be converted into more or less permanent applications. A considerable part of the production of commodity plastics such as polyethylene, polypropylene and polystyrene will be converted into one-way packaging, bottles, trays, plastic bags and other containers. Of these, a full forty-five percent are disposable.

The problems of disposal and pollution of all the above items have to be carefully evaluated. Plastic garbage, which is that part of the material which is properly disposed of and collected by urban authorities, will make up a relatively small portion of urban garbage, by weight not more than six to eight percent. When put into a landfill and properly compressed, it will not take up more space than any of the other constituents except vegetable and animal matter. Once there, plastics will pose no threat to the ground water or surrounding soil. It is litter—plastics haphazardly discarded into the environment—which causes the most visible and disturbing impact.

What are the ways of ameliorating the problem?

Recycling is the art of transforming plastic waste into a useful raw material. There are two types of plastic waste: Industrial and urban. The former is increasingly regenerated by industry. Industrial waste and scrap is homogeneous and relatively uncomtaminated. It is a highly cost-effective way to lower the cost of the raw material.

Urban waste is a heterogeneous mixture of many polymers and is heavily contaminated with other materials. Recycling can and is being improved, a small but important contribution to the disposal problem. A system now being introduced in the United States uses this waste for the production of a wood-like material which lends itself to the production of posts, planks and so on.

In most plastic materials, an equal weight of plastic contains 125 percent of the thermal content of prime coal. Recovering this resource by incineration requires sophisticated and expensive equipment. Air flow, carbonization and the containment of fumes generated must be carefully addressed. Although at this stage community acceptance is still a problem, the equipment has been developed and is naturally held in high favor by resin manufacturers.

Two types of self-destruct methods are known to the plastics industry. Biodegradation means the eventual breakdown of the plastic product—and therefore the polymeric material—by the action of micro-biological organisms such as bacteria and fungi. Plastics, apart from a few exceptions, are totally impervious to this type of attack. Therefore altering them so they are no longer impermeable poses the danger of losing control. Years of research have gone into mixing starch and starch-like additives into the polymer matrix causing it to disintegrate when buried in the soil. Primary drawbacks here are the negative changes in its physical properties and the unpredictability of its final disintegration.

It is a paradox that the industry has spent years of research and millions of dollars to make plastic products light-stable. It is this accumulated knowledge that has made it possible to find ways of using ultra-violet light to cause the controlled disintegration of plastic materials. The time control, which ranges from days to months or even years, makes it possible to adjust this method to a wide range of products without compromising in any way the physical and chemical properties of the plastic. The necessary ultra-violet light at the correct wavelengths and rather large quantity of light energy is only found outdoors in direct exposure to sunlight. Once started, the disintegration process is very rapid, and at a certain stage is supported, sustained and accelerated by microbiological attack, which becomes possible by the chemical and physical changes the polymers undergo as a consequence of the petro- and thermo-chemical reactions. At an early stage, sunlight is no longer needed as the reaction that was initiated by light can continue in its absence. The end products of all these reactions are very basic compounds such as water and carbon dioxide, which return harmlessly to the natural carbon cycle.

Life is a web. All the different ways of reducing and controlling plastic waste are interconnected and complement each other. No one single method can address all of the varied aspects of the problem. What is needed is a greater understanding of this concept by the plastics industry, consumers and governmental authorities. The time to act is now.

Dr. Dan Gildead is head of the College of Plastics Technology of Israel. He has been head of R&D for Plastopil Hazorea Ltd. (Libbutz Hazorea 30060, Israel) since 1963, where he is still acting as consultant. He was also president of the Society of Plastics of Israel from 1981 to 1983.

Product: **Spectra sun care products**
Client: **Coppertone Corp.**
Processes: **Injection molding; blow
molding**
Materials: **Polypropylene; high-
density polyethylene**

Spectra comes in both white and gray
pearlescent bottles with multi-color
"rays" that help to distinguish each
formula. A 24mm closure supplied by
Sequist is made of polypropylene and
features exact orientation to the bot-
tle, with the ridge of the closure per-
fectly matching the ridge of the bot-
tle. An anti-backoff torque lug feature
means the closure won't inadvertently
open during shipping or on the retail
shelf.

Product: **Lady Stetson perfume** ▶
Client: **Coty**
Designer: **Group Four Design/
William H. Valls**
Process: **Injection molding**
Material: **Clear high-impact
polystyrene**

Most perfume is sold in glass bot-
tles—the fancier, the better. Budgetary
considerations dictated that Group
Four Design create a plastic container
that resembled glass for this mass-mar-
ket fragrance. Accented with a hot-
stamped foil band, the package is as
elegant and classy as any glass bottle.

Product: **Disc top dispensing closures**
Client: **Sequist Closures, a division of Pittway Corp.**
Designer: **Sequist Closures**
Process: **Injection molding**
Material: **Polypropylene**

One finger is all that's needed to operate a Disc Top closure. Push the front down, and the bottle is sealed tight. Push the back down and the cap opening is exposed and ready for action. The primary seal is available in either plug or crab's claw style.

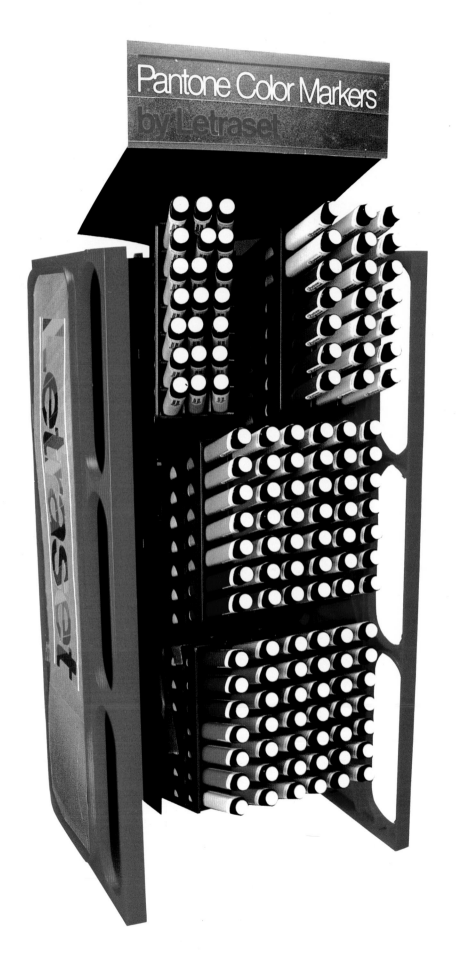

Product: **Art marker organizers**
Client: **Letraset Manufacturing**
Designers: **Barry David Berger + Associates Inc./Barry Berger; Art Martin; Hillery Muldow; Chung Ping Liao**
Process: **Injection molding**
Materials: **High-impact polystyrene; ABS**

Letraset™ developed three styles of organizer systems that can be expanded as needed. At the heart of the system is a pivoting cassette, best illustrated by the Personal Marker Organizer at left. The cassette, which holds seven markers, pivots from left to right, enabling the user to see the colored wrapper of every marker in the unit. The color of the wrapper corresponds to the color of the marker. The same modular back and side panels form the building blocks of the retail point-of-purchase system (opposite page) and the Studio Marker Organizer (below).

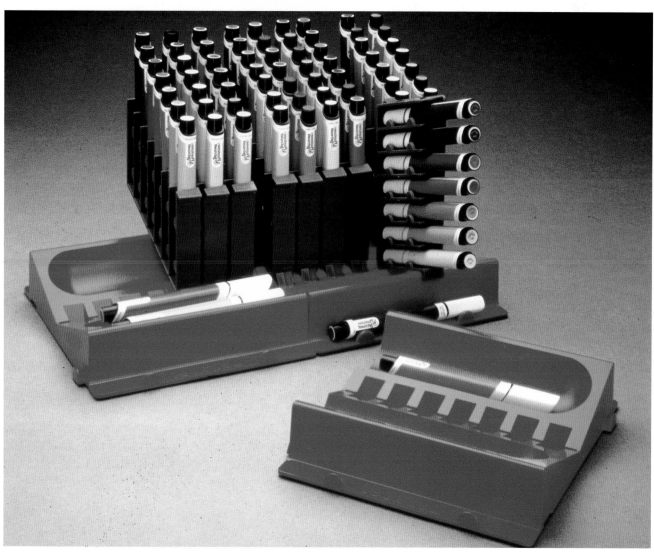

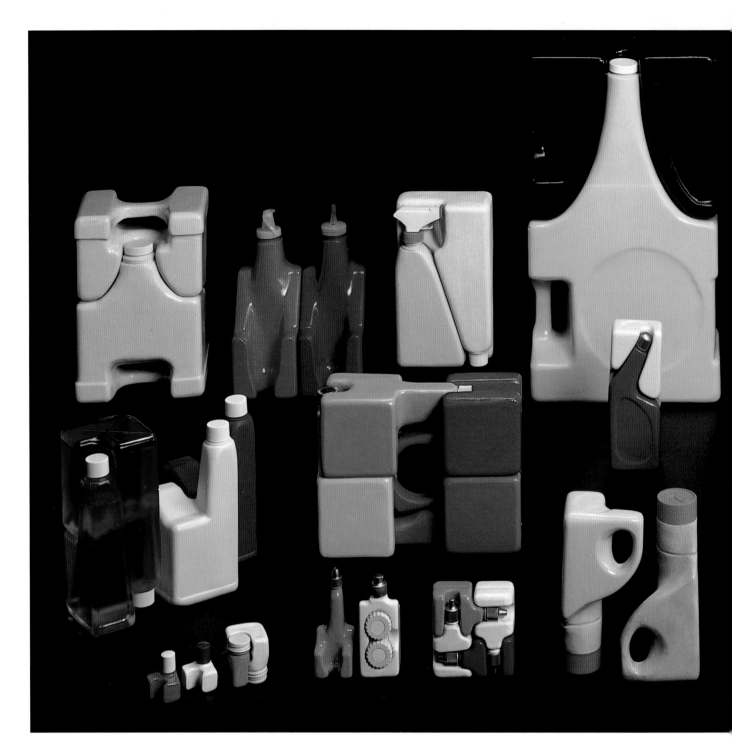

▲ Product: **Pac Mate Containers**
Client: **Universal Symetrics Corp.**
Designer: **Universal Symetrics Corp./ Juris Mednis; Robert Stank**
Process: **Extrusion blow molding**
Materials: **Polyethylenes**

Pac Mate containers, available in just about every size, shape and color imaginable, were designed to address a common problem among retailers and marketers: how to stock the maximum amount of product in the smallest amount of space without compromising convenience or aesthetics. Pac Mates fit together to form rectangular space-saving packs. Universal Symetrics Corp. estimates that the packaging system designed for the bottles enables retailers to stack 50% more product on a standard pallet or on a retail shelf. The colorful packages are blow molded in sizes ranging from one ounce to one quart or larger.

Currently manufactured in high-density polyethylene, container systems can also be produced in a variety of thermoplastic resins.

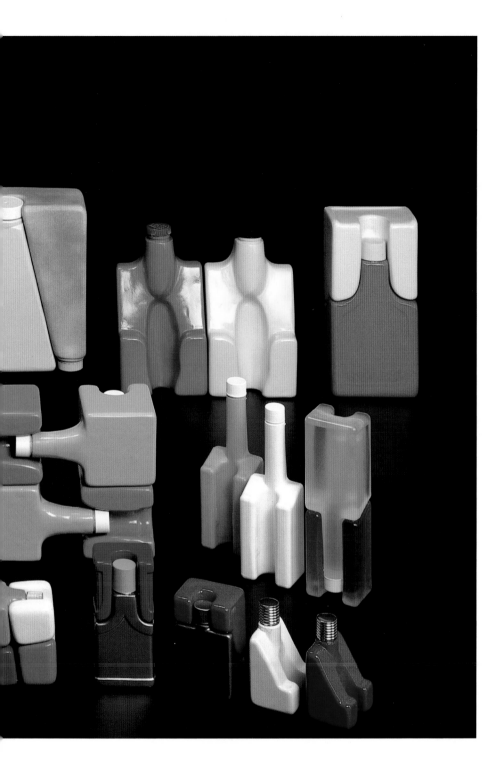

▲ Product: **Heavy Hands packaging**
Client: **AMF**
Designer: **Selame Design (graphics)**
Fabricator: **Klearfold**
Processes: **Thermoforming; die-cut sheet**
Material: **PVC**

Most weight equipment is hidden from the consumer in cardboard boxes, some designed with bold graphics, most not. Massachusetts-based Selame Design took a different tack by designing a transparent PVC package that would clearly show the product. Clear plastic supports cradle the hand weights, keeping them standing upright in the package.

Product: **Timex Prism packaging**
Client: **Timex Corp.**
Designers: **Barry David Berger +**
Associates Inc./Barry Berger;
Art Martin; Hillery Muldow;
Chung Ping Liao
Process: **Injection molding**
Material: **Polystyrene**

These modular packs for Timex show off the watches to best advantage— upright instead of flat. Additionally, the packs can be used to display the watches singly (above) or en masse (right). The sharp lines contrast with the rounded shapes of the band and watch face, and the truncated angles of the box give the viewer an exaggerated sense of perspective.

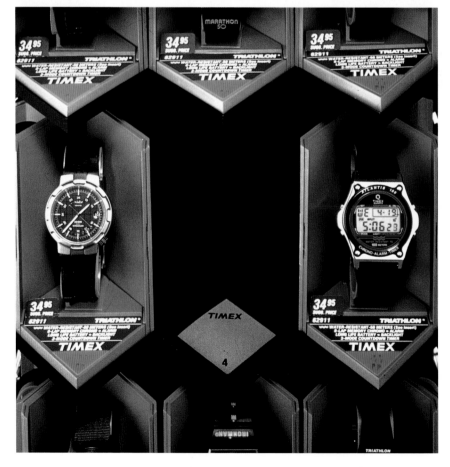

Product:	**Automatic bottle/can vendor**
Client:	**The Coca-Cola Company**
Designer:	**American Industrial Design Co./Coca-Cola USA**
Processes:	**Injection molding; cold forming**
Material:	**Polycarbonate**

The bright red, steel-fronted Coke™ machines were an icon of American culture for decades. The corner drugstore in virtually every town on the continent had one; for the loose change in your pocket, it would drop a bottle filled with ice-cold Coca-Cola into your hand. On a hot day, a Coke™ machine was a freestanding oasis for many a weary traveler. Replacing such a familiar and beloved object is never easy. But despite its virtues, steel is heavy, expensive and very, very opaque. And while existing steel machines incorporate small, illuminated windows and even signs, the Coca-Cola Co. and American Industrial Design teamed up to produce the very first vending machine lit from top to bottom. Cold-formed polycarbonate sheets form the exterior while a variety of injection-molded parts keep the details soft-edged and friendly. The result—an oasis ingeniously transformed into a beacon ready to bring a familiar glow into darkened hallways and parking lots around the world.

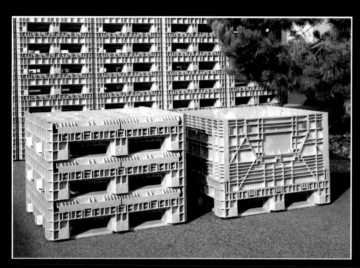
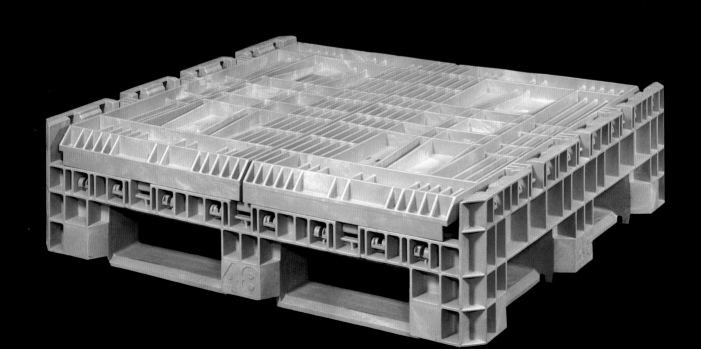

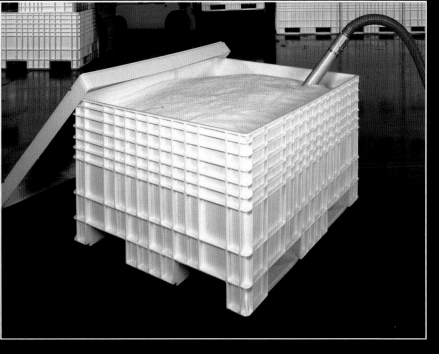

Product:	**Magnum containers**
Client:	**Xytec Plastics Inc.**
Designer:	**Xytec Plastics Inc.**
Processes:	**Structural foam molding; Injection molding**
Materials:	**Polyethylene (base only); polyethylene with 5% glass**

These containers—which come in both a porous collapsible version and a solid-wall non-collapsible model—have no metal parts. Both have molded-in pallets for easy handling with a forklift.

The non-collapsible container can hold liquids, fine powders and most chemicals. Liquids can be stored all the way to the top of the unit and the curved interior corners make clean up easy.

The collapsible containers can be erected and collapsed without tools and the side walls go on and off quickly with a screwdriver for easy knock-down storage. Also, they're equipped with a one-inch positive interlock for stacking when open or collapsed.

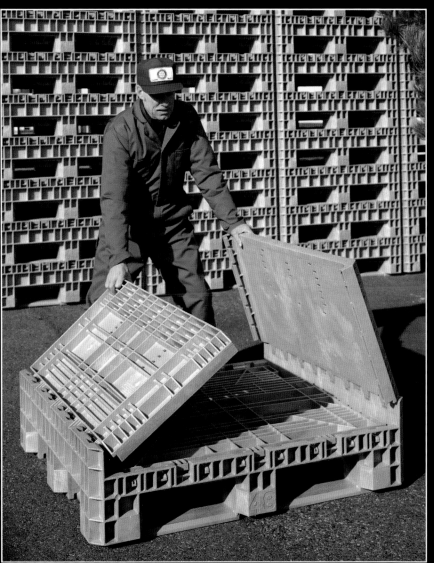

Product: **Packing materials**
Client: **Dow**
Process: **Expanded foam**
Material: **Dow Pelaspan expanded polystyrene**

Pelaspan Mold-a-Pac packaging "popcorn" is made by molding particles of polystyrene together. This creates a strong cushion that protects breakable and expensive items—like a computer keyboard—during shipping.

Product: **Water bottles**
Client: **Pine Grove Springs, Sand Springs Springwater Co.**
Designer: **GE Plastics**
Process: **Blow molding**
Material: **Polycarbonate**

Water bottles made of transparent plastic not only resist denting and crushing, they also keep their odors to themselves, preserving the clean, refreshing taste that consumers expect from bottled water. Another marketing plus: the vivid colors of fruit juices add visual appeal to store shelves.

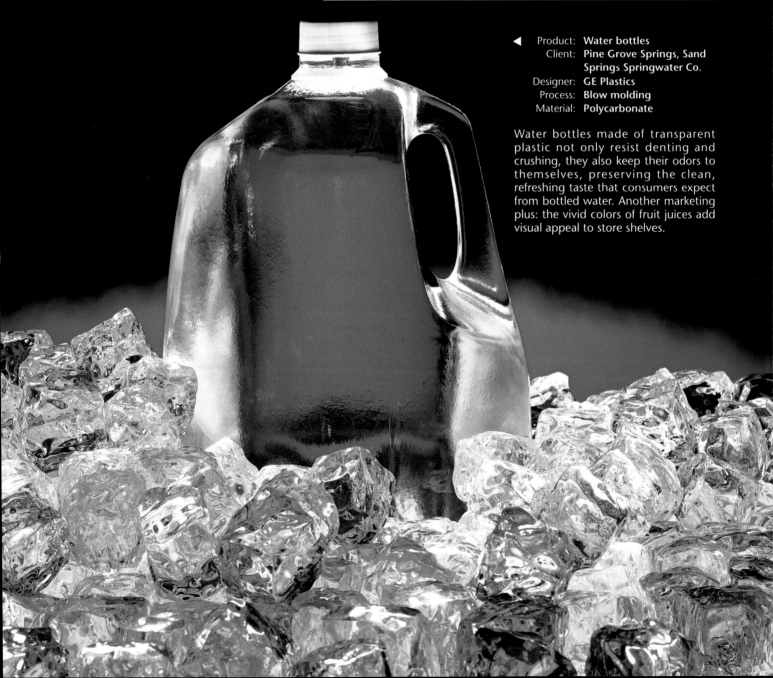

Product: **Snap-top closure**
Client: **Sequist Closures**
Designer: **Sequist Closures**
Process: **Injection molding**
Material: **Polypropylene**

You could say a lot of nice things about Sequist's Pour Spout Snap-Top closure—there's no chance of losing the cap, food doesn't clog in the cap, so it's more sanitary. But the best thing about this patented design is that it helps certain products, like ketchup, flow better.

Product: **Food packaging**
Materials: **Polypropylene; metallic coating**

Another packaging innovation—food containers made of polypropylene film. Metalized coating seals in freshness and holds bright colors well. The material can also remain transparent so that consumers can see the product inside the package. ▼

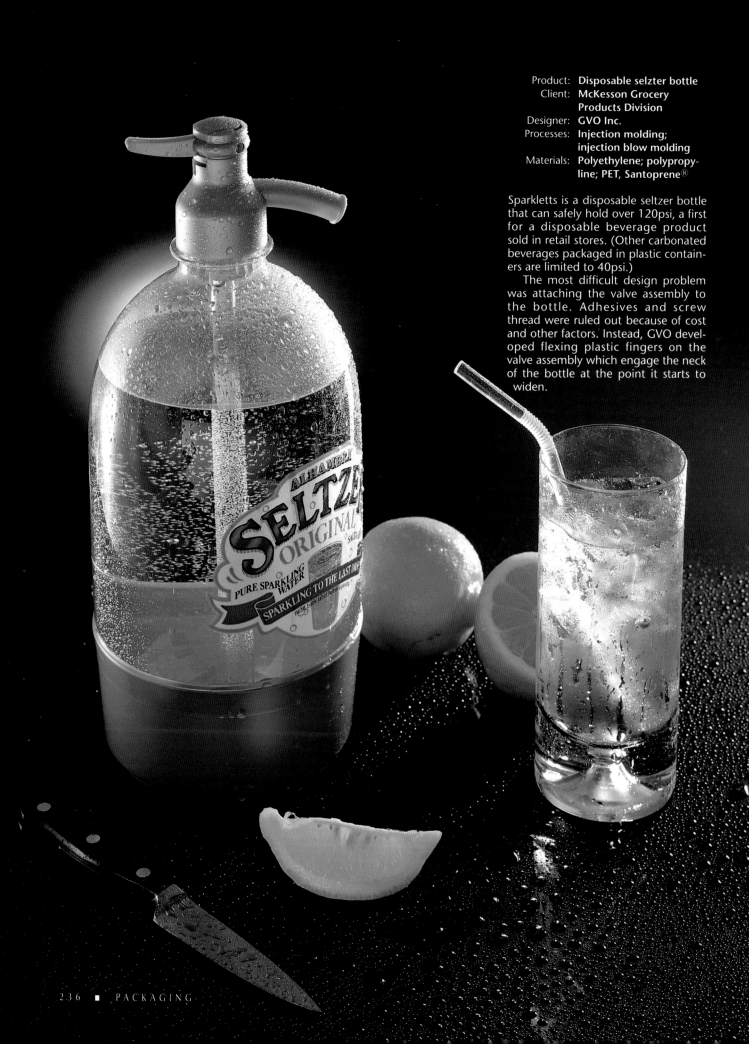

Product:	Disposable selzter bottle
Client:	McKesson Grocery Products Division
Designer:	GVO Inc.
Processes:	Injection molding; injection blow molding
Materials:	Polyethylene; polypropyline; PET, Santoprene®

Sparkletts is a disposable seltzer bottle that can safely hold over 120psi, a first for a disposable beverage product sold in retail stores. (Other carbonated beverages packaged in plastic containers are limited to 40psi.)

The most difficult design problem was attaching the valve assembly to the bottle. Adhesives and screw thread were ruled out because of cost and other factors. Instead, GVO developed flexing plastic fingers on the valve assembly which engage the neck of the bottle at the point it starts to widen.

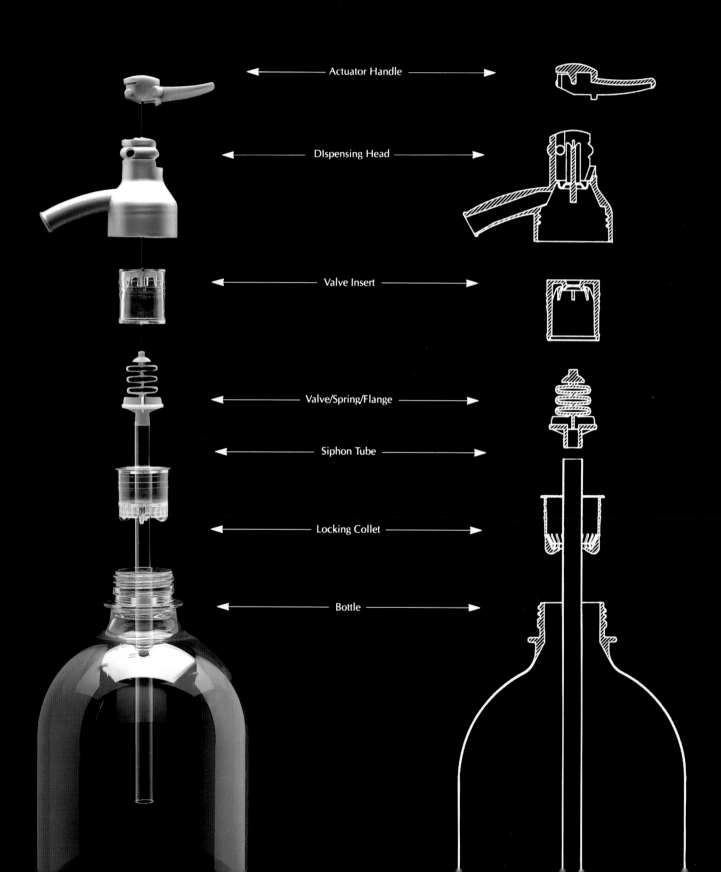

Actuator Handle

Dispensing Head

Valve Insert

Valve/Spring/Flange

Siphon Tube

Locking Collet

Bottle

Photo Credits

Pg. 53

Featured is the Conserve-N-Aisle filing system designed by Barry David Berger + Associates Inc. for Supreme Equipment & Systems Corporation. Materials consist of ABS (control area elements), polyurethane-vinyl blend and high-pressure laminate on the hardboard panels.